C000175126

The Secret Life of
Ealing Studios

The Secret Life of Ealing Studios

Britain's Favourite Film Studio

By Robert Sellers

Aurum
Press

First published in Great Britain 2015 by Aurum Press Ltd
74–77 White Lion Street
Islington
London N1 9PF
www.aurumpress.co.uk

A catalogue record for this book is available from the British Library.

ISBN 978 1 78131 397 8
eBook ISBN 978 1 78131 483 8

2015 2017 2019 2018 2016

1 3 5 7 9 10 8 6 4 2

Typeset in Adobe Garamond by Saxon Graphics Ltd, Derby
Printed and bound by CPI Group (UK) Ltd, Croydon, CR0 4YY

Contents

Acknowledgements

I would like to thank the following Ealing veterans for their memories of working at the studio, without whom this book would not have been possible.

Christopher Barry (assistant director)
Lord Michael Birkett (personal assistant to Michael Balcon/assistant director)
Betty Collins (personal assistant to Alexander MacKendrick)
Ray Cooney (child actor)
Peggy Cummins (actress)
Norman Dorme (art department)
Alex Douet (camera assistant)
Rex Hipple (sound department)
Maureen Jympson (administration/casting department)
Mandy Miller (actress)
Peter Musgrave (sound department)
Madge Nettleton (production secretary/continuity)
Gerry O'Hara (assistant director)
Joan Parcell (production secretary)
Nicholas Parsons (actor)
David Peers (assistant director/production manager)
Tom Priestley (editorial department)
Tony Rimmington (art department)
Maurice Selwyn (runner/clapper loader)
Ronnie Taylor (camera operator)
David Tringham (assistant director)
Ken Westbury (camera department)
Robert Winter (editorial department)

Also many thanks to Joanna McCallum for sharing her memories of her parents, Googie Withers and John McCallum, and to Sylvan Mason for allowing extracts from her father Jack Whittingham's film diary. And special thanks to Charles Barr and James McCabe.

Foreword

What an amazing story. A group of talented people come together under a charismatic leader, they band together to meet the demands of a special set of circumstances, and they create something beautiful and lasting. And then, as the circumstances change, they drift apart, everything comes to an end... the way things do. And it lives, powerfully, in their combined memories.

When I was young and getting interested in movies – watching them, slowly figuring out that they were *made*, then that they were made by teams of individuals, and then, gradually, *how* they were made – there were names that meant something. Sometimes they were the names of people – directors, producers, actors. Sometimes they were the names of companies, each of which had its own special logo: the Warner Brothers shield, the Universal planet, RKO's radio tower, Powell and Pressburger's The Archers with the arrow hitting the target, the strong man striking the J. Arthur Rank gong. And then there was Ealing Studios, a modest design: the company name between laurel branches, like parentheses.

We associated each of these logos with a certain mood or feeling, comprised of the memories of all the pictures you'd seen from that company coming together in the mind. With the Ealing pictures, we always anticipated something special. There were all of those wonderful British actors, familiar friends who were right there when you needed them, and I always loved seeing the new faces, the people who'd been welcomed into the fold. And every Ealing film seemed to have been hand-made – each element, from the narrative to the production design to the cinematography to the acting to the language to the tone. That's very important – the *tone* of the Ealing movies was quite different from everything else around, the comedies in particular of course.

As we learn in this lovingly compiled history, Ealing's glory years, from Michael Balcon's arrival in the late '30s through to the sale of the studio facilities to the BBC in the mid-'50s, coincided with the War followed by

the long national recovery. You see this again and again in film history, people drawn together at a time of national emergency, working together to create films that responded to the moment, sometimes directly (as in the case of *Next of Kin* or *Went the Day Well?*) and sometimes indirectly, striking a chord with the audience (I'm thinking of *Dead of Night* or Robert Hamer's *It Always Rains on Sunday* or the comedies directed by Alexander Mackendrick and Charles Crichton). A little world was created at Ealing, a world that was sometimes egalitarian and sometimes not, every day filled with triumphs and calamities and sudden promotions and hilarious misadventures. When things were at their best, everyone was working towards the common goal of making a great movie.

How did a movie like *Kind Hearts and Coronets*, one of the peaks of English moviemaking, actually come to be made? A brilliant director (Hamer), equally brilliant actors (Alec Guinness, Dennis Price, Valerie Hobson, Hugh Griffith), a great writer (John Dighton) and DP (Douglas Slocombe, who never looked at a light meter – he read the sunlight on his hand), Art Director (William Kellner) and Costume Designer (Anthony Mendleson)… but beyond that you have to think about the conditions that made it all possible, the tone that Balcon set. And you could say the same of *Dead of Night* or *Whiskey Galore* or *The Lavender Hill Mob* or smaller, lesser-known films like *Champagne Charlie* or *Secret People*.

I love the reminiscences that Robert Sellers has compiled, about the can-do-spirit, the near-disasters (like Hamer and his crew forgetting that they'd left Alec Guinness strapped in an underwater cage for five minutes), the petty grievances of the union leaders (which Peter Sellers studied and later made use of in *I'm Alright Jack*), the challenging working conditions in the studio itself. It all feels oddly familiar. In fact, this lively, funny, moving history of a movie studio and the people who made it feels uncannily like…an Ealing comedy.

Martin Scorsese, 2015

Welcome to Ealing

The first thing that struck you upon arriving at Ealing Studios was that it didn't look like a film studio at all. It also had absolutely no right being where it was, slap bang in the middle of suburbia, surrounded on either side by prosperous homes and set on a village green, an odd place for a thriving hubbub of movie-making. But there it was, its glorious white administrative block that faced out onto the road and first greeted the gaze of the visitor, looking for all the world like a small private Regency manor house.

The next thing that caught your eye was a large man dressed in a smart uniform, usually standing to attention. His name was Robin Adair and he was an ex Coldstream Guards sergeant and guarded the front gate as if it were the Khyber Pass. 'He was quite a formidable character,' recalls Maurice Selwyn, who started as a runner at the studio. 'And his word was absolutely law.' Nobody got in without his permission. He was a permanent fixture at the studio, standing by the gates in all weathers from first thing in the morning until the end of the working day, always on hand to greet the artists arriving in their cars and studio head Michael Balcon in his chauffeur-driven limousine.

Moving on past the gate, one came to the inner workings, the coalface as it were. And yet, what lay before you was scarcely sprawling, not in the same league as Shepperton, Pinewood or even Denham. Ealing was close knit, compact, with everything bunched together. As one visiting journalist amusingly noted, Ealing was, 'A postage stamp of a studio, with a back lot barely large enough to turn a car in.'

There were three main sound stages: Stage 2, which was the first to be built and the biggest, and stages 3A and 3B, which had a sliding door between them so they could be turned into one big stage. Flanking these stages were large office blocks housing all manner of different departments. 'As far as I can remember,' says Ken Westbury, who worked with the camera unit, 'on the south side of the stages on the first floor were offices and the camera workshop, the ladies' wardrobe was on the second floor and on the top floor were the cutting rooms. And on the other side was the makeup department, the first-aid room, a dark room, some production offices and above that were the men's wardrobe and a few dressing rooms.'

Away from this main block there was Stage 1. 'That was little more than a large soundproof shed where artist's tests were shot,' recalls Christopher Barry, an assistant director at Ealing. 'And there was also a model stage where miniatures and shallow water shots were done. Apart from these buildings there were construction workshops, the art department, front offices and West Lodge, another brick building housing producers, writers and directors as well as the photographic and publicity departments.'

You see a sign on the wall, which reads 'The studio with the team spirit'. The most important factor about Ealing was that Michael Balcon gathered around him a young creative team of

directors and writers, a film-making community that became known as Balcon's 'Bright Young Gentlemen'. Monja Danischewsky, Ealing's head of publicity, characterised the studio as 'Mr Balcon's Academy'. These film-makers were invariably trained at the studio, first as editors and then as associate producers, and when they were ready and the time was right Balcon promoted them to directors. All of them were under contract, like the rest of the studio staff, which gave everyone a feeling of corporate loyalty far greater than those working at the other studios. It was a unique situation and helped to create an invigorating family atmosphere where co-operation and the sharing of ideas were actively encouraged. As one critic noted about Ealing: 'Its films, one feels, are made by a family for the family.'

With the majority of the workforce permanently on the books, everybody knew each other and for the most part got on together. 'At other studios different crews came to work on different pictures and then when it was over everyone was gone,' says Rex Hipple, who worked in the sound department. 'Whereas at Ealing Mick wanted to maintain constant production in order to keep hold of his workforce. And a lot of them had been there for twenty-one years, that's why it became almost like a family institution.' And a special place, not only the films that were produced there, but the environment in which they were made. 'It was a film factory,' states Tony Rimmington, from the art department. 'They made their own particular, unique brand of films which were not made anywhere else.'

Those films were very much a reflection of Michael Balcon himself who ran Ealing Studios according to very clear-cut ideas. 'He was a very strict man,' his daughter, Jill, once

remarked. 'Moral in the best sense of the word, upright, honest, uncorrupt.' His strongest belief, one he never strayed very far from, was that films should be socially responsible and that they should be trying to say something that was positive.

Not surprisingly it was his presence and influence that dominated the entre fabric of the studio. 'I remember just being in total awe of him,' says Maureen Jympson, who worked in the studio's administration. 'He was like some kind of benign God, that's how I viewed him.'

Without fail, every morning at 10.30 sharp, Balcon would turn up on one of the sound stages. Filming would stop, everyone would say, 'Good morning, Sir Michael', he would watch a little bit of what was going on and then leave again, followed by a small retinue of assistants. 'There was always a degree of formality when he came on the set,' recalls Maurice Selwyn. 'He'd sit on a seat with his name on the back and have discussions with the director and the artists. It wasn't tense, but I can remember the atmosphere was always charged with much respect for Michael Balcon.'

In previous books and other written material, Ealing has usually been considered from the point of view of the academic outsider, and the films themselves explored from the perspective of a critic primarily concerned with their cultural aspect and social significance. Nothing wrong with that whatsoever, but something that hasn't been explored in any proper detail is what it was actually like to work at the studio nine to five, and the roles played by those unsung heroes who worked behind the scenes – the secretaries, draughtsmen, clapper loaders, editors, production managers, assistant directors, et al., without whom Ealing wouldn't have been able to function, let alone make movies.

One is left to wonder why these people's testimonies have scarcely been heard before. At the time and in subsequent years they perhaps weren't deemed important enough. Today, however, their voices offer us a rare and unique glimpse into the inner sanctum of Britain's most beloved movie factory, how it was run day to day, the remarkable characters employed there, the fun and games that went on, and how those classic Ealing films were dreamt up and put together.

Remarkably, given that it is sixty years since Ealing closed its doors, there are people still alive who worked there, but it is an ever-dwindling group, proving just how important it has been to get their testimony on record. With a few exceptions, everyone spoke of their time at Ealing with a huge fondness. 'There was never an unpleasant moment. I enjoyed all of it,' confirms art director Norman Dorme. 'I can't think of anything else I wanted to do other than be in the film industry. I always thought it was so much better than working. It never seemed like work, ever.'

Maurice Selwyn, though, perhaps sums it up best: 'My half days were a nuisance and Sundays were a nightmare. If I could have, I would have lived my life at the studio. I'd have worked there for nothing because I just loved every second of it.'

Chapter One

Balcon Takes Control

When he reported for duty on his first day of work at Ealing Studios in 1941, Robert Winter could have been forgiven for experiencing a heavy dose of déjà vu as he walked through the gates and wandered the narrow alleyways in between the busy stages. He'd been here before. It's where he fell in love with the movies for the first time as an eight-year-old child.

It was all thanks to his music teacher, who also happened to be an agent for child extras and got Robert a few days' work on three Gracie Fields films made at Ealing back in the mid 1930s. He found Gracie enchanting but it was the heady mixture of working on a sound stage that left the most indelible mark.

I was fascinated by it all, the lights, the pungent smell on the set, and especially the orange make-up. Because of the exposure rate of the film the lighting had to be so intense, that's why the actresses all walked round with orange faces, and almost deep-purple lipstick and painted-in eyebrows. That's where I first met Carol Reed, he was the assistant director on one of the films. I remember he gave me half a crown because it was my birthday. I was just so gaga and entranced by the whole atmosphere.

Leaving school there was no question of any other career path but the movies. With his father away on war work and not available for consultation about his future, Robert took matters into his own hands and turned up one day outside the gates of Ealing Studios, coming face to face with the formidable security guard, Robin Adair. He was in luck, Adair told him to come back in three months' time and they'd have a job for him. 'Because of the war there was a great shortage of people with so many young men going into the armed forces,' says Robert. The job was basic, just taking the mail round to all the departments, but at least it afforded him the chance to check out the studio and choose which particular field he wanted to specialise in. One morning, arriving at the props department, Robert was surprised to bump into his uncle, having no idea he worked there. By a strange coincidence he also discovered that his aunt had a job at Ealing, too, in Wardrobe. This wasn't all that unusual. 'There was a family called the Thriffs who worked at the studio,' recalls Ken Westbury. 'The father was a carpenter and his son was a stand-by carpenter. He would literally just stand around on the set all day until he was needed. There was also another son who worked in the machine shop, sawing and planing wood. Then, much later, his grandson worked in the publicity department.'

After a few months' delivering letters, Robert decided on sound editing and was taken under the wing of sound cutter/editor Mary Habberfield, who worked as dubbing/sound editor on many Ealing films. It was Mary who created the memorable 'guggle, glub, gurgle' noise of Alec Guinness' chemical laboratory in *The Man in the White Suit*.

I was a trainee. You had a five-year apprenticeship in editing. You had to do those five years before anybody in any studio would promote you. You had to learn all manner of technical stuff. Sound was a very tricky thing in those days and one of my early jobs was to go through a print of the edited sound track and look for any little specks on the negative, which would make a noise when it was projected, and paint them out by hand. You don't think of having to do something like that now, but back in those days things were certainly more complicated and time-consuming.

Over the many years Robert worked there, the sound department operated as a true democracy, with plenty of co-operation between productions.

I think we had something like ten cutting rooms, so somebody would say, oh can you do this for me, and you just moved on to somebody else's picture. As an assistant you always moved from one person who was in a bit of trouble and wanted help to another. I worked with Seth Holt who'd say, 'Come and have a look at this. What do you think about it?' That's how it was, a real community.

Robert didn't have an enormous amount of dealings with Balcon, remembering him as a very gentle person who'd stop and have a chat with anyone.

One day he said to me, quite out of the blue, 'Would you like to see my new shoes? Just have a look.' I had to

admit they were beautiful shoes. Then he said to me, 'Do you know how much I earn?' Well of course I'd no idea. I was on about £2.10 a week or something. He said, 'This year I've been paid £32,000.' What other boss would reveal that? But Mick was that kind of person. Not aloof at all. In fact he was a softly spoken man, as was his wife, who used to greet visitors at the front of their house in her Red Cross uniform.

By the time he was asked to take over as Head of Production at Ealing Studios in 1938, after the previous incumbent, Basil Dean, had been forced out by the board following a series of poor performing films at the box office, Balcon had already established himself as one of the figureheads of British cinema. Born in 1896 into a middle-class Birmingham family, Balcon entered the film industry in the early 1920s, producing films out of Islington Studios, which he later bought. Though small, Islington was well equipped and staffed by enthusiastic and talented technicians, including the young Alfred Hitchcock, who quickly came to Balcon's attention, 'because of his passion for films and his eagerness to learn'. When Balcon formed Gainsborough Pictures in 1924, he didn't waste time in giving Hitchcock his first directorial assignment with *The Pleasure Garden* (1925).

When Gainsborough joined forces in 1928 with Gaumont-British, at that time amongst the largest names in films in the country, Balcon was made Head of Production for both companies. Over the next five years, under his careful stewardship and guidance, Gainsborough, still operating from Islington, and Gaumont, which owned Lime Grove Studios in Shepherd's Bush, produced some of the most popular and

renowned British films of the period. There were the Hitchcock classics *The Man Who Knew Too Much* (1934) and *The 39 Steps* (1935), the comedy thriller *Rome Express* (1932), Boris Karloff's first British horror film *The Ghoul* (1933), *I Was a Spy* (1933) with Conrad Veidt and Madeleine Carroll, the comedies of Jack Hulbert and Cicely Courtneidge, musicals with Jessie Matthews, including *Evergreen* (1934), historical dramas such as *Tudor Rose* (1936), and even a flirtation with the documentary movement when Balcon, in the face of fierce opposition from the Gaumont board, backed the documentary pioneer Robert J. Flaherty to make *Man of Aran* (1934).

This success led to Balcon being head hunted personally by Louis B. Mayer to join his MGM corporation, which was setting up its British operation at Denham Studios. Balcon was excited by the challenge of making Anglo-American films for the international market, 'blending the best from both sides', but did not take to Mayer's despotic way of working and, after completing just one film, the overly romanticised *A Yank at Oxford* (1938), walked out of the deal. Contemplating moving into independent film-making, Balcon went to see an accountant friend, Reginald Baker, on a financial matter. Some years earlier Baker had been instrumental in the negotiations to buy Islington Studios and was now in administrative charge at Ealing. During the meeting Baker suggested that since Balcon was leaving MGM, why didn't he bring his talents over to them?

It wasn't long into Balcon's reign before war clouds began to gather and conflict with Germany looked inevitable. Balcon had already begun developing ideas about how Ealing and the British film industry in general should play its part. These thoughts were written down in a memorandum entitled 'How to put films to work in the national interest in wartime', and

sent to the relevant government department. It was totally ignored. Even when hostilities began, Ealing was at first given no official guidance on how it might help with the war effort. For a time it looked as if the entire film industry might be put into mothballs when the government ordered all cinemas to be closed, fearful of mass carnage should a bomb fall on a packed auditorium. Within days George Bernard Shaw had written to *The Times* with his thoughts on the matter: 'What agent of Chancellor Hitler is it who has suggested that we should all cower in darkness and terror for the duration?' As Shaw put it, denying entertainment to soldiers and civilians was 'a masterstroke of unimaginative stupidity'. Within weeks the order was rescinded and the cinemas were back open.

Other industries, too, faced upheaval, not least newspapers. Straight from leaving school, Madge Nettleton had gone to work in the Features Department at the *Daily Express* in Fleet Street, staying there for five years.

I loved the job. I would have stayed there forevermore, but six months into the war I got my notice to leave with a month's money, myself and several other people. We couldn't do anything about it, the papers just dwindled in size. They went from eighteen pages or so down to about four. I was 21 and didn't know what to do. I'd only been used to working on a newspaper.

It was then she remembered what one of her former bosses, an arts editor, had told her; that should she ever come unstuck in any way, to give him a call. Now was certainly the time to take him up on his offer and Madge got in touch. He was no longer in the newspaper business, he told her: he was currently over at

Ealing Studios: 'I've got an idea for a cartoon for one of those Ministry of Information films.'

Ealing had started to provide short films for the Ministry of Information and other government departments. These were a mainstay of cinema programmes, along with cartoons and newsreels, and were largely instructional in tone: take for example *Go To Blazes* (1942), Ealing's ten-minute comedy short starring Will Hay explaining how to deal with incendiary bombs. Perhaps the most famous of Ealing's wartime shorts were their 'Careless Talk' trilogy – *All Hands*, *Dangerous Comment* and *Now You're Talking* – which were seen by something like 20 million people in 2,000 cinemas from May 1940. These highlighted the danger of gossiping about military matters, however small or seemingly insignificant, in pubs and other public places where one could be overheard. 'These films were a reminder that the only safe subjects to discuss in public were football and mothers-in-law', joked John Mills, who appeared in them.

If Madge wanted to help on the film her old boss could only manage £5 a week, he said. Well, that was a lot of money in those days, so Madge made her way to Ealing only to discover there was, in fact, hardly any work for her to do. 'I think he gave me that job out of pure kindness.' In a small office five draughtsmen were working away at a series of drawings. And all these years later Madge can still remember what that animated short was about. 'It was to do with herrings and The Ministry of Food trying to get people to buy herrings because they were cheap and good for you. It's like they do nowadays, they try and palm something horrible off on you by telling you it's jolly good.' When the short was finished, it was presented without much success. 'It wasn't any good,' admits Madge.

'And they all got the sack, except me. I was offered the job of production secretary and I got more money, too.'

It sounds rather grand, production secretary, but Madge's duties were no more than those of a regular secretary. Occasionally she'd get the chance to help on a movie, such as when a crowd scene was being filmed and extras were hired to come dressed in the clothes of a particular historical period. Then Madge would be asked to stand at the gate at 7.30 in the morning to watch them all arrive to check what they were wearing was appropriate. 'Because some of them used to creep in not looking at all right.'

She did at least get her own office, but there was nothing grand about that, either. 'It was very small with an old cast-iron radiator by the window and two desks and that was about all.' There was the odd sprinkling of glamour and excitement, such as the day Michael Wilding and Michael Rennie paid her a visit.

> I was thrilled because Michael Wilding was rather nice-looking and had a lovely speaking voice. I can't imagine why he went off later to America and married somebody like Elizabeth Taylor. It was astonishing, really. Anyway, when he came into my office I was struggling to sharpen a pencil and he took it off me and got a penknife out of his pocket and did it straight away. And that's what Ealing was like, everybody was very friendly and always happy to help each other out, there was no side to anybody, even the stars.

The atmosphere was special, too. As Madge remembers it, everybody addressed each other by their Christian names. 'It

didn't matter who you were, you got called by your Christian name. Always. Never anything else. So the place always *sounded* very friendly.'

By the time of Madge Nettleton's and Robert Winter's arrival at Ealing, the war had inevitably affected the kind of films Ealing were making. From thrillers and comedies, including *Cheer Boys Cheer* (1939), about a small traditional brewery fighting a takeover by a large corporate competitor, and *The Four Just Men* (1939), crime novelist Edgar Wallace's tale of a clandestine band of vigilantes who fight tyranny and protect British interests around the globe, the shift was more towards stories with a propaganda flavour. Or in Balcon's words, 'first-class war subjects realistically treated', with what he termed as, 'a departure from tinsel'. Yes, the aim remained to make the best possible films that people wanted to see, but at the same time those films should carry some kind of message, 'Or an example which would be good propaganda for morale and the war effort', Balcon decreed.

The first of these was undoubtedly *The Proud Valley* (1940), directed by Pen Tennyson and starring the celebrated American singer and actor Paul Robeson, who Balcon was particularly eager to work with. Based on a story by communist sympathiser Herbert Marshall from the left-wing Unity Theatre, Robeson plays a stranger who is accepted into a south Wales mining community and is given a job down the pit. After an accident the colliery is forced to close, putting the livelihood of the entire village in jeopardy, and the miners march on London to demand it be reopened.

War was actually declared halfway through production and Robeson never forgot his anxious and weary journeys to and from the studio, watching as London began to mobilise with

anti-aircraft guns appearing on the streets and the arrival of the blackout. It was a harrowing time. Robeson's wife had all their belongings already packed and three days after the end of filming the couple sailed back to the United States due to mounting fears over German naval presence in the Atlantic. The film's original ending was also changed, from the miners taking over the abandoned pit to run it themselves as a workers co-operative, to the more patriotic idea of the pit reopening in the national interest. As one of the miners exclaims, 'Coal in wartime is as much a part of our national defence as guns or anything else.'

A more straightforward war picture was *Convoy* (1940), inspired by a radio broadcast Balcon heard in which eyewitnesses described an enemy attack on Allied shipping. Approaching the Ministry of Information and the Admiralty with the idea of a film saluting the brave sailors who protected merchant ships, Balcon received enthusiastic support, including equipment and naval advisers.

For the director, Balcon again chose his young protégé, Pen Tennyson, the great grandson of the Victorian era's greatest poet laureate. Educated at Eton and Oxford, Tennyson was crazy about films and, after just two terms, left university in 1932 to work in the script department at Gaumont-British. Balcon knew the Tennyson family and looked upon Pen 'as if he were my own son', and helped in his promotion to assistant director on Hitchcock's *The Man Who Knew Too Much* and *The 39 Steps*, where he bizarrely doubled for Madeleine Carroll in high heels and a blonde wig during the chase scenes across the Scottish moors.

After working with Balcon at MGM, Tennyson was invited to join him at Ealing, and at the age of twenty-six was given his first film to direct, becoming the youngest feature director then

working in Britain. The film in question seemed a strange vehicle given his background. *There Ain't No Justice* (1939) was an exposé of racketeering in the boxing world set amongst the working class of London's Notting Hill. But Tennyson had boxed at Eton and was a keen follower of the sport, and, as Balcon emphasised, possessed 'a preoccupation with social problems'. As the young aspirational boxer ordered to throw a fight, Tennyson cast Jimmy Hanley, who was taught to box by Bombardier Billy Wells, famous as one of the muscular figures seen striking the gong at the beginning of a Rank film.

Produced on a low budget and given only a limited release, *There Ain't No Justice* showed enough promise to convince Balcon that Tennyson had a future as a director. The *Monthly Film Bulletin* declared the film, 'An extraordinarily vital and accurate picture of everyday working-class life as it is lived, not as it is imagined.'

With a suitably stiff upper-lip cast – Clive Brook was personally told by Balcon that it was his patriotic duty to appear in the film and there was an early role for the young Stewart Granger – it was hoped that *Convoy* would serve up the requisite flag-waving entertainment along with a degree of realism. Thus we have a melodramatic sub plot of a young lieutenant (John Clements) running off with the captain's wife sitting uneasily with the heroic action of a destroyer, HMS *Apollo*, escorting a convoy of merchant vessels and engaging with a German pocket battleship. Indeed, when the finished film was shown to the Ministry of Information it was deemed to be of little propaganda use. Undeterred, Tennyson arranged a private viewing for Admiralty top brass. It was watched with due reverence until the final battle sequence where HMS *Apollo*, taking hits from all sides, tries to manoeuvre itself into range so

it can fire its guns at the enemy. Unable to contain himself any longer, one of the admirals shot out of his chair and shouted at Brook's captain, 'Dammit, man, use your torpedoes!'

Convoy opened to much praise: 'A magnificent spectacular and thrilling entertainment', wrote the *Daily Mirror*. Certainly the public agreed, making it the most popular film at the British box office in 1940. Surely after such a success Tennyson would carve out an illustrious career in film. Sadly it was not to be. Tennyson had already decided to join the Forces, against the wishes of Balcon who tried to talk him out of it, saying how he could make just as much of a difference staying with Ealing and making propaganda films. After several months serving on an anti-submarine vessel, Tennyson was asked by the Admiralty to take charge of its Educational Film Unit. Again, Balcon tried to persuade him to come back to Ealing, and in a letter the young man wrote to his mentor in June of 1941 he admitted that his 'head, feet and hands are kept pretty busy by the navy, but my heart is undoubtedly still in the movies'. Tragically, just a few weeks later while flying to Rosyth the plane he was in crashed into a mountain in dense fog killing everyone on board.

Balcon hoped to follow the enormous success of *Convoy* by paying homage to another vital part of Britain's armed services. After exploring the possibility of a drama focusing on the Royal Air Force, delays and difficulties obtaining facilities ultimately led to the abandonment of the project and Balcon instead chose the Fleet Air Arm, resulting in *Ships with Wings* (1941), directed by Sergei Nolbandov. Again the Royal Navy supported the film and cameraman Roy Kellino was allowed on board the famous aircraft carrier HMS *Ark Royal* for several weeks to shoot footage of swordfish aircraft landing and taking off.

Balcon personally presented the film to a group of naval bigwigs, including Lord Louis Mountbatten, at a special lunch screening at the Savoy hotel. The screening was nearing the end when he was called away to the telephone. It was bad news. Churchill had seen the film over the weekend and was considering pulling it, or at the very least stalling its release. He feared that its climax, where the Fleet Air Arm receives severe losses in order to achieve its objectives, would cause 'alarm and despondency'. Balcon contested the decision and, after much prevaricating, Churchill left the final say to his First Sea Lord, Admiral Sir Dudley Pound, who saw no reason not to release it.

Ships with Wings was another hit with the public but its overblown plot, which sees John Clements as a pilot dismissed from the Fleet Air Arm after his reckless actions cause the death of a fellow airman, only to later redeem himself by volunteering for a dangerous mission, was heavily criticized. Balcon took the poor reviews to heart (the *New York Times* thought the climactic scene, in which the hero pilots two planes, by locking his own with a Nazi's, into a dam, 'preposterously artificial'). He even agreed with some of them, believing the film's melodramatic storyline had strayed too much from the semi-documentary approach of *Convoy*. This prompted a total rethink of the studio's treatment of war subjects; henceforth Balcon wanted to aim for greater realism: 'We learned to snatch our stories from the headlines and they had the ring of truth.'

The film also proved important for one of Ealing's contract artists, Michael Wilding. Balcon hadn't taken to the young actor at all; indeed upon seeing his screen test announced, 'Tell Mr. Wilding to go away and not to come back until he has learned his job.' But Charles Frend, who had directed Wilding's test, saw potential and talked Balcon round. Shortly after the

London premiere of *Ships with Wings*, Wilding was having lunch at The Ivy when Noel Coward came over to his table and shook his hand warmly.

'You were absolutely marvellous in that film.'

'Which film, sir?' asked Wilding.

'Ships with something,' said Coward. 'You were so obviously an officer and a gentleman.'

Without further hesitation, Coward asked Wilding to appear in his next picture, due to start shooting – *In Which We Serve* (1942). The meeting also led to a lifelong friendship between the two men.

Another way of keeping up the nation's morale was to make them laugh, something Balcon understood and valued highly. When he arrived at Ealing in 1938, Balcon inherited George Formby's contract from his predecessor, Basil Dean. By far Dean's biggest achievement during his tenure at Ealing was launching the film careers of two working-class Lancashire entertainers, Gracie Fields and George Formby. Born above a fish-and-chip shop in Rochdale, Gracie was a leading music hall star and, under Dean's stewardship, the country's highest paid film performer, earning £2 per minute the press reported. This was in spite of the fact that the pair did not get on. When she arrived at Ealing for her first day it took hours to get a simple shot in the can. All Gracie had to say was, 'Good morning, George', to a cab driver, but there were incessant re-takes. Finally Gracie sauntered over to where Dean was observing proceedings and told him that if he wished her to continue with the film he would henceforth have to make do with the first or second take – or get stuffed!

In a series of films that rolled off the Ealing conveyor belt at a rate of one a year in the early-to-mid 1930s, Gracie's plucky,

cheery working-class persona, which embodied traditional values, bolstered the nation's spirits during the Depression years. As Grahame Greene noted: 'Unemployment can always be wiped out by a sentimental song.'

By the time she made her last film for Ealing in 1937, lured away to Hollywood with the promise of even greater monetary remuneration, Dean already had a pre-packaged replacement in George Formby. Born in Wigan in 1904, Formby was the son of Lancashire's most famous music hall star, and it was no surprise that he followed his father onto the stage, making his debut as a seventeen-year-old. Formby had already made two unremarkable films when Dean snapped him up, impressed at how his personality 'seems to bounce off the screen'. *No Limit* (1935), a fast-moving comedy about a chimney sweep who builds his own motorcycle and enters the Isle of Man TT race, was the first of eleven pictures Formby would make at the studio.

Like the films starring Gracie Fields, Formby's were churned out with alarming speed and followed a strict formula: George the hapless underdog outwits the baddies and gets the girl. Amidst the high jinks and broad comedy, there was always time for Formby to get out his ukulele and sing to the nation, whether they wanted him to or not. Although these unpretentious films were box office gold, Ronald Neame, who started his career as a clapper boy on Hitchcock's *Blackmail* (1929) and was cameraman on seven Formby Ealing comedies, didn't take to the comic at all, baffled by his popularity. 'He was what in farming terms would be called a yokel. And he was as mean as mean can be.' To be fair, Formby's grumpy disposition stemmed from his relationship with his wife, Beryl, who was impossibly jealous of his leading ladies, and remained

incessantly on set, where she was much disliked. Neame recalled on one film the crew cheering when they heard that the dreaded Beryl had been rushed to hospital with appendicitis. 'I never saw George look so happy. For a whole week he was a changed man, laughing and joking with everyone.'

The enormous success of the Formby and Gracie Fields films wasn't enough in the end to save Basil Dean's job. He'd arrived at Ealing in 1931 and set up his own company there, Associated Talking Pictures, after reading a positive report from the Meteorological Office that Ealing didn't suffer from either fog or the air pollution that blighted other areas of Greater London. Films had been made on the site as early as 1902, meaning that Ealing predates not just places like Pinewood but the big studios of Hollywood, making it probably the oldest continuing centre of film-making in the world. Back then it was a modest affair; the first stage was just a glass structure resembling a greenhouse. It was Dean who was responsible for turning Ealing into the first purpose-built sound studios in Britain.

Coming as he did from a theatrical background, Dean's production slate tended to lean towards screen adaptations of West End hits or popular novels, with an emphasis on British subject matters. Too many of them floundered at the box office, such as a botched starring vehicle for his young wife Victoria Hopper, *Lorna Doone* (1934), and an expensive Mozart biopic, and he was forced out by fellow board member Stephen Courtauld, a businessman who had ploughed sizable amounts of his own fortune into the studio.

His resignation was not altogether a disagreeable situation, for Dean had become somewhat disillusioned with the film business and was happy to return to the theatre, his biggest

love, where he remained a pivotal figure. Dean would also go on to found and run ENSA (Entertainments National Service Association), which brought variety shows to the troops on active service during the war.

Upon Balcon's arrival at Ealing, he surveyed the state of the studio and it was obvious that their biggest revenue earner remained George Formby; they would end up making five comedies together. *Trouble Brewing* (1939), directed by Anthony Kimmins, was the first. Googie Withers was Formby's latest leading lady and once again Beryl was ever present on the set, watching her husband like a hawk. 'Beryl would shout "cut!" before the director did if there was going to be a kiss or anything like that,' says Joanna McCallum, Googie Wither's daughter, who recalls that the film ends with Formby and her mother falling over backwards into a large vat of beer. 'They were sitting in this barrel and George said to my mother, "Come over here and sit on my lap, Beryl can't see us." He was so sad. My mother felt so sorry for him. But she liked him very much.'

When Phyllis Calvert came to make *Let George Do It!* (1940), Googie Withers warned her to be careful of Formby: 'He'll be in your dressing room telling you how much he loves you.' Not a lot happened for a while, although poor Phyllis expected to be pounced on at any moment, until the very last day of filming when Beryl went out shopping and Phyllis was alone in her dressing room. There was a knock at the door and Formby's gormless features appeared: "Eeee, I'm crazy about you!"

Phyllis would make her way to the top of British cinema in the 1940s with the Gainsborough costume epics, vying with Margaret Lockwood at the box office, but back then she was just a young actress unsure quite what to make of her famous

co-star. While admiring Formby's technical brilliance and screen craft, Phyllis later referred to him in interviews as 'a strange creature', and 'quite brainless'. Formby, as much as she could see, didn't act at all, but played himself. As for the dreaded Beryl, Phyllis saw no visible friction between the two of them; she fussed over him as much as she protected him, such as preparing his lunch which he nearly always ate alone in his dressing room. 'It was taken for granted she should be there, and he accepted the arrangement,' commented Phyllis. 'He seemed to me a simple man without guile, content in his own world.'

In *Let George Do It!*, directed by Marcel Varnel, Formby plays a ukulele player who accidentally ends up in neutral Norway instead of Blackpool and is mistaken for a spy. After plenty of broad slapstick and musical interludes, our clumsy hero manages to help smash a Nazi spy ring and, as always, gets the girl. In spite of a surfeit of well-worn ingredients, this is considered by many as his best film. It was also Ealing's first comedy with a topical wartime setting, and is perhaps best known today for a bizarre dream sequence in which Formby falls from a barrage balloon and lands in the middle of a Nazi rally, where he decks Hitler, a moment that was seen as a great morale booster. Released in America under the title *To Hell with Hitler,* the film also played to packed houses in Moscow for months.

While still making money, Formby had begun to grate with some at Ealing, including Balcon who never really liked him personally. When it became clear that he was being wooed by another company, and would in fact soon leave, Balcon looked to bring in a couple of replacements who might have the same kind of wide audience appeal. First was Tommy Trinder, then

a huge success at the London Palladium. 'Formby was without doubt one of the most unpleasant people about,' Balcon's son Jonathan was later to admit. 'So it was somewhat of a relief to get hold of a good, strong Cockney comedian.' *Sailors Three* (1940) was Trinder's first film at Ealing, a broad comedy about three shipmates (Trinder, Michael Wilding and Claude Hulbert), who get drunk in a South American neutral port and end up on a German battleship. Written to exploit Trinder's music hall roots, the film has terrific pace, thanks to the direction of Walter Forde, and features a couple of song-and-dance numbers and proved a sizable hit.

Next, Balcon successfully lured Will Hay away from Gainsborough and put him to work straight away in *The Ghost of St Michael's* (1941), where, in his familiar guise as an inept schoolmaster, he exposes a nest of traitors at a school that has been evacuated to a remote Scottish castle. While some fans regretted the exclusion of Hay's usual comedy stooges Moore Marriott and Graham Moffat, compensation arrived in the form of a young Charles Hawtrey and Claude Hulbert, who had turned the playing of silly asses into an art form. This was followed by *The Black Sheep of Whitehall* (1942), which Hay directed alongside Basil Dearden, and featured the young John Mills who had recently been invalided out of the army. Then *The Goose Steps Out* (1942), which Madge Nettleton vividly recalls being shot on the Ealing stages.

> One afternoon I went on the stage to deliver some papers and the set was of a classroom and all the boys were sitting at their desks, one was Peter Ustinov, making his film debut, and the other one was Charles Hawtrey. Peter Ustinov was being very funny, as he always was: as

he was presented in films so he was in life. Will Hay was the complete opposite, he was a miserable man, ultra miserable, you couldn't speak to him.

Hay was not averse to changing lines in the script or altering complete scenes and would often use Hawtrey as a sounding board. As the pair sat eating breakfast, if Hawtrey laughed at any of the new business it went in. One morning on the set Dearden admonished the pair for standing in the wrong place. Like a flash Hay replied, 'Oh no, we've changed it.'

For one scene Hay and Hawtrey are trapped in a plane spiralling out of control. The moment Hawtrey walked onto the stage and saw the mock-up aircraft suspended high above the floor with no safety net he protested: 'Where's the net? I'm not going to do it without one.'

Dearden tried to calm him down. 'Stuff and nonsense. You don't need a net.' Still not satisfied, Hawtrey insisted on seeing his insurance policy which covered him in the event of an accident. 'It's up in my office,' said Dearden.

'Then I'll wait until someone gets it,' said Hawtrey. 'I'm not going to do this scene without a safety net unless I'm properly insured.'

As the crew waited for Dearden to return, the actor playing the pilot was up in the plane working out his positioning when he fell out and landed with a sickening thud on the studio floor. Rushed to hospital, it was later reported he had injured his spine. Hay walked over to Hawtrey. 'You were right, Charles. We should have listened to you.' Hay then put into place his tried-and-tested method for calming any tricky situation, 'I've ordered tea for two.'

Chapter Two

New Blood Arrives

Because of the war Balcon had lost many valuable technicians to the armed services. He calculated at the end of 1940 that around fifty of his workforce of roughly 200 employees had been called up or had volunteered. Even his older brother, Chandos, who worked for Ealing as an associate producer, was drafted into the local Home Guard battlion as a colonel. Ealing's head of publicity, Monja Danischewsky, was unable to fight due to an injured hand, so remained at the studio, although at night he monitored Russian broadcasts over at the BBC.

Pretty much all of the main directorial talent had gone, such as Robert Stevenson and Walter Forde, who had both left for America (Stevenson went on to make *Mary Poppins* for Disney), and Pen Tennyson who had died; between them this trio had been responsible for the bulk of Ealing's output since Balcon's arrival. A transfusion of new talent was needed and Balcon found inspiration in the Crown Film Unit, a group of documentary film-makers working for the Ministry of Information, formerly known as the GPO Film Unit. From there Balcon recruited Alberto Cavalcanti, and later Harry Watt; both men were to become vital in bringing more documentary realism into Ealing's film-making.

Cavalcanti would prove particularly important. Brazilian-born, he brought a cosmopolitan outlook to cinema, along with an amazing sense of structure in film and a great sense of style; he had been an art director in France. Arriving as a producer, Cavalcanti worked in tandem with Balcon and his influence was immense, as Balcon himself later freely admitted: 'It was Cavalcanti's close association with me which provided the force from which emerged what are now thought of en bloc – though their variety was considerable – as the Ealing films.' Indeed for many years it can be said that Cavalcanti was the power behind the throne, and that one had to curry favour with him in order to find acceptance with Balcon. 'It was he one had to get on one's side if we hoped to get a project approved,' admitted art director and later producer Michael Relph. 'This was surprising in that Cavalcanti remained obstinately foreign – his English was almost incomprehensible – and his homosexual bohemianism might have been expected to offend Balcon's straight-laced principles.'

Cavalcanti's first Ealing credit was as associate producer on *The Big Blockade* (1942), which started life as a short government film illustrating the importance of waging economic war against German industry and manufacturing, before Balcon realised its feature potential. Fictionalised story elements were then combined with existing documentary footage, with mixed results and the film remains a fascinating curio today, mainly due to the sheer weight of star cameos from the likes of Will Hay, Michael Redgrave, Bernard Miles, John Mills, Michael Rennie and, best of all, Robert Morley as a ranting Nazi.

Much more successful was Cavalcanti's directorial debut *Went the Day Well?* (1942). Based on an original story by Graham Greene, the setting is an idyllic English village, as far

away from the front line as it is possible to imagine. When some military vehicles turn up, everyone is told it's an army exercise, but after the men are discovered to be German paratroopers in disguise the villagers fight back. As Cavalcanti himself explained: 'People of the kindest character, such as the people in that small English village, as soon as war touches them become absolute monsters.'

Intended to highlight the dangers of a Nazi invasion, by the time *Went the Day Well?* reached screens its effectiveness was neutered since the real threat of invasion had receded. However, critics of the time recognised the film as a fine piece of work. 'At last,' declared *The Sunday Times*. 'We are learning to make films with our own native material.'

Balcon felt differently: he was disturbed by the film's savage tone. During one battle a teacher saves the children in her care by throwing herself onto a grenade, and, most famous of all, an elderly, kindly postmistress hurls pepper into the eyes of her German lodger and finishes him off with an axe. Seventy-plus years on, this particular scene remains shocking, although at the time it elicited whoops and cheers from British audiences.

According to production documents the cast was going to look very different. For the pivotal role of respected villager Oliver Wilsford, who turns out to be a fifth columnist in league with the enemy, Ralph Richardson was originally considered before Cavalcanti settled on Leslie Banks. A young James Mason was in line for one of the Germans masquerading as a British soldier, chillingly ordering the execution of five children as a reprisal for an attempted escape. Instead David Farrar was cast. And in one of the main juvenile roles George Cole was considered too young and it was played by Harry Fowler. The film also sees an early role for Thora Hird, then under contract

to Ealing. Thora was actually recommended to Balcon by George Formby, who'd spotted her talents in a play, and arranged for her to have a test at the studio. The omens didn't look good, for no sooner had Thora walked through the famous gates than the air-raid sirens sounded. 'Everyone started running so I followed them. I ended up in a bomb shelter next to a woman who was shelling peas for the restaurant.'

When it was safe to emerge, Thora was directed to Make-up and the audition began. The script she was given to read was simple enough. A young comic actor by the name of Bill Fraser said his line: 'Where will you go, Lydia?' To which Thora was required to respond with, 'I shall go to London.' Take One. 'Cut,' said the director. 'Can we do it again.' Take Two. Again the director wasn't happy. This went on for ten takes, until Thora had quite had enough and replied to Fraser's line, 'Where will you go, Lydia?' with, 'I shall go to London and bugger you because I really don't think I'm very good at this and if I haven't got it right by now, I never will!'

Madge Nettleton just happened to be passing outside the studio where Thora was auditioning when the door opened and one of the crew came out. 'And he was laughing his head off. I asked them what was going on and they said, "There's an actress in there, never heard of her before, she's in there and she's an absolute scream."'

Taking her seat the next day in the preview theatre, Thora was dumbfounded that all the takes were shown, including her outburst. 'The room was full of people. When we got to my outburst, there was quite a bit of laughing, though I was speechless.' Expecting to be asked to leave the premises, instead Thora was told that Balcon wanted to see her. 'I felt like a schoolchild being sent to the headmaster's office.' To her

enormous relief, and surprise, Balcon offered her a seven-year contract at £10 a day. Thora made several films for the studio before going on to enjoy an illustrious career, becoming one of the nation's favourite and most dearly loved performers, earning a damehood in 1993.

Interestingly, *Went the Day Well?* began life under a completely different title, 'They Came in Khaki', which nobody particularly liked. Several alternatives were suggested: 'Zero Hour', 'The Bells Rang', 'Germans on the Green', 'Black Sunday', 'World's End', 'It Happened at Easter' and 'Village in Arms'. When no one could make up their minds, a memo was sent out to all heads of department to nominate which title they liked best and the one with the most votes would be selected. This didn't work either, as new suggestions were being submitted all the time. In the end, thirty-five different titles were considered, which all goes to show just how important it is to get something like this right.

This carried on for two more weeks until Balcon himself came up with *Went the Day Well?* which came from an anonymous quotation:

Went the day well? We died and never knew,
But, well or ill, freedom, we died for you.

Still working as a production secretary, Madge Nettleton recalls one day being hauled up to Cavalcanti's office to mind the phone, because he was busy on something and his secretary wasn't available. 'And I minded the phone but everybody who rang up spoke in Spanish! I couldn't answer anything at all. Fortunately it was only for one day.' Madge remembers, too, the impressive set of the interior of a church, into which at one

point in the film the villagers are rounded up and locked inside. There was only one problem; nobody on the film knew anything about the workings of a church. By chance, there was a church just across the road and Madge volunteered to go over there. 'So I trotted across the road and went inside and met with the reverend. I told him what we were doing and that we needed some help and asked if he would be good enough to come over to the studio and put us right about everything, which he very kindly did.'

Not long after that Madge got her call-up papers. In December 1941 the National Service Act had made the conscription of women legal, with single women aged 20–30 the first to be called up. 'I turned up one day and said, I've got to leave you all. And they said, we can't lose you, you're vital to the war effort here, all that nonsense. Anyway, somebody rang up the War Office and I was later told I didn't have to go and that was the end of that.'

Two other seminal Ealing war films from this period were *The Foreman Went to France* and *The Next of Kin*, both 1942. *The Foreman Went to France* came about after Balcon read a newspaper article detailing the exploits of a works manager from a midlands firm who went over to France during the collapse of 1940 to recover a vital piece of machinery from a factory plant before it fell into the hands of the advancing German army. The story struck Balcon as being of paramount importance in stressing how the civilian population, especially those concerned with the manufacture of wartime equipment, were equally as vital as front line troops.

With Cornwall standing in for the French countryside, Balcon cast the Welsh actor Clifford Evans in the role of the

foreman who faces dive-bombing stukas and refugee-clogged roads on his journey, and runs into two Tommies separated from their unit, played by Tommy Trinder and a young Scot making his film debut, Gordon Jackson. Balcon had written to BBC Scotland requesting a 'Scots-type' and was recommended Jackson who, as a schoolboy, had done radio drama work. Now an apprentice draughtsman for Rolls-Royce, Jackson was successfully screen-tested and given permission to leave his office for several weeks because of the propaganda nature of the film. 'So I got this part and I did it and I thought, great fun, and then went straight back to Scotland again.' A year later, Ealing wanted him for another small film job, after which Jackson returned again to his draughtsman duties. 'This went on for about three or four years until my boss said, "You really should make up your mind, are you going to be an actor or are you going to be a draughtsman?"' Jackson chose acting and stayed under contract to Ealing for almost ten years, appearing in several of their films, including the classic *Whisky Galore*. 'Ealing was my happiest time ever,' he later revealed. 'And I was very lucky to serve my apprenticeship there.' A familiar face in British cinema during the 1950s and 1960s, it was television that finally turned Jackson into a household name thanks to his role as the butler Hudson in *Upstairs, Downstairs*.

Much of the success of *The Foreman Went to France* Balcon put down to the skill of Charles Frend, a former editor directing only his second film; his first had been *The Big Blockade* (also released in 1942). Born in Kent and educated at The King's School, Canterbury, Balcon saw Frend as, 'a man with his roots firmly planted in the soil of this country', and thus ideal for film subjects that exulted traditional English values. Michael

Relph reckoned that Frend was always Balcon's favourite amongst his team of directors:

> Charles conformed to the gentlemanly pattern which he favoured. A staunch beer-drinking 'man of Kent', he was everybody's favourite uncle until he went onto the studio floor – when he became a fiend in human shape! I always put this down to his basic insecurity as a director.

It's true that Frend could be a little tetchy at times. Robert Winter remembers being in the screening room when they were showing the rushes for *Scott of the Antarctic* (1948), which Frend was directing.

> Suddenly the theatre door opened and Rowland Douglas came in and apologised for being a couple of minutes late. Frend yelled out, 'Who are you?' Douglas answered, 'I'm your assistant director.' Frend looked at him and said, 'Are you? Well you can bloody well clear off! What are you doing in this theatre?' And poor old Rowland replied, 'I'm working on your picture, Charles.'

Coming on the heels of *Foreman* was *The Next of Kin*, which began life as an army training film. Balcon had been personally approached by General John Hawkesworth, the Director of Military Training at the War Office, to come up with something he could show his men to illustrate the importance of security and how the issue of 'careless talk' could endanger lives and military operations. Promised government money and assistance, Balcon felt this was a lesson that could be equally well learnt by the public and so doubled the budget with an

injection of Ealing money and turned the idea into a commercial feature.

No sooner had Thorold Dickinson been installed as director, the film ran into trouble. Dickinson had been around Ealing during the time of Basil Dean, but when it was revealed that he had been on the Republican side during the Spanish Civil War he was bizarrely labelled a security risk by Whitehall, concerned that in planning the film he would have access to confidential military files. After much brouhaha Dickinson was eventually cleared. Indeed after the film was completed, according to Balcon, Dickinson was immediately commissioned into the army as a second lieutenant to make training films, and later promoted to the rank of major.

The controversy didn't stop there, as once again Churchill tried to stop an Ealing film from being shown. The plot revolved around Mervyn Johns as a Nazi agent at large in Britain and a commando raid carried out in France compromised by some careless talk. The battle itself is extremely well staged – filmed on location in Cornwall working with actual commando troops – and although the objective is accomplished the loss of life is severe. As was the case with *Ships with Wings*, Churchill felt such a scenario would cause the public distress. Balcon refused to back down: 'Now more than ever it should be hammered home to the public that careless talk could mean disaster.' Churchill deferred the decision to a military panel who concurred with Balcon and the film was granted a release, where it met with great success. Not that Ealing made any money out of it. Their deal with the government meant that all they saw in return was their original investment, plus a token percentage of the box office. Most of the royalties, not unreasonably, ended up in the coffers of the Treasury.

Not only did Ealing rely on government assistance in the making of their war pictures, with the provision of men, weapons, vehicles and liaison officers – all at a price, mind you – Balcon also sought technical advisors who could offer invaluable assistance and advice. One of these was Richard Hillary, who had suffered horrendous injuries as a fighter pilot and came to Ealing for several months on loan from the RAF. Madge Nettleton remembers him well.

> Poor Richard, I would see him walking around Ealing quite a lot, his face had been burnt and was all red because he'd had plastic surgery. He walked around the place quite openly, it didn't worry him at all, so long as people didn't stare. But I still remember his face. I'd never seen any war injuries before.

When the time came for Hillary to re-join his squadron, Balcon and many others hoped he'd stay on with them at Ealing, but he went back and was later killed in action.

Another serviceman who worked for a time at Ealing was John Wooldridge, later a film composer, again from the RAF. One time he went missing from the studio for several days. When at last he turned up, Balcon asked, 'Where the hell have you been, John?' Wooldridge revealed that he had been told to return to his base for a secret operation, as a result of which he'd been shot up and had to bail out over the English Channel. 'I had to have the water pumped out of me before I could come back,' he apologised.

Went the Day Well? was still on the floor when Ken Westbury arrived for his first day of work and he can still vividly remember

looking in on the stage and seeing a large mock-up of a church and being highly impressed by it. 'There was all this turf laid out and the place smelt so strongly of grass. After that I always used to enjoy looking in on what was happening on the stages.'

When Ken left school he didn't have the first clue what to do with his life. He admits to having been not terribly well educated, which was often the case in wartime, with lots of children, Ken included, having to be evacuated, leading to inevitable gaps in their schooling. By luck an uncle of his was a vehicle mechanic in Ealing's transport department and heard of a job going in the camera workshop for a 'sweeper-upper' and general errand boy. Ken was fifteen and got the job, which paid the princely sum of fifteen shillings a week. 'The camera workshop was at the end of a long corridor on the south side of the studio and there was this wall, half of it was painted red and the rest was painted yellow, horrible colours! And there was some well-worn lino on the floor. It wasn't very glamorous.'

The workshop was quite small, just room enough for a couple of laves and a drill for repairing the cameras, and Ken stayed there for almost two years. Opportunities for other bits of work did arise from time to time. The guy who helped run the camera workshop also carried out rear projection duties at the studio and often asked Ken to help him out with menial tasks like cleaning the arc lights and rewinding the film. Such was Ken's enthusiasm and eagerness to learn that his boss managed to get him the odd day's work as a clapper loader. For a youngster this was quite a responsible job, entailing loading the raw film stock into camera magazines, operating the clapperboard at the beginning of each take, keeping a record of the footage taken and marking up the takes due for printing

before unloading the magazines and sending the film off at the end of the day to the lab.

It took a while for Ken to get used to working at Ealing, especially bumping into stars that only a short few years before he'd idolised from afar. 'As a kid I used to get a comic called *Film Fun* and the actor Claude Hulbert was one of the characters who had his own page, now here I was working with him. And he wasn't very much different from his comic counterpart it seemed to me.' Ken also got to work with Will Hay on *My Learned Friend* (1943). 'He was quite a serious man as I recall, not at all funny around the set.'

Another of Ken's early films was *The Bells Go Down* (1943) with Tommy Trinder, who Ken recalls as very much the opposite of Will Hay, a real character, always joking and clowning about.

> One day there was this heated confrontation between him and Mervyn Johns. There was a hosepipe laid across the floor and as Mervyn Johns walked across it Trinder pulled it tight so Johns tripped over. He wasn't best pleased, I can tell you. It really upset him. But that was Tommy, always mucking around.

The Bells Go Down became something of an infamous film at Ealing since it nearly resulted in one of the stages burning down, ironic given that the film celebrated the bravery and endurance of volunteer firefighters in the Auxiliary Fire Service facing the Blitz in 1940. As Robert Winter recalls:

> The set was petrol jellied and set on fire, but it accidentally got out of control. Unfortunately when the local fire

brigade was called, their hoses were not long enough to run from the mains in the street right across the studio grounds and onto the set on Stage 3B. So everybody grabbed buckets of water. It ended up burning a big hole in the studio roof, something Hitler's bombers hadn't managed to achieve.

Cast opposite Trinder was rising British star James Mason. Madge Nettleton was elected to go and wait at the gates for him to arrive and then escort him up to his dressing room and make sure everything was made comfortable.

> Well, I went to the gate. 'Hello, Mr Mason, how are you?' I said. 'Alright,' he replied, rather sullenly. Oh he was most put out. I was much too low on the ladder to register with him, just this mere slip of a girl. I think he expected Michael Balcon to greet him at the gate. That's how he was in real life, I think, rather dour. On the film Tommy Trinder and his gang used to muck about on the set, playing jokes. Mason never joined in with them at all. That kind of thing was beneath him. He was a very difficult man.

Madge much preferred the film's director, Basil Dearden. 'He was nice, but a very quiet person. I never heard him raise his voice in anger. He was not a bombastic man at all.'

Working on several more films as clapper loader, Ken Westbury has never forgotten the day that changed his life, when his boss at the camera workshop called him over for a chat. 'Listen, Ken, one of the assistants has just been called up to the army, they need somebody on the floor quick. So get on

that floor with a clapper board and I don't want to see you in this workshop ever again.' It was the breakthrough Ken had been waiting for.

> So I began as a clapper boy. And by the time I was 17 I was just about starting as a focus puller on the odd film, which is very young by today's standards. Again, a focus puller was a job of immense responsibility; looking after the camera, keeping it clean, setting it up and adjusting focus as the actors moved around.

Over the years Ken was in the fortunate position of learning from some of the best cameramen to pass through Ealing, such as Otto Heller and Douglas Slocombe, two professionals that Ken particularly singles out for praise:

> Otto was a nice man. I learnt some good things from him. Sometimes on the set he'd give me the exposure meter to take the reading. I didn't know any other cameraman who would let you do that; the light meter is sacred to them. It's one of their tools of the trade. Except for Dougie Slocombe, that is. Dougie never used an exposure meter; he used to just hold his hand up to the sun or the studio lights. Even Steven Spielberg, when he worked with him, couldn't make it out. And yet Dougie's exposures were always dead right.

Like *The Bells Go Down*, *Nine Men* (1943) was another important film made at Ealing that brought home to audiences the effect the war was having on people. It was also a film that had a huge effect on Madge Nettleton's life. Set in North

Africa, but filmed on a small stretch of sand in south Wales, the story concerned a lost patrol in the desert. Harry Watt was given his first chance to direct a feature, with Balcon believing him to be the ideal candidate for this sort of subject as he had been a war correspondent and had shot wartime documentaries. 'Harry had real swagger,' remembers Robert Winter. 'Plus he knew everything about films.' He was also partial to the odd tipple. One evening Charles Crichton, who was producer on the film, received a phone call at home from a frantic Harry pleading with him to catch a train to Wales and help him out. Crichton explained that the last train left in twenty minutes. 'You must come, you must come,' pleaded Watt. Putting his clothes over his pyjamas, Crichton raced to Paddington and just about managed to catch the last train out. It was a nightmare journey, with the train so crammed with people Crichton spent the entire time sat on the toilet, the only place he could find a seat.

Arriving, Crichton found a hotel, had a wash and brush up, got changed and made it to the location at nine o'clock in the morning, only for Watt to take one look at him and say, 'What the fucking hell are you doing here?' Crichton was far from amused, but stayed on for a few days shooting second unit.

Playing the tough, no-nonsense sergeant in charge of the patrol, who has to lead his men to safety after their commander is killed, was Scottish actor Jack Lambert, then a serving officer with a battalion of the Royal Scots who was given special leave to appear. Lambert only agreed to play the role on condition the film was premiered in Glasgow in aid of war charities.

Appearing as one of the soldiers, besides being technical adviser on army procedure, was Jack Horsman, who had been medically discharged from the army. Only recently he had

written his autobiography, *A Thousand Miles to Freedom*, a fascinating account of his escape from the Germans after being captured at Dunkirk and held in a prison camp. 'He and this Polish chap escaped and walked all the way through France and across the Pyrenees into Spain,' says Madge. 'They both got on a train and were caught by the Spanish police. They managed to elude their captors and jump off the train. The Polish man was killed, Jack landed on his nut and was picked up and put in a Spanish prison.' Not only was Jack partially blind for a period of time because of the knock to his head, but he was mistreated at the hands of the Fascist Spanish authorities. 'Fortunately,' says Madge, 'there was a chap from the *News Chronicle* who was in Madrid, who heard there was a British prisoner of war and, using his influence, managed to get Jack out and back to England.' Once home, Jack Horsman was awarded the Military Medal.

Among the people Jack met after writing his book was Harry Watt. 'So that's how he got the job on *Nine Men*,' confirms Madge. 'Because he was no actor, bless him, he was no actor at all. But he could fire a gun all right and showed the actors how to do it.' At the film's wrap party Madge was properly introduced to Jack and they had a good natter. 'Although you could hardly understand what he said, his Durham accent was appalling. The real Durham accent is very hard to understand, or it was in those days. Anyway, I had a good dance with him and asked if he wanted a drink, but the bar was closed so I said, we'll have it some other time.' The chance arrived a few nights later in The Red Lion pub, which was a short walk from the studios. 'The routine in those days was to go straight from work to the pub across the road,' says Madge. 'Nobody went home straight away, they all went to The Red Lion. And one

day we were all in there and Jack bought me a drink, and that drink was the start of many.' Jack and Madge would be married within the year, and it was the very same reverend Madge had asked to come to the studio to help on *Went the Day Well?* who officiated at the service.

Chapter Three

Waving Goodbye

Maurice and Lionel Selwyn were twins and had never been separated. When it came time to leave school at the age of fourteen, Lionel pestered his father to write to Ealing to see if a position could be found for him, as they lived not too far away in Fulham. Much to everyone's surprise, they received a positive response back, with the studio requiring a messenger boy at the front gate. Their father quickly wrote off another letter explaining, well actually they were identical twins, could the studio possibly find room for two messenger boys, and they did. This was early in 1943.

The two boys came under the supervision of Robin Adair, and part of their job was to take parcels or packets of film to different locations in London. 'My only memory of being on the front gate is seeing Will Hay,' recalls Maurice. 'He must have been finishing a film at the studio as we started. I recognised him as he drove through the gate in an open-top Rolls-Royce, it was a beautiful car. And I remember seeing him smile at some people clustered round the gates as he came through, but then the smile vanishing from his face instant-aneously as he drove out. It was my first encounter with a famous artist.'

special instructions from the cameraman, and then leave it at the front gate where it would be collected and processed overnight before being returned to the studio the following morning in time for rushes. 'On one occasion,' Maurice recalls with a grimace. 'And it's the sort of thing that every clapper loader does at least once in his career and has nightmares over it for ever after, I forgot to take the film up to the front gate and so there were no rushes the next day.'

The first film Maurice worked on was *San Demetrio London* (1943), directed by Charles Frend, who he found most impressive: 'I don't ever remember Charles Frend talking to the artists without holding the script in his hand, he was a man that stuck rigidly to the script and nobody dared alter one word from it.' Maurice encountered some difficulties later with Robert Hamer, who took over directorial duties on the film when Frend fell ill about halfway through. 'The first thing I had to do of a morning when Hamer appeared on set was to go to the canteen and get him a bacon sandwich and a large black coffee. This became a routine; he had to have that before he could really function properly.' Hamer, who had been brought to Ealing from the Crown Film Unit by Cavalcanti to work as an editor, was already showing the signs of the alcoholism that would ultimately ruin his career. 'But he was a lovely man,' says Maurice. 'And a very friendly man, there was always a thank you and a please, he was very courteous.'

San Demetrio London, which Dilys Powell in *The Sunday Times* thought, 'In many ways a model for war films', was based on a true story which occurred in the autumn of 1940 when a merchant tanker was attacked in the mid-Atlantic by a German cruiser and the crew abandon ship. Adrift in a lifeboat for days they find the ship miraculously still afloat and, after

dousing the fires and patching up the engines, manage to heroically bring it back to port. The story caught the public imagination when it appeared in newspapers and Balcon immediately seized on it as an excellent subject for a film, a great example of human endeavour and resourcefulness. There was also the propaganda element, reminding the public not to waste petrol at home since people were risking their lives keeping the pipeline flowing.

For those scenes in which the crew are adrift in the sea, a rowing boat was rigged up in the studio on rockers with a large screen behind it with a back projection of high waves. 'To simulate the waves breaking over the boat there were a couple of guys each end of the boat throwing the occasional bucket of water over the actors,' recalls Maurice. 'It sounds very amateurish now.'

As for the *San Demetrio* itself, a large section of the tanker had been reproduced on Stage 2, using the actual blueprints and plans loaned to the studio by the owner. For added authenticity, the real chief engineer was drafted in as technical adviser and much of the set was smeared with oil and grease. This did, however, lead to a very unpleasant working environment. 'Everyone working on the film was paid "dirty" money,' recalls Maurice. 'I got seven and six a week "dirty money", which was wonderful for a fifteen-year-old.'

That set was dangerous, too. One day a young actor by the name of Barry Letts saw something falling off the ship and gave me a tremendous push and a very, very heavy piece of machinery landed on the deck where we'd been standing seconds before. With hindsight he may have saved me from very serious injury or even worse. It

was a piece of the ship's equipment that hadn't been fixed down properly.

Letts would ultimately leave acting to take a BBC director's course, which led to him working for the corporation as director, writer and producer on many shows, chiefly *Doctor Who*.

Madge also worked on the film, this time in the capacity of continuity, which entailed watching the actors and making sure they followed the script exactly. 'One day we were on the set of the ship and Ralph Michael, who was playing a second officer or something, looked down over the side and said, "The bulk head below's buggered," instead of saying "buckled". Everybody laughed. Obviously that didn't get through.'

Today continuity on movies is vastly simpler due to the fact that prior to shooting a scene digital photographs are taken of the whole set in order to record exactly where everything is. 'In my day they had no cameras to do that sort of thing,' says Madge. 'So I had to draw on a piece of paper everything that was on that set, or make some kind of note of it, so the next day they could pick up the scene straightaway and it all corresponded.' It was a job that also involved working extremely closely with the director. 'Where the director went, you went. And you always paid attention to him. What he said was always right. He was God, more or less.'

Madge enjoyed the work, finding she had a knack for it. No doubt her years on newspapers proof-reading copy did much to sharpen her brain to recognise and identify errors. Even today she can't watch a programme or a film on television without spotting and pointing out the numerous continuity errors. But the job was a bit of a chore on *San Demetrio* purely

from a physical point of view, because by that time Madge was pregnant. 'The ship was built on rockers, high up in the studio, and every day I had to climb a ladder to get there, and that didn't sit very well with a pregnant woman, and the rocking backwards and forwards.'

At the end of filming Madge handed in her notice, content to become a housewife and bring up a family. 'I was in love. I wasn't as interested in the studio as I was before.' A few years later, when Ealing began work on its lavish adaptation of *Nicholas Nickleby*, they sent Madge a telegram asking her to come back:

> But I couldn't. I had a small child and had fully retired from the film industry. I never went back. And I never regretted it. But I have very fond memories of Ealing. I did enjoy my time there. Nobody seemed to worry about things terribly, nobody went around with a worried frown. You went to work in the morning quite happy, and you came home quite happy, too.

While *San Demetrio* spelled the end of a career in films for one member of staff, it heralded the beginning for one anxious school leaver. Many of those who entered Ealing did so with a burning desire to make it in movies, others arrived purely by happenchance or luck. Such was the case with Norman Dorme. He was attending Willesden Technical College studying construction and technical drawing and hadn't remotely thought about a career in films. 'I assumed I would become a draughtsman or train to be an architect.' When he left as a sixteen-year-old, a former classmate told him how he'd landed a job at Pinewood Studios in their art department and how much fun it was.

My nearest studio was Ealing. I lived near Wembley at the time. I managed to get an interview with the plastering department because I wanted to be a modeller, really, a sculptor. I went to see the master plasterer who looked at some of the drawings I'd taken with me and said that I really ought to apply for a job with the art department. He managed to get me an appointment to see Michael Relph, who was the top art director at Ealing. Relph was a very quiet, very shy sort of person, but an excellent designer. Luckily there happened to be a vacancy open, and after looking at some of my work he asked if I could start as a trainee.

It really was as simple as that.

I was fascinated by it all, I loved it. Even now, over seventy years later, the smell of that plasterer's shop has stayed with me. They were working on a large model of the Houses of Parliament at the time for some film. It was wonderful there. It was like a factory, Ealing, but it had a sprinkle of magic about it.

There wasn't anything particularly romantic about the environment in which he worked, though. Norman refers to the art department office as 'grotty'. Its location was also unfortunate, being situated above the main generator that powered the studio.

In the summer the doors of this power station were always open and these generators were churning away and you used to get a lot of dust – it came in through the

windows. So every night when you left you had to put an old print over your drawing board, and in the morning the first thing you did when you came in was clear all the dust off the top and remove the cover, otherwise you'd be drawing over grit. It was like that all the time. You learned to live with it, though.

It was unusual for draughtsmen like Norman to go out on location to study first hand the things they would be required to reproduce on their drawing board. 'They didn't waste money sending you off on research trips, it was all done from photographs. They sent the stills man to take a few shots and then designers worked from the resultant photograph.' This was all part of Balcon's policy of keeping as tight a rein on expenses as possible. Ealing films weren't cheaply made, but the spending was tightly controlled. Saying that, if Balcon didn't approve of something, however much it cost, it wouldn't be used. Norman remembers one particular set that Balcon scrapped without a frame of celluloid exposed on it simply because he didn't like it, although this was a rare occurrence.

Like many of the new boys, Norman was required to join a union, which even in the war years exerted a powerful influence over the studio floor. In spite of the sense of national unity that informed so much of Ealing's wartime output, of everyone pulling in the same direction for the communal good, the unions remained entrenched in their fixed positions. 'The electrician's union was probably the most difficult,' claims Norman.

They'd just switch off all the bloody lamps. You got to the end of the day and the director might not be quite

finished, so he called the quarter (an extra quarter of an hour), which you could do, though you had to ask for it, you couldn't just do it. Generally they agreed because they got overtime, but on certain occasions they'd say no and switch off and that was it. There was nothing you could do.

This could be annoying, especially if you'd been rehearsing something difficult, let's say a tracking shot involving a lot of crowd artists that took the cameraman a long time to light properly. The director might have done two or three takes and it still wasn't quite right. 'Then before you could do another take we'd get to finishing time, around half past five or twenty to six,' says Maurice Selwyn, who also remembers how intransigent the unions could sometimes be. 'And there'd be a yell from the rafters, "Pull the breakers!" And the lights would go out and you'd just have to close everything up and go home. Of course, the following morning you couldn't just switch everything on and start from scratch again, there'd be the crowd people to re-engage, another rehearsal. The unions were very strong.'

Chapter Four

Bombs Over Ealing

While the studio itself was never hit during the war, the borough of Ealing was not immune to the odd bombing raid and the ear-piercing blast of the siren warnings. 'I remember more the sirens because they interfered with the sound recording,' recalls Maurice Selwyn. 'So whenever there was an air raid we stopped filming and just had to sit there and wait until the all-clear. I don't recall us going to any sort of air-raid shelter.' While this may have happened on the odd occasion, for the most part staff were required to leave their work and assemble in the studio's own air-raid shelter, which was about fifty-feet-long, made of brick with a concrete roof. 'Ealing also had their own air-raid warning system,' recalls Ken Westbury.

On the top of Stage 3A in a sort of sandbag emplacement was a plane spotter. He was an ex-stagehand and would always be up there. To keep busy we'd pass up bits of scenery for him to paint, but if an air-raid warning came in or he saw any anti-aircraft fire, he'd pack it up and hit the air-raid siren and everybody had to go to the shelter.

It was pretty miserable down there, to be sure, but everybody was acutely aware of how fortunate they were compared to other parts of London. 'At night you could see the flames burning in the East End,' remembers Madge. 'We'd all say, "They're doing the East End again", and there was nothing you could do about it. We were lucky in Ealing. We were left alone pretty much.'

Still, a selection of staff did volunteer to carry out stints of fire-watching overnight at the studio, in case of incendiary bombs. 'On top of that, the studio had its own Home Guard unit,' recalls Ken. 'Robin Adair was the sergeant and I assume Reginald Baker, or Major Baker as he liked to address himself as, was the commander. One of the shop stewards was another of the commissioned officers, having served in the First World War (Baker had fought with distinction on the Western Front during the First World War), and other staff members who were over military age were drafted in. They used to parade in front of the canteen. And there was a park right next to the studios with a gate leading onto it, and they used to do their military exercise out there after hours. It was just like *Dad's Army*. There was rationing, of course, a shortage of just about everything, mostly petrol for vehicles, which affected location shooting. Also actual film stock, remarkable given how important it was in the making of a picture, as Robert Winter recalls:

The cameraman would ask, 'Give us another roll of film.' And the assistant would have to say, 'Well, I've just been down to the camera store room and there's nothing there!' And so you couldn't do anything. Mick Balcon would do all he could to talk to Kodak

and the government. Mick was very well in with the government.

Ironically though, the war years saw Ealing operating at its most productive, with staff working a five-and-a-half-day week and long hours. 'The studio would lay on special suppers for you if you had to work in the evening, which was quite a few of us,' recalls Robert. 'Sometimes you could be working till eight, nine or ten o'clock at night.' To keep spirits and morale high, the studio organised a dance at Ealing town hall every month in which staff could mingle with directors and stars. As Robert remembers, any hubris or snobbery was left outside. 'There was no, oh she's a great actress like Phyllis Calvert or whoever, you can't dance with her. We just all mixed and had a great time. Mick Balcon used to come along, too, when he could.'

The war also brought its own set of unique problems in terms of film-making. Ealing had decided to make a picture about the Yugoslav resistance movement led by General Mihailovic entitled 'Chetnik'. The exiled Yugoslav government in London were fully behind the project, even going so far as to present the entire crew with decorations. Then disaster. Halfway through filming, Churchill withdrew British support from Milhailovic's Chetniks and went into alliance instead with Tito's Partisans. Those previously helping Ealing were now persona non grata and the film had to undergo drastic changes, and as a consequence took longer than usual to complete. For instance, when it came time to reshoot a scene that involved a dog, several months had gone by and the dog in question was now somewhat larger. There had been a beehive in the background of certain shots and somebody on the crew

thought it was a smart idea to build the beehive twice as big in order to make the dog look the size it was before. 'But where are we going to get bees twice as large?' a lone voice piped up. The idea was abandoned.

In the end *Undercover* (1943), as the film went on to be called, was a rather routine war drama with the mountains of south Wales doing their best to stand in for Yugoslavia. Male extras were recruited from nearby coal mining towns, as well as from local acting groups and schools, including a fourteen-year-old Stanley Baker. At the time Baker was appearing in an end-of-term play in the village where he was born in the Rhonda Valley when director Sergei Nolbandov arrived and happened to see it. Impressed, he took Baker back with him to Ealing for a screen test and he got the part, not only his first role in a film, but his first professional job as an actor.

To re-create the look of an authentic battle, the effects crew employed smoke powder, which was stored in a can. For some reason this highly flammable material was kept beside the camera. One day a crew member was having a crafty fag and dropped the still-lit butt on the powder. The resulting explosion injured production supervisor Hal Mason, who was standing nearby and had to be rushed to hospital. Luckily he came away from it with only superficial burns.

A war film with a difference was Basil Dearden's *The Halfway House* (1944), a supernatural tale concerning a group of strangers all seeking shelter at a remote Welsh inn during a storm, unaware the owners were killed when the building was bombed a year before. This picture, along with others such as *Champagne Charlie* (1944), which saw Tommy Trinder and Stanley Holloway as rival music hall performers in Victorian England, signalled a definite shift in the direction Ealing

intended to head in the future. With the inevitable sense that the war was coming to an end with the Allies victorious, the search had already begun for new and exciting subjects, with less emphasis on the documentary-style approach that had characterised so much of the studio's recent product. There was also the feeling that audiences' appetite was for more escapist entertainment. Perhaps Balcon had read a recent editorial in the cinema trade paper, *Daily Film Renter*, which represented cinema exhibitors: 'Their patrons do not want war films,' it began. 'They want humour, music and light romance. Their patrons have been bombed and gunned time and again. Do they want to sit in a cinema and be harrowed by more bombing – if only screen bombing. Wouldn't they rather relax in their seats and laugh with the comedians in comedy, or lose themselves in the harmonies of musicals.'

Alberto Cavalcanti was associate producer on *The Halfway House*. During a location recce in Tiverton, Devon, he was driving past a cottage when he ordered the driver to stop. He had spotted a small dead tree in a garden and thought it ideal to lend the film an eerie touch. Getting out of the car he knocked on the door. An elderly man answered. 'You will sell me please your tree,' said Cavalcanti. The old man looked surprised: didn't he realise the thing was dead? 'That is why I want it.' Cavalcanti took out his wallet. 'I geeve you £5 for it. All right, hey?' The old man couldn't believe his luck. Just then a van belonging to the unit came tootling up the road and Cavalcanti made the occupants get out with spades and dig up his dead tree.

Unquestionably, Cavalcanti's most significant contribution to the film was pairing director Basil Dearden with art director Michael Relph. 'Cavalcanti was very much aware of what I

contributed as an art director to the picture,' recalled Relph. 'He thought that Basil had certain strengths but that there were artistic qualities that could be supplied by me. That's why he took me from being an art director and made me a producer to work with Basil.' Together Dearden and Relph became the most prolific film-making team at the studio. 'They were so reliable,' claims Michael Birkett, who arrived a few years later at the studio where he worked closely with Balcon and on the studio floor.

> You could rely upon them to shoot anything efficiently, they never made a pig's ear of any movie they made, they did it absolutely with maximum efficiency. And if some movie got cancelled or delayed you could say to Basil and Michael, 'Have you got anything?' And they'd say, 'Oh yes.' They always had a script ready of something they were going to do one of these days and they would be able to shoot it for you immediately.

For Those in Peril (1944) was another of Ealing's war pictures that paid special tribute to an unheralded strand of the armed forces; this time the nautical heroics of the Air Sea Rescue Services, which picked up stricken airmen from the sea in high-speed launches. From a story by Richard Hillary, the RAF airman who was killed after spending time at Ealing, it marked the directorial debut of Charles Crichton, and much of it was shot during actual manoeuvres in the English Channel. Crichton and his camera team would go out on the launches, but it was made clear that if a crash call came through, sod the film, the priority was the downed man in the water. Fair enough. 'And we got a crash call once,' remembered Crichton. 'And to accelerate from just idling along at five knots to

something like forty-five knots in no time at all, I mean how we didn't go overboard I don't know.'

Crichton was born in 1910 in Wallasey, Cheshire, and enjoyed a public school education. While studying History at Oxford he met Zoltan Korda, who offered him a job at London Films as an assistant editor, where he worked on several of the studio's prestige productions: *The Private Life of Henry VIII* (1933), *Things to Come* (1936) and *The Thief of Bagdad* (1940). It was Cavalcanti who brought Crichton over to Ealing, where his editing work impressed Balcon enough to let him direct his own picture. Maurice Selwyn worked on *For Those in Peril* and remembers Crichton as, 'always relaxed, never hurried, always with a pipe in his mouth. He was not standoffish, but not a very chatty sort of bloke at all.'

The film is also notable for the first screen appearance of an actor who, over the course of the next three decades, would become one of the most instantly recognisable of all British stars – James Robertson Justice. He was discovered one night by the film's co-writer Harry Watt compèring at the famous Players Theatre, which like The Windmill had the distinction of never closing for the whole duration of the war, and given the small role of Operations Room Officer.

For Those in Peril proved highly significant in another way, in that it introduced a certain Thomas Ernest Bennett Clarke to Ealing. A former Cambridge law student 'Tibby' Clarke, as he would be known to everyone at Ealing, had tried his hand at journalism, writing novels, even being a door-to-door salesman. Rejected by the army on medical grounds, he'd become a wartime reserve constable in the Metropolitan Police, until he was invalided out due to ill health. It was his friend Monja Danischewsky who invited Clarke one morning to a

press show for Ealing's latest release. After it was finished, the great and the good of the studio went to the bar at the Café Royal to thrash out the picture's merits. After a long discussion it was decided that it didn't have any; the script in particular was thought to have been of inferior quality.

'We've got to get some new writers,' announced Harry Watt.

'But where are we going to find them?' argued Basil Dearden.

After a heated debate the conclusion was reached that there was a serious lack of good screenwriters out there. It was at this moment that Clarke made himself known, 'Well, I'm an available writer.' Everyone looked at him with inquisitive eyes. 'But I'm afraid I've never written a film script.' They all looked away again; the sense of anticlimax was palpable.

About a week later Danischewsky made the suggestion to Balcon that perhaps Clarke could become a screenwriter at Ealing given half a chance. Balcon was dubious to say the least.

'What films has he written?'

'None,' admitted Danischewsky. 'But he's lived a few.'

Clarke was about to take another job in Fleet Street when the Ealing offer came through. He would go on to pen some of the studio's most fondly remembered films, from *Hue and Cry* and *Passport to Pimlico* to *The Blue Lamp* and *The Lavender Hill Mob*. 'Such was his reputation within the studio,' says Norman Dorme, 'you reckoned that if it was a Tibby Clarke script it would be better than any of the other films.' As Michael Relph put it: 'Tibby had a streak of anarchy in him and understood those foibles of the British character with which the studio became associated.'

For Those in Peril was Clarke's first screenplay proper, but he did work previously on *The Halfway House* – just a bit of script fixing. One evening on location in Tiverton, Clarke, Dearden

and Cavalcanti wanted to hold a script conference. The manager of the hotel they were staying at suggested a small private room that after dinner was only ever used by one of his permanent residents and he was a dear old clergyman who was stone deaf. The crux of this meeting was to try and find a suitable juncture in the story to shoehorn in an important plot point.

'I suppose at a pinch it could be worked into the dialogue between Steve and Jane when he first arrives,' Clarke suggested. This idea was met with instant disapproval.

'In the bedroom scene!' decried Cavalcanti. 'Oh no – Steve is seeing her for the first time in one, two month. He has no time for plot points, only for bim-bam, I love you, darleeng.'

'Absolutely,' agreed Dearden. 'Steve's only thought is to get her down on that bed and bang the daylights out of her.'

Just then the clergyman, whose presence the film-makers had totally forgotten about, raised his head from above his copy of *The Times* and said, 'Your work must be very much like mine when I am composing a sermon.'

Chapter Five

"Mullet Sighted"

Like many who worked at Ealing, Maurice Selwyn prided himself on his work ethic. The lad was keen and nearly always the first one back from lunch. This paid dividends once on *Champagne Charlie* (1944). Back from lunch early, as usual, Maurice was on his own on the set when Stanley Holloway breezed in, saw there was no one else about, sat down and began to recite his famous 'Brahn Boots' Cockney monologue for Maurice.

> Well, to sit there and have somebody who I knew was very famous reciting something just for me was absolutely wonderful. Gradually the rest of the crew returned from lunch and out of respect for Stanley they all tiptoed in until finally the whole of the crew were sitting silently in awe as Stanley finished his monologue. It's a memory that has always stayed with me.

For Holloway, *Champagne Charlie* always remained a very special film: 'it helped to establish me, as one or two critics kindly wrote, as "in the first flight of British comedy actors".' Certainly Tommy Trinder was the bigger star at the time, if

the salaries they were paid are anything to go by. Trinder's rate was £1,000 a week for the ten-week schedule. Holloway received £3,000 for eight weeks' work. These weren't huge amounts by Hollywood standards, but Ealing were generous in the money they paid their top actors, less so when it came to supporting players, whose daily rates from this period ranged from £15 to £50.

Maurice worked with Tommy Trinder next on *Fiddlers Three* (1944), a bizarre little film that saw Trinder and Sonnie Hale as a couple of servicemen on leave who are mysteriously transported back to ancient Rome during a visit to Stonehenge.

Trinder's co-star was a very pretty blonde actress-cum-singer called Frances Day. As the queen she was required to bathe in asses' milk in a large pool, and the shooting of this particular scene had been hotly anticipated. 'I remember she descended by some steps into the pool until she was waist high,' recalls Maurice. 'And then she whipped her towel off exposing her boobs, which to a fifteen-year-old was the first time I'd ever seen that part of a woman. Then she flung the towel aside with a sort of coquettish look at everybody and dropped down into the water. But the number of yells and screams and whistles made you realise how many guys were in the gantries, the extras and the maintenance people. It was full of them.'

Ken Westbury also recalls that day clearly, not least the image of Trinder sitting on the edge of the pool tickling Frances' breasts with his toes. 'That would be classed as sexual harassment now; but I think she was enjoying it!'

Elizabeth Jane Howard, later a distinguished novelist, was working as an extra on the film as one of many slave girls and later recalled coming upon Tommy Trinder in a dark corner of the studio one day, clad in a very short toga: 'He was doing a

little dance, lifting his toga and muttering, "Now you see it, now you don't.'"

The director of *Fiddlers Three* was Harry Watt, an unusual choice since he'd just done a war picture and his background was documentaries. But he'd brought *Nine Men* in at just £20,000 and it turned out to be very successful at the box office. 'The money man at Ealing was a sinister chap called Major Baker [Reginald Baker],' Watt later recalled. 'And he used to stop me in the corridor, "Harry, can't you make another *Nine Men*?"' Then the idea for *Fiddlers Three* came up at a meeting and Watt asked, 'Why can't I make that?' There was a brief silence. 'Alright Harry, do you want to make it?' 'Sure I'll make it.' Only he hadn't directed a musical comedy in his life. 'I had an awful lot of fun making it. We had lashings of girls and all sorts. It wasn't all that successful, but it didn't fall flat on its face, either.'

In an unusual move for Ealing, given the meticulous preparation that went into their films in order that as little money as possible was wasted, a large portion of *Fiddlers Three* was re-shot, according to Ken. When a rough cut was assembled, the opinion was that it just wasn't working and on Balcon's orders there was between two and three weeks of extra shooting.

Ealing was quite democratic in gathering the opinions of all the staff in discussing the quality of the work being produced. 'Balcon talked to everybody,' states Robert Winter. 'He got ideas from lots of people. For instance, he used to get some of the staff to sit in on the rushes.' One of Robert's early jobs was synching up the rushes and presenting them in the viewing theatre at roughly a quarter to two every day.

And Balcon would say, so what do you think? The director never felt a subordinate because he would have

to have an answer for Mick if somebody said – that's wrong. Also, if a performer was wearing a wristwatch in a period film, or if there was something that wasn't right with a scene, not the way the actors played it but what they were wearing or something else, you put your hand up. It was very open like that.

According to the editor Peter Tanner, at the final-cut stage Balcon used to call all the other producers and directors in to take a look at the film and write their comments. It was a practice that Tanner didn't think altogether worked. 'They were congratulating their colleagues to their face but saying a terrible picture behind their backs very often.'

Continuing to work as a clapper loader, Maurice was put to work next on *Johnny Frenchman* (1945), which told the story of rival fishermen in a Cornish village and a French port who band together to thwart the German menace. Scripted by Tibby Clarke and directed by Charles Frend, the film was developed as a starring vehicle for the grand dame of French cinema, Françoise Rosay. The actress had managed to get out of occupied France and make her way to North Africa, where she 'thumbed a lift' in a bomber to England and stayed until the end of the war.

Shot in Mevagissey in Cornwall, Tibby Clarke observed how quickly the locals got the hang of film-making. Given the task of researching information about pilchards, Clarke came across one old fisherman who dismissed his questions out of hand: 'Don't know, m'dear. But I'll take 'ee out in my boat and show 'ee a handsome bit o' coast for your back projection.' The unit had hoped to film the local fishermen catching grey mullet, which appear in large shoals near Land's End only

a few times a year, convinced it would make for an exciting sequence. A couple of locals were put on the payroll to inform the director the moment any grey mullets were sighted. Nothing happened for weeks, until one morning Clarke took a stroll down by the harbour and witnessed a catch of grey mullet being landed. Frend was livid and wanted to know why he hadn't been informed. Apparently the fishermen were so overcome with excitement they plain forgot. A week later there was another large catch of grey mullet and again the film crew were not alerted. This time the excuse was that it all happened in the middle of the night. Frend still wanted to capture this sequence and when location work was completed, left a cameraman behind. This fella stayed in Mevagissey for a month, had a lovely holiday, but didn't see one blasted grey mullet. In the end they had to make do with filming pilchards being caught, not quite the same thing. Months later Clarke, was at Ealing Studios getting ready to leave for the Leicester Square cinema for the West End premiere of *Johnny Frenchman* when a telegram arrived for him. He opened it and saw it was from one of the Mevagissey fishermen. It read: 'mullet sighted'.

Maurice always enjoyed going out on location. A crew of some fifteen people would descend on a village or a town, with the director and the main artists claiming the best rooms in the local four-star hotel. 'The men used to thoroughly enjoy themselves in every sense of the word being let off the leash.' The idea of working to a designated schedule was pretty much abandoned when you were on location. The crew would arrive on site early and from then on it was largely dependent on the weather.

On many, many occasions the cameraman would look at the sun behind a cloud and say, 'We've got about

twenty seconds to go before it comes out but it's only going to last for around a minute.' So everybody would rush around, the camera and sound would start running, the sun would come out, the director would shout 'Action', and hopefully you'd get the shot before the sun went in again.

Maurice remembers one incident from the *Johnny Frenchman* shoot. The camera was set up on a tripod on a cliff top overlooking the harbour to shoot a sailing boat going out to sea.

The poor camera assistant came along and tilted the camera down to see what it was like through the viewfinder and the bloody thing just slid off the head and went straight onto the rocks. It couldn't have been fastened on properly to the tripod. Ghastly moment, particularly since the idea of having spare cameras back in those days never existed. We had to wait for another camera to be rushed up from Ealing.

The assistant responsible was rushed the other way in disgrace.

It was while they were shooting in Mevagissey harbour, remembers Ken Westbury, that news reached the unit of the liberation of Paris. 'Françoise Rosay and the other French actors began singing the "La Marseillaise" on the quayside. That was a special moment.' The war, however, was still a very real threat in Britain as that summer the flying bombs had begun to be sent over the channel. A month earlier, Ken had seen one of the first of them to come over London.

The air-raid siren had gone at Ealing and we went to the shelters but I hovered by the door with a few other people and we saw this plane going across towards Acton. As the ack-ack guns went after it, the thing went down and there was an explosion and everyone shouted, 'We've got it.' Nobody knew it was a flying bomb. It wasn't until much later on that it came out what they were.

By the time the crew went out on location to Cornwall, the threat facing London from these flying bombs had become so real that Balcon personally saw to it that his workers were both protected and put at ease. 'Balcon was pretty good on that film,' says Ken. 'If electricians or camera people had wives and families back in London and they were worried about leaving them exposed to the flying bombs, Ealing paid for them to come down to stay with their husbands in Cornwall.'

Johnny Frenchman marked the debut of another new recruit to the Ealing staff. Tony Rimmington had just left Ealing Technical College & School of Art with distinctions in both illustration and geometrical drawing, this despite having blown a finger off after mucking about with explosives in Army Cadets. Looking for a career that would best exploit his talent, Rimmington's father, a policeman, sought out an old friend, Robin Adair, with whom he had served during the First World War. With Adair's help and influence, Rimmington got an interview with Basil Dearden and Michael Relph. Bringing along his drawings, they were of such outstanding quality that after scanning through them, the film-making pair said, 'Start Monday.'

Tony was put to work in the art department, and, like Norman Dorme, remembers working above the power house and those generators. 'The rumbling noise went on all day.'

Beginning as an apprentice junior draughtsman, Tony joined a small permanent staff of around five draughtsmen, among them Norman, Bert Davey, who was to return from Malaya where he had been on Bristol Beaufighters as a navigator, and Len Wills, whose ill health had kept him out of the war. The whole studio, Tony remembers, was full of personalities. One of the set dressers believed he was an illegitimate descendent of Charles I. 'He was a very good set dresser this chap, but he was a bit odd. He had a picture of Oliver Cromwell in his lavatory and used to throw darts at it.' Robert Winter recalls another of Ealing's more colourful characters. 'One of the make-up men, who was an Australian, always used to walk around with a cowboy hat, a crocodile belt and American boots.'

What impressed Tony the most about Ealing was that it was totally self-sufficient; everything that one would want to employ on a film was right there at a director's fingertips.

> Ealing even had its own plumbing department. If, for example, there was a set of a kitchen, the plumber would come on the studio floor and lay them water or gas, any of that lark. The place was completely self-contained. We also had a model department under Fred Guy who was a beautiful modeller. In his spare time he cut lettering into war memorials. He used to get half a crown a letter, things like 'to the glorious dead', all that kind of stuff.

Indeed, Ealing's crafts people and technicians earned such a reputation that many of them were asked to help with the Festival of Britain in 1951, building models and performing other tasks. 'They were loaned out for about four weeks,' confirms Tony.

As a trainee, most of the menial tasks usually ended up being carried out by Tony, such as being sent out to buy cigarettes for senior colleagues or St Bruno flakes for the pipe smokers – with their permission, of course. As a rule, if you wanted to leave the studio gates for whatever reason during the day you had to get your boss to sign a piece of paper giving you permission. And when the staff went off to the canteen for a tea break or morning coffee, it was Tony who stayed behind holding the fort. If there was an important phone call that needed to be answered, a system to alert his colleagues had been devised.

> The Art Department was on the first floor opposite the canteen, and an arrangement was made whereby everyone who went down for lunch or a tea break would sit close to the window where I could spot them. If the phone went, 'Is Mr such and such there?' I'd say, 'He's on a break at the moment.' 'Well, can you contact him? It's very important.' I'd say, 'Hold on a minute,' and open the window, and with a bent paper clip and an elastic band I used to fire at the canteen window. They'd look up and see me holding the phone and come up to answer it. This is what you had to do in the days before mobile phones.

The first of his drawings that Tony saw up on the screen was a London bus that was made into a four-foot model for a shot in the film *Dead of Night* (1945), where it's seen travelling down a street past a row of flats, which were also built to corresponding scale on Ealing's model stage. Understandably, these were the sort of minor tasks Tony was given responsibility for as a

trainee, but he was learning all the time and drawing things in the minutest detail that would then be sent down to the workshops and built into three-dimensional forms. There was a lot of research and study involved, too. One had to know about windows, doors, lock rails, French windows, the construction of sash windows, casements, staircases, banisters, also the different forms of construction and the different periods of architecture. Tony's bible was Sir Banister Fletcher's *A History of Architecture*, a work still in print.

As time went on, Tony graduated to drawing up large and complex sets and had a hand in practically every Ealing film that went on the floor, which ranged from simple set dressing to helping design and build Mrs Wilberforce's house for *The Ladykillers* on a bomb site near King's Cross. Another unique job for Tony on that film was designing the railway signal arm that knocks out Alec Guinness's Professor Marcus and sends him to his death. 'I got covered in soot measuring the blooming thing and then later rag-bolting it to the bridge. And because it dropped and hit Guinness on the head, we had to put a rubber edge along the end of it so it wouldn't do him a mischief.'

To give you an idea of the kind of efficiency that went on at Ealing, the art department were required to make models of every set that they worked on, as Tony explains. 'We did the drawing of the set, then took prints off the drawings and stuck the prints onto cardboard and made a little half-inch scale model. We'd then rig up the model in the office and the director would come in to look at it and perhaps make one or two alterations.' From these models the director had to work out each one of his shots from the script, entrances and exits, dialogue, panning left to right, and all the rest. 'Then they'd make the director sign a form saying that he had okayed the set

and once he'd signed that form, that was it, he couldn't make any more adjustments because by then it had been costed and gone up to Accounts and marked with a green pen, and then it was built.' It wasn't only an efficient way of doing things, but a means to keep costs under control, as last-minute changes were invariably expensive. 'Ealing were very aware of costs,' says Tony. 'For example, instead of building a door properly, that is double-sided, they'd build only one side because that's the only side you saw on the screen. Why build the other side if no one was going to see it? It was as tight as that.'

Painted Boats (1945) was next on the Ealing schedule, a largely inconsequential film at the time, but like so many Ealing productions is today a rare historical document of a forgotten part of English cultural history. Directed by Charles Crichton, it tells the story of two families living and working on cargo-carrying canal boats – the 'traditional' Smiths on their horse-drawn boat and the 'modern' Stoners on their motorised vessel – and is very much a eulogy to a very particular way of life, and was certainly intended to remind audiences what Britain had been fighting to preserve. Indeed, the film was instigated by the Board of Trade, who wanted to show the kind of work the canal boats were doing, lugging coal, steel and wood up and down the waterways as part of the war effort.

The film is also interesting in that it featured the last screen performance of an extraordinary English 'character' in Bill Blewitt. This middle-aged Cornish fisherman-cum-postmaster was discovered by Harry Watt in a chance meeting at a village pub lock-in. Blessed with, as fellow documentarian Pat Jackson termed, 'a mesmeric gift of the gab', Watt cast Blewitt as the lead in a 1936 GPO documentary short that illustrated the

wisdom of saving with the Post Office. He turned out to be a complete natural and was subsequently cast in small acting roles in *The Foreman Went to France*, *Johnny Frenchman* and *Nine Men*, becoming something of a personality around the lot. Charles Crichton once saw Blewitt in The Red Lion persuading people he wasn't Bill Blewitt at all but his twin brother, inventing a whole history. On location for *Painted Boats*, during lulls in shooting Blewitt would sit outside the pub nursing a pint and tell a fascinated audience long stories about his early days when he was a boy on the canal. 'Well, he'd never seen a canal before,' said Crichton. 'But everyone would believe him, absolutely rapt attention.'

Chapter Six

Peace Comes To Ealing

The war had finally come to an end in August 1945 after the surrender of Japan, and as Balcon had seen a role for cinema during the years of hostilities, he now recognised just as vital a function for it during peacetime. He sat down and wrote a clear manifesto as to what he believed post-war British cinema should strive to be:

The need is great for a projection of the true Briton to the rest of the world ... Britain as a leader in social reform, in the defeat of social injustices and a champion of civil liberties. Britain as a patron and parent of great writing, painting and music. Britain as a questing explorer, adventurer and trader. Britain as the home of great industry and craftsmanship. Britain as a mighty military power standing alone and undaunted against terrifying aggression ... fiction films which portray contemporary life in Britain in different sections of our society, films with an outdoor background of the British scene, screen adaptations of our literary classics, films reflecting the post-war aspirations not of governments or parties, but of individuals.

Balcon's statement, which appeared in a cinema trade magazine at the time, was a rallying cry worthy of Churchill. And he believed every word of it. For Balcon the only sort of nationalism worth a damn was cultural nationalism and that definitely applied to films, and films that were absolutely rooted in the soil of the country, truly indigenous British films.

However, the film-making landscape in Britain had changed dramatically over the last six years, most notably the emergence of J. Arthur Rank whose company had a virtual monopoly over the industry, controlling two of the three main cinema chains (Gaumont and Odeon), along with the studios at Pinewood, Denham, Shepherd's Bush and Islington. He also had controlling interests in distribution, production and equipment suppliers. Balcon knew that if Ealing was to survive and get its films shown, he would have to come to some kind of arrangement with Rank.

The eventual deal, brilliantly negotiated by the reliable Reginald Baker, couldn't have worked out any better for Ealing. Rank would offer substantial financial support and guaranteed distribution for Ealing films as first features in its cinemas, and Ealing would retain its independence; Rank agreed not to interfere in any creative matters. It was an arrangement that lasted eleven years. 'The contract certainly cushioned Ealing against the possibility of financial disaster,' Balcon wrote. 'And in terms of achievement those years proved to be the most rewarding of my life, as it was during them that the best Ealing films were made.'

Certainly *Dead of Night* (1945) numbers amongst the studio's greatest achievements: acclaimed American writer and critic James Agee called it, 'One of the most successful blends of laughter, terror and outrage that I can remember.' It is an

anthology of spooky tales based around an architect, played by Mervyn Johns, who drives out to an isolated country house and encounters a group of people who he's seen before, but only in his dreams. These premonitions encourage everyone present to tell a story of their own brush with supernatural occurrences.

It had begun life as an attempt to put on screen a number of tales from the celebrated ghost story writer M.R. James, but when this became impractical (the stories were deemed too difficult to visualise), the idea of doing a portmanteau film remained. It was a good way of showcasing the creative team that had been built up at Ealing over the years, with each story handled by a separate director – Alberto Cavalcanti, Charles Crichton, Basil Dearden and Robert Hamer. The clever script was courtesy of John Baines and Angus MacPhail, who also adapted Hitchcock's *Spellbound* in the same year, with additional dialogue from Tibby Clarke. It was very much a cooperative effort with two units shooting simultaneously, a healthy rivalry between both of them, and the whole thing completed in just four weeks.

Making his directorial debut on *Dead of Night* was Robert Hamer. Born in 1911 in Kidderminster, Worcestershire, he got a First in Mathematics at Cambridge and his skill with numbers never left him, according to Ken Westbury. 'He could work out the most incredibly complicated sums in his head on the spot. He was a lovely man,' he added. With the emphasis at Ealing always on the need to save time and money, Balcon never heard anyone put the studio's economic situation better than Hamer one day on the set when he called his crew over for a pep talk. 'Time on the studio floor costs us one shilling and four pennies a second. A cinema seat brings us an average of four pence. This means that for every second we lose

in production we have to attract four more customers to make up for it.'

More than any other director, Hamer knew the high cost of every minute working on the floor and if he asked for something that wasn't actually there ready for him he would always say the same thing to his assistant: 'How long will it take to get?' And if the reply was fifteen minutes, he would know exactly how much fifteen minutes of shooting time on that particular film's budget cost, and would reply with either, 'I'll wait for it' or 'It's not worth it, I'll do without.'

Such was his dazzling intelligence and memory that Balcon believed Hamer had the talent to become a university don; he could read a newspaper column upside down and repeat it verbatim and do *The Times* crossword in ten minutes. But his love was movies and after Cambridge he began his career in films as a cutting-room assistant for Gaumont-British studios in 1934. A year later he joined London Films at Denham, working for Alexander Korda. The start of the war saw Hamer with the GPO Film Unit under Cavalcanti, and when Cavalcanti moved to Ealing he recruited Hamer as an editor.

Given the fact that Hamer was the novice on *Dead of Night*, it is his segment that is by far the best in the film, about an antique mirror with a dark history that drives a man to attempt to kill his wife. The shot in which the man looks into the mirror and sees an ancient room staring back at him would, of course, today be easily accomplished using optical effects. Back then, the art department had to build an entire set beyond the mirror to achieve the desired look.

Without doubt, the best-remembered sequence is Michael Redgrave's haunting performance as a deranged ventriloquist who believes that his dummy, Hugo, is alive. Prior to the film,

Redgrave worked with ventriloquist Peter Brough of radio's *Educating Archie* to advise on the kind of 'cheeky chappie' persona he wanted for Hugo. The effect is chilling. Maurice Selwyn's abiding memory of working on that film is the presence of Redgrave: 'Even when he was having lunch he insisted on remaining in character.'

The film's famous twist ending of the recurring dream was already in the script, but during a preview of the rough cut it was a projectionist, who always liked to comment on the pictures, who said, 'Why don't you carry on, it ought to go on longer at the end.' Everyone looked at him and said, 'What a marvellous idea, how right you are.' And that's exactly what now happens. The whole of the beginning of the film of the architect making his way to the house is repeated under the end titles instead of just leaving it with him realising he's been there before. This kind of thing was symptomatic of the way anyone at Ealing could make suggestions, from one of the directors to somebody relatively low on the ladder.

Hugely influential on British horror cinema, *Dead of Night* was also significant for being Douglas Slocombe's debut as director of photography, after which he rose to become Ealing's main cameraman, and subsequently one of the best in the business. 'He was a very nice chap,' recalls Maurice. 'And always somehow found the petrol to drive his car. He lived a long way from the studios and he had this large American-style car that he somehow got the petrol for despite petrol rationing. He was a very friendly and approachable guy. You were not allowed to smoke in the stages spacing but people like Dougie invariably had a fag between his fingers.'

Slocombe had begun as a news cameraman during the early years of the war in Europe. 'He went to Poland before the war

to shoot still photography for *Life* magazine,' says Ken Westbury. 'And some producer saw this stuff and said, this is great, it's got to be put on film. So he gave Dougie a 16mm camera, and it was right at the time war was declared. So Dougie shot this stuff and just managed to get out of Poland in time.'

One incident Slocombe liked to recall was when he managed to get inside a Nazi rally. His camera was an American model, the Imo camera, which made a fearsome racket when it started up, so as Slocombe began to film Goebbels up on the stage speaking, the noise interrupted the fearsome Minister of Propaganda and he stopped mid-sentence.

> All the stormtroopers looked around hurriedly to see what the commotion was and one could see that they were earmarking my position so they could sort me out afterwards. Then suddenly everybody stood up and called out 'Heil Hitler' and so I bent double, held my camera and marched underneath these outstretched arms to the exit where I beat a hasty retreat.

It was Cavalcanti who invited Slocombe to Ealing after his war footage had been used in several documentaries. Beginning work at Ealing without any formal training whatsoever, Slocombe's first tentative steps in learning how to do the job was as camera operator for Wilkie Cooper on *Champagne Charlie*. Slocombe later admitted he did rather badly at it. Ken Westbury was clapper loader on that film and still wryly recalls a huge blunder Slocombe made. A mock-up of a variety music hall had been built on one of the stages and Slocombe's camera was placed right at the back in order to achieve a wide shot of the whole theatre and the proscenium arch. 'The next day in

rushes everyone noticed that the boom swinger was clearly in the shot, there he was, right at the front of the stage. God knows how that happened; he must have just got up at the last minute. Nobody noticed it at the time. Sometimes you do accidentally get a microphone in a shot, but not the operator as well!' The entire sequence had to be reshot the following day, much to Slocombe's embarrassment.

Having proved his ability with 'The Haunted Mirror' segment of *Dead of Night*, Robert Hamer was given his first full feature to direct, a slice of costume melodrama played out against the background of Victorian Brighton called *Pink String and Sealing Wax* (1945). For the pivotal role of Pearl, the frustrated wife of a drunk and abusive tavern keeper who persuades a chemist's son (Gordon Jackson) to act as accomplice in a murder plot, Hamer cast Googie Withers, who had been working in films since the mid-1930s. Born in India to a British naval captain and a Dutch mother, as a child back in England Googie took dancing lessons and persuaded her parents to send her to the Italia Conti school. At the age of seventeen she began appearing as a chorus girl in West End shows before getting opportunities in films, mostly quota quickies playing too many bubbly blondes. It was Michael Powell who changed her career, casting her as a Dutch resistance leader in *One of Our Aircraft is Missing* (1942).

During the war years Googie appeared in concert parties entertaining the troops. 'They were sent overseas to Belgium,' recalls Googie's daughter Joanna McCallum. 'And they were virtually on the front line playing in this huge auditorium. My mother was on her way to the stage when there was a direct hit, and it was full of American servicemen, it was dreadful. My mother was one of the very few people who survived it, she was thrown against the back wall by the blast.'

Returning to London in 1943, Googie appeared in a stage production of J. B. Priestley's *They Came to a City*, which brings together nine characters from across British society who are transported to a mysterious walled city. What they find inside, according to their class and prejudices, is either a socialist utopia or a hell starved of ambition and riches. When Ealing decided to adapt the play to the screen the following year, most of the original stage cast were asked to recreate their roles, including Googie. It was her first Ealing film, after which Hamer cast her in *Dead of Night*, then again in *Pink String and Sealing Wax*. It was the beginning of a fruitful collaboration. 'My mother thought that Bob Hamer was a wonderfully talented director,' says Joanna. 'Not only was he very good technically but he also was magnificent with actors. He would coach performances out of the actors and be very patient, then he'd push a little bit further. My mother said it was really special working with him, both my parents had huge admiration for him.'

Following the success of *Dead of Night*, Michael Redgrave returned to Ealing for *The Captive Heart* (1946), playing a Czech captain who, in an attempt to escape the Gestapo, takes on the identity of a dead British officer. Taken prisoner, he is forced to keep up the masquerade, even to the extent of corresponding with the dead man's widow, who is cruelly led to believe her husband is still alive. After his release he finally must face the widow, played by Rachel Kempson, Redgrave's wife in real life, and confess the truth. 'It was a very emotional scene,' remembers Maurice Selwyn.

And the set was cleared except for essential people. When Michael Redgrave explains what he's done and Rachel

Kempson replies, so you misled me all these years, I thought it was my husband writing to me, that sort of dialogue, she stood there, spoke those very emotive words in a heartrending fashion and as she did so her tears came quite naturally, it was a quite remarkable moment. And when Basil Dearden said Cut, there were a few seconds of silence and then the crew applauded the artist, and you rarely ever saw that happen.

One rather less successful performance was given by an actress playing another wife welcoming her husband back from a prisoner-of-war camp. Naturally Dearden wanted the actress to show in her face an overwhelming feeling of love and yearning as her husband walked up the front path, but take after take he wasn't getting the required performance. In the end Dearden called time on the scene and ordered all the outtakes to be printed to see if he could salvage something. Sure enough, after one of the numerous takes when Dearden had cried 'Cut', an anonymous voice announced, 'Tea's up!' and the actress's face lit up and produced exactly the right expression.

The inspiration behind the film came from Balcon's own wife whose work with the British Red Cross saw her dealing with the repatriation of prisoners of war and wounded soldiers. One day she told her husband of the remarkable stories some of these men were telling her and that perhaps this might be a good basis for a picture. Ealing regular Angus MacPhail worked on the script with Guy Morgan, a former film critic of the *Daily Express* who had himself been a prisoner of war. A modest success, the film drew high praise from some critics: 'A warm, emotional, intensely human document, entitled to rate amongst the best twenty films of the last ten years,' said the *News of the World*.

Making his film debut in *The Captive Heart* was Derek Bond, who would appear in several more Ealing films. An actor in repertory theatre before the war, Bond was on leave, having been wounded in North Africa, when he was invited to a cocktail party. There he met Diana Morgan, a scriptwriter at Ealing, who took a keen interest in his acting past. 'Ealing are having a terrible problem casting young men,' she complained. 'And they are stuck on their next film. Why don't you come over and make a film test?' This was when the war was still on and Bond argued that the War Office would never release him from the army. 'They might,' said Diana. 'After all, you've been in action and been wounded. It's not as if you're a dodger.'

The test went well but, as Bond predicted, the War Office refused to release him. 'Never mind,' said Balcon. 'How would you like to come under contract to us when you get out of the army?' It almost seemed too good to be true, but Bond was taken into Balcon's office and a contract was drawn up on the spot.

It was ironic that Bond's first Ealing film after his demobilisation was set in a prisoner-of-war camp, because when he re-joined his battalion for the advance into Italy, he was captured and spent the rest of the war as a POW. Like many ex-POWs, Bond had sworn never to set foot back in Germany, and now here he was again. Ealing had been given permission by the British army of occupation to film at a real camp, Marlag near Bremen, only six weeks after the Nazis had abandoned it. 'The place was perfect because most of the buildings were still there,' recalls Tony Rimmington. 'Although the art department had to construct an extra guard tower and a couple of sentry boxes, but a lot of it was still standing; the gates, searchlights, the lot.' Bond found it a decidedly eerie

feeling walking through the gates of that camp on the first day of shooting. 'All the debris left by the departing POWs was littered about – small heaters, homemade frying pans and other artefacts made from Red Cross parcel tins.'

The unit was also supplied with soldiers from the Argyll and Sutherland Highlanders and The Black Watch to act as extras. 'They were a very tough bunch indeed and rather bolshie, as they all wanted to be sent home,' Bond recalled. Some of these men had fought at El Alamein and in Europe and didn't take kindly to being ordered about by film types. 'Their mood wasn't helped by Dearden trying to do a "Monty" and wearing both regimental badges in his beret. This and the monotony of repeating shots over and over again almost brought them to the point of mutiny.'

The action of the story took place on the first Christmas of the war and for one long shot Dearden wanted the whole camp under a blanket of snow. They were shooting at the height of summer so the army fire service obligingly sprayed the whole place with foam, which from a distance looked wholly authentic. Unfortunately, just as cameras were about to roll the rain came down and ruined the effect. They tried again the next day, only this time a burst of sunshine dried up the foam and the wind blew it all away. Finally, on the fourth day conditions were perfect and the shot was captured.

With the backing of the powerful Rank organisation, Ealing settled down into what became a routine production pattern. 'It took about eight to ten weeks to shoot a film, they very seldom went over that,' confirms Norman Dorme. 'And there wasn't much of a gap in-between films either, usually a few weeks of preparation and then they'd go straight into the next

one. I'm sure the preparation was going on even while they were doing something else. Still, it's not like today when they spend six months or more preparing a film.'

During these lulls in production the staff were all retained. While at other studios workers were essentially freelance, which meant that when a particular film was finished your job was finished too, that didn't happen at Ealing; the staff would still come in every day. 'We'd just sit around and wait for the next film,' recalls Ken Westbury. 'Maybe there would be the odd day with an artist's test or perhaps a day of shooting inserts, pages of a book, stuff like that. But for the most part we'd just wait and then prepare for the next production.' Sometimes films did overlap each other, but it was rare for two films to be in production at the same time due to lack of studio space and also the fact that it was largely the same crew on each film. 'So you needed people to finish on one film because they were going to be needed on another one,' says Ken.

And there was always an end-of-shoot party, usually held on the studio's smallest stage, which was Stage 1. 'They were lavish parties under the standards of that time,' says Tony Rimmington. 'It was mostly beer, very little spirits.' And when the film was ready to go on release there was always a screening beforehand for the crew and staff. 'Usually it was in the Odeon, Northfields,' says Norman, 'just down the road from the studio, on a Sunday morning.'

Studio staff tended to arrive from 8 a.m. onwards; actors though were usually in Make-up by 7 a.m., and the working day finished at 6 p.m. It wasn't unusual for the art department to work on Sundays, since there were always slightly more things to do and get finished. 'It was partly a sort of panic they got into,' says Norman. 'That you're two weeks away from

85

shooting and you're building a set or you're still designing it or haven't made up your mind or the director's changed something. There were always things that pop up. So it was normal to come in on a Sunday and we would be the only ones at the studio apart from maybe the cutting rooms who seemed to be there a lot.'

Norman remembers bumping into Tibby Clarke quite often on a Sunday.

> We'd always end up in the canteen, with Tibby, making tea for ourselves. In those days you didn't have a kettle in your office, you went down to the canteen and if there was nobody there you had to make it yourself. And I do remember Tibby was often there. He had his own office in the front block. He was a very nice man.

With its base of operations in England secure for the immediate future, Ealing began what turned out to be the first of several films it would make overseas. In 1944 Balcon had been asked by the Ministry of Information to make a film highlighting Australia's contribution to the war effort, which it was felt had not been sufficiently recognised. Harry Watt, due to his documentary experience and reputation as a bit of an adventurer, was duly dispatched down under to look for suitable story material. With an assistant, Watt rented two tiny offices in a Sydney office block, which they shared with Ealing's Australian head of distribution, 'who had long ago decided we were mad,' Watt recalled.

> We were besieged by the usual masses of crackpots who turn up when they hear a film is going to be made. The

passages were crowded with children showing off their dancing and in the street outside men waited with performing dogs and horse dealers paraded their wares. Films were a rarity in Australia and our lives were made a hell.

In pursuit of a good story Watt travelled the country for something like five months and in the Northern Territories was told about a great cattle drive back in 1942, when, in a bid to protect food supplies, 100,000 heads of cattle were driven across the north of Australia in case the Japanese invaded. Watt cabled Balcon that he thought this would make the basis of a terrific adventure movie and it was given an immediate go-ahead. Watt himself wrote the script for what would become *The Overlanders* (1946).

For his star Watt chose Chips Rafferty, regarded then by many as the personification of the stereotypical rugged, straightforward and laconic Aussie male. The supporting cast was made up of mainly regional actors and local people. This is something that Watt did a lot of when he filmed abroad: take three or four actors from the UK and then cast the rest of the film from the local amateur societies. 'And they were just as good as taking some bum from the Charing Cross Road.' In one important role, Watt had wanted to cast a young British-born Australian actor by the name of Peter Finch, but was warned off him with tales of bad behaviour and hell-raising. It was a decision Watt later regretted. 'Finch was my man but, of course, I couldn't see it.'

The search for a leading actress took Watt all over Australia, but in the end the right person was found purely by accident. Daphne Campbell was a twenty-one-year-old army nurse on leave in Sydney when she was asked as a favour to make a

delivery to a local film company. The secretary took one look at her and asked, 'Can you ride a horse?' Daphne had grown up in Orange in New South Wales and rode a horse the five-mile trek to school every morning. Interviewed by Watt, Daphne made a test and was instantly hired, despite having no previous acting experience. After a few phone calls, including to the prime minister, it was agreed that Daphne could temporarily leave the Services without pay in order to make the film.

Government assistance was to prove invaluable, without which *The Overlanders* would have been practically impossible to make. Watt and his team were given the use of army camps, army food and cooks, army vehicles and Air Force aeroplanes to take them to far-flung locations. Still, Watt complained that making the film was something of a nightmare. Part of the problem was the fact there was no real infrastructure for film in the country, a lot of the things they needed had to be virtually started from scratch. Film equipment was also in scarce supply and items such mic booms and dollies had to be improvised. Of the thirty-five strong crew and cast, only six had worked on a movie before.

Most of the location shooting took place around Alice Springs where conditions were tough. At one point a horse fell on Chips Rafferty, injuring him slightly. In another incident someone almost lost an eye using a stock whip. In a bid for almost total authenticity, the actors were encouraged to perform as many of the horse riding and physical action scenes themselves, notably the scenes of driving the cattle through rivers that were known to be infested with crocodiles; Watt assured his actors these were not man-eating.

When *The Overlanders* opened, its success at the box office both delighted and baffled Balcon, since none of the players

were known to British audiences. 'I wonder if the sight of so much beef on the hoof didn't have a certain appeal to a meat-starved population.' Even better, the cattle used in the film were later sold for a handsome profit.

As for Daphne Campbell, her endearing performance caught the attention of Hollywood and she was offered a seven-year contract from both United Artists and MGM. She turned them down flat. During filming she had fallen in love with a young pilot recently returned from long and esteemed service in the Air Force and wanted to start a family. It was a decision she never regretted.

Back at Ealing, many technicians and members of staff had returned to their jobs after war duty, while some of the younger ones were being called up for National Service. Ken Westbury got his conscription papers and, after basic training, found himself in Berlin at the start of 1946. His memories of the city at that time was of a wasteland, a shattered place with everything in near ruins. One day he and a pal came across Hitler's bunker and found it totally unguarded, so went inside for a quick look around. 'We never got right down into the deep depths of it, it was full of water and almost pitch black, once you'd walked down a few steps you couldn't see very much. The garden was all burnt, I remember.' After a tour in Palestine, Ken returned to Ealing, who felt obliged to take him and his colleagues back, even though legally they didn't have to. 'Nobody had signed letters or legally constructed contracts,' says Robert Winter, who was in the Royal Army Medical Corps and did his National Service in India and Johannesburg. 'Which is difficult to believe, especially these days when everybody has a lawyer sitting on their right-hand side whatever

they do. Often you just turned up and they'd say, oh, are you back then?'

In the case of Norman Dorme, things were a little different since he served on oil tankers going down the American coast as part of the Merchant Navy, which Ealing didn't count as one of the main Services and so it was up in the air that he would be allowed back in. 'Luckily, the personnel manager at Ealing was an ex-Merchant Navy skipper and said, "I'm not having any of that, the Merchant Navy is the same as anything else," and so I went straight back in. I don't know what would have happened otherwise.'

Chapter Seven

The Kids Take Over

Ealing had always made comedies, right back to the days of Basil Dean, whether with Gracie Fields, George Formby, or later Will Hay. Yet *Hue and Cry* (1947) is seen by many, not least by Balcon himself, as really the first of the classic Ealing comedy films, quite an irony since, according to Norman Dorme, it was originally made purely as a children's film. Only when it was finished did people realise its quality and it was released as a main feature. How much truth there is to this story is debatable, but certainly this must have been a rumour going round the studio.

Directed by Charles Crichton, who had proved his comedy credentials handling an amusing golf tale in *Dead of Night*, much of *Hue and Cry* was filmed amidst the war-torn buildings and bomb sites of London with not a tower block in sight becoming, in the words of cameraman Douglas Slocombe, 'not just a piece of fiction, but a historic record of the times'. Young Cockney actor Harry Fowler plays the leader of a gang of south London kids who discover that their favourite blood-and-thunder comic is being used by crooks to send coded messages about future robberies. Naturally the police don't believe a word of it so the boys decide to go it alone and catch the villains themselves. Jack

Warner plays the main heavy and his gang members were made up of real-life wrestlers. And there's a glorious cameo from Alastair Sim as the comic's eccentric author. But this knockabout comedy belongs to Fowler and his fellow scruffs, and turned out to be a huge success and well received by critics. The *Monthly Film Bulletin* called it, 'English to the backbone'.

The script was courtesy of Tibby Clarke, who, like Crichton, was taking his first stab at comedy, something he had wanted to try ever since arriving at Ealing, given his previous career as a journalist of comedic prose in *The Evening News*. Curiously the film began life back to front, so to speak, when associate producer Henry Cornelius had a picture in his mind of some kind of climactic chase or situation involving boys from all over London. 'I'd like our final sequence to give the impression that for one glorious hour boys have taken over the city.' It was up to Clarke to fit a scenario around this wondrous thought. He brainstormed for a week with no luck until, by chance, walking along the street he saw a young kid engrossed in a comic book and the idea was born.

There's a lovely moment during that climactic scrap on a bombsite between the kids and the crooks when a cab arrives and in, quick succession, a whole bunch of children roll out of it one by one. It was hoped that the taxi could stop at a spot where it was possible to hide an infinite number of people who could then flood out almost in cartoon fashion. Instead they did the shot for real and Crichton managed to cram in, probably very uncomfortably, almost twenty kids. Harry Fowler later talked of Crichton's supreme technical ability as a director but that it was Cornelius who was better at handling the child actors, 'taking their inhibitions out of them so that they gave great performances'.

In amongst that cast of kids was a fourteen-year-old by the name of Ray Cooney, who went on to become a hugely popular playwright and actor. His biggest success, *Run for Your Wife* (1983), ran for nine years in London's West End. At the time he was still in school but desperate to leave to pursue a career in the entertainment world. 'My parents had scrimped and saved to send me to a public school and I said, it's pointless doing that, me passing exams, because all I want to do is go into the theatre.' Back then you could leave school at the age of fourteen and Cooney pleaded with his parents to let him go. 'We sat down with the headmaster and the deal was, if I could get a professional job in my school holidays everybody would agree to me leaving school. So I traipsed round all the agents and, finally, about a week before the holidays were up, I got this tiny one line in *Hue and Cry*.'

Cooney was hired predominantly as a crowd artist and filmed for a day at Ealing Studios and five days on location. 'There's a sequence where there's a lot of kids heading down the street and I'm in amongst that lot.' Looking back all these years later at what was his start in show business, Cooney remembers it as great fun. 'I was just so goggle-eyed meeting all these famous people. I don't think I dared speak to Alastair Sim, but I spoke to Jack Warner. I do remember being a little nervous though on my first day; after all, I'd never done anything like this before. I didn't have any training.'

Hue and Cry was followed by a rather too earnest adaptation of Charles Dickens' *Nicholas Nickleby* (1947), starring Derek Bond in the title role. Despite a pedigree supporting cast, which included Cedric Hardwicke, Stanley Holloway, Sybil Thorndike and Bernard Miles, it didn't find favour with the public, having been released fresh upon the heels of David

Lean's vastly superior screen version of Dickens' *Great Expectations*.

It was directed by Cavalcanti, who Maurice Selwyn recalls had a peculiar working method. 'He would always half-shout the word action, like ac-TION! His face would go red very often as he yelled it. Even if it was an emotional or intimate scene, where a quiet action would have done the trick, Cavalcanti was always – ac-TION!!' A fine director, Cavalcanti did have problems with his English and made sure that the movements of his cameras and the actors were clearly marked in the script prior to his arrival on the floor in order to spare himself the ordeal of trying to explain his ideas to the crew. He also clashed occasionally with the unions. Bernard Miles later revealed an astonishing impasse one day on the set of *Nicholas Nickleby*. There was a book lying on the floor of the set and Cavalcanti asked his first assistant, Jack Martin, to remove it. 'Jack replied that we couldn't touch it because there were no Props people available and if anyone else touched it there'd be a strike. They had to send a car to Wembley to fetch a Props man to move the thing, while shooting just stopped.'

Calvalcanti's association with Ealing ended after *Nicholas Nickleby*. He didn't think his services were being amply rewarded and decided to go freelance. His departure hit Balcon hard. 'I think Cav was enormous,' Crichton later admitted. 'I think he was the really creative thing about Ealing. He always was talking about the necessity for truth, he was always looking for sincerity. I think he had an enormous influence.' Especially over the studio's team of directors, many of whom he had been personally responsible for recruiting. As Monja Danischewsky later commented, if Balcon was the father figure to his directors, Cavalcanti was the nanny who brought them all up.

* * *

By the late 1940s, Ealing had established such a coveted position in the film industry that many hopefuls with a strong desire to become directors chose the studio as their number one destination. For some it was more difficult to get an interview than others. Fortunately for Christopher Barry, fresh out of the RAF in 1947, his father knew Michael Balcon through their membership of the Savile Club, a gentlemen's meeting place in the heart of Mayfair, and he managed to arrange an interview. 'Halfway through our meeting Balcon said to me, "Can you write? Your father can!" My dad was editor of the *News Chronicle* from around 1937 to 1949 when he resigned to run the Festival of Britain. I replied I didn't know – never tried – and with that Mickey Balcon gave me a job as a trainee scriptwriter and reader.'

Christopher started on £4 a week under Stella Jonckheere, who headed the script department. 'She would give me books to read and complimentary tickets to plays and I would write up a synopsis of the plots and characters with my rating the possibility of each making a screenplay. My timing was left to me within the studio working hours but I worked conscientiously.' Christopher can't remember from his short time with the script department any suggestions he made that eventually ended up as Ealing films, but novels of all kinds, from thrillers to comedies were always being sent into the office. 'Although on the whole the studio's own established writers, producers and directors came up with their own ideas and stories.'

This was pretty much the norm; hardly any outside material was accepted, it was largely all done in house. As Balcon said: 'Basically our best films started with a blank sheet of paper and an idea.' This had been the practice in the golden days of Hollywood when studios kept writers working on site. 'And this is how it was done at Ealing,' says Tony Rimmington.

A script would be written by say Tibby Clarke and then that script would be copied and distributed to all heads of department with a slip of paper saying something along the lines of, do you like this script or don't you like this script. After a week or two they were all returned to Michael Balcon and the board members and I gather that if the scripts had been liked they were put into production. Simple as that. It was unique. I don't know of any other studio that did that.

Christopher recalls that his first office at Ealing was far from glamorous.

It was a Nissen hut at the rear of the studio complex against Walpole Park fence, shared with two storyboard artists, Pat Furse and Ken Norrington, who were often visited by Sandy Mackendrick. Sometimes other people were put into the hut. It was a very happy milieu, seldom bothered by the suits, but on one occasion I had moved my chair out into the glorious sunshine and removed my shirt only to be embarrassed by a surprise visit from Michael Balcon himself.

Though his dealings with Balcon were infrequent and fleeting, Christopher liked him and valued the status and reputation he had built for himself within the studio's set up.

His presence permeated the working atmosphere of the whole place. He was stern and yet very democratic and approachable. He was greatly respected and would tour the premises daily visiting the stages, workshops and all

areas stopping to chat and banter with long-standing employees.

From a personal point of view, Christopher always appreciated Balcon's gesture of granting him extra leave for his honeymoon, no matter that it was unpaid, and time off (paid this time) after a death in the family.

The spring of 1947 saw another new arrival at Ealing. Joan Parcell was still at school when a neighbour, who just happened to work at the studio, told her of a vacancy in the mail room. Interviewed by the head of personnel, Joan got the job and was allowed to leave school six weeks early. 'I was incredibly excited but I'm sure I was nervous, too, because this was my first job. I'd never worked before. It sounds ridiculous but I didn't even have a proper coat or jacket, so for the first few weeks I wore my school blazer.' Living in nearby Hanwell, Joan cycled to work. 'I even went home for lunch every day because it took me twenty minutes to get home, twenty minutes to eat my lunch and twenty minutes to get back, so for a long time that's what I did.'

The mail room was situated in the front administrative block near the gates. 'That's where I used to get in; there was a little side door. Only the big noises, as I called them, were allowed through the front door, people like Michael Balcon and other directors of the company.' Most mornings Joan would see Balcon arrive and if she was lucky she might even get to exchange a few quick words with him. 'He was the God of the place, he really was.' Balcon's office was just across the entrance hall from where the mail room was located. It was not particularly grand and sparsely furnished, with wood panelling, and Balcon liked his desk pushed back towards the window so

he could see who was coming through the door. When Maureen Jympson came to work at Ealing she paid the odd visit to it. 'I remember it being like somebody's old home, that they'd lived there many, many years. It had that feeling to it.' But generally few of the regular staff were allowed inside.

Joan was never allowed in there but did quite often bring over letters and parcels to his secretaries' office.

> Michael, in fact, had two secretaries working for him. His main secretary was an older lady and she looked after this garden that you could only reach through French windows in the office. It was enclosed by a wall, I think, because you couldn't see it from anywhere else in the studio. It was an English garden, quite large and very pretty. There was a beehive in it, too.

As for the mail room, Joan remembers it being small and narrow with barely enough space for a couple of stools. She worked alone in there, sorting out the letters that needed sending on and collecting and organising the mail for the errand boy to deliver around the studio. 'I guess for someone coming straight from school I had quite a bit of responsibility.'

If any problem arose, she could always ask Robin Adair for help. She remembers him fondly. 'He was quite a character, and quite a large man. He was disciplined, though, but always very friendly with me and to everybody, in fact, and everyone at the studio liked him. But yes, he was disciplined, he had everyone there under control.'

Robin Adair took his job manning the front gate very seriously, and although he had a little cubby hole where he could sit, rest and maybe put his feet up, he seemed always to

be standing rigidly to attention, carefully vetting people in and out, so Robert Winter recalls.

> He stood on that front gate in all weathers. And because there were no visitors allowed in the studios he would know if people were trying to get in to have a look around. If he saw somebody who was an extra or a supporting artist he'd recognise them straightaway and sign them in. If he didn't recognise you he'd go, 'Is this your picture? Are you working on this picture? No? Well, get out of the studio.' That's how it was.

After a brief spell in the mail room, Joan went to work in the general manager's office as a junior secretary. The general manager was a man by the name of Hal Mason who, according to Balcon, came from a family of well-known trapeze artists. After years working around theatres and film studios, along with a bit of acting with touring companies, Mason joined Ealing during the war and was to become one of Balcon's most trusted lieutenants, as he wrote: 'The whole organisation and physical control of the films came under Hal Mason's charge.'

Joan remembers Mason as 'a very nice man. I liked him very much'. But she could see that he was literally at Balcon's beck and call. Whenever Balcon got in touch with the office, which was frequently, Mason would stop whatever he was doing and make his way to see Balcon without delay.

Next, Joan ran the transport department for quite a few years.

> Every day we had what they called a 'town car' and that car would run all over London with whatever anybody

wanted them to do. They'd pick up Wardrobe or take film to laboratories, things like that. It wasn't a difficult job; in fact you did quite well out of it because the drivers, who were all self-employed, were always very nice to me so I would hire them. In those days when you couldn't buy nylon they would find nylons for me; that kind of thing went on.

Norman Dorme seems to recall there were two studio cars, both Buicks, that were at one's disposal. 'If you needed to go to London or a location, you'd get the production office to lay on one of these cars, with a chauffeur who wore a black hat. I had to go out once to measure up one of those blue police boxes and you'd sit in the back of this car and feel rather grand being driven around.' Cars in general were a pretty rare sight around the Ealing lot, largely due to the fact, hard as it is to believe today, that not many people actually owned one. 'There was only one car that I can remember being parked at Ealing under the art department window and that belonged to the lighting cameraman,' recalls Norman. Of course the likes of Balcon were chauffeur-driven in every day. Later on, cars became much more common and it was something of a status symbol to have one's name on a section of wall where you could park it.

Next on the Ealing production slate was *The Loves of Joanna Godden* (1947), another starring vehicle for Googie Withers met with indifferent critical praise. 'One reviewer at the time,' recalls Googie's daughter Joanna McCallum, 'after praising the visual quality of the film and care with which it was made, wrote that – viewing it was rather like watching a village cricket match on a lovely summer's day, nodding off

now and then, and waking up to see that Googie Withers was still batting.'

Googie plays a headstrong young Edwardian woman who inherits her father's farm on Romney Marsh and, to the scandal of the local farming community, insists on running the place herself. Graced with fine photography from Douglas Slocombe, the film makes fine sweeping use of its Romney locations but the unit was plagued by foul weather. 'They were going to shoot out there originally for about four weeks,' claims Joanna McCallum. 'But because of the atrocious weather, it just rained and rained, the schedule stretched and stretched and they were unable to film and just sat around most of the time in old pre-war limousines playing cards. My father John McCallum and Chips Rafferty, who had a part in the film and were old mates, ended up playing chess all the time.'

McCallum was cast by director Charles Frend as a neighbouring farmer who, at the close of the film, Googie ends up marrying. McCallum and Googie had never worked together before, indeed had never met prior to filming, but during those weeks on Romney Marsh they fell in love and later married. Their daughter Joanna was named after Googie's character in the film.

McCallum was born in Australia but was sent with his two brothers to be educated in England. With a promising university education before him, McCallum chucked that in to go to RADA, and was a young actor at Stratford-upon-Avon when war was declared, and he returned with his brothers to fight with the Australian forces. McCallum and Googie were two extraordinary people perhaps destined to meet; Googie, who had miraculously escaped death, and McCallum, who was shot at by the Japanese and had bullets taken out of his leg without

anaesthetic. 'And then they end up playing in romantic comedies and things like that together,' says Joanna.

Googie was a well-known star by this time; McCallum had seen some of her films out in the jungle. When he returned to England, his agent first got him a film opposite Phyllis Calvert within two weeks. Next up was *Joanna Godden*. 'He'd already seen Googie,' says Joanna. 'Because she was on stage, just before, doing *Private Lives*, so he went and had a little peek, saw her twice, and decided he liked her very much. But he said to me, waiting to actually meet her in the hotel where they were staying at on location was nerve-wracking. There he was; downstairs, pacing around, and he said the minute she came down that staircase with all this vitality, she was fizzing always with energy and electricity, he was rather smitten.'

Their first scene together was actually a quarrel, but that didn't seem to put a dampener on things. And for Joanna, of course, *The Loves of Joanna Godden* means something very special. 'I love the fact that I can see them when they were young. And they were sexy together on screen. They did have a great chemistry.'

Quickly Ealing sought to exploit this chemistry by casting them together again in another film, although Balcon was nervous about what the newspapers might say about the relationship. 'He was very relieved when my parents eventually got engaged,' says Joanna. 'Mikey Balcon was such a moral man that the idea of the two of them living together was simply terrible.'

It Always Rains on Sunday (1947), directed by Robert Hamer, though highly revered today, was an uncharacteristically bleak film by Ealing standards. As the *Monthly Film Bulletin* moaned: 'Though the background of this film is carefully done,

and direction and acting good, it is a sordid and dreary affair.' Indeed, when the film opened there were protests from the inhabitants of Bethnal Green, where the story is set, who complained that their lives were made to seem more miserable than they actually were. Googie plays a bored working-class housewife who shelters an ex-lover (McCallum), now an escaped murderer on the run.

Hamer had wanted from the start to make as much of the film as he could on location. 'I want to do this out in the streets where it all happens.' The film's highly atmospheric climax is a night-time chase through the deserted, wet streets of Bethnal Green, ending up at a train yard where the actors were required to do their own stunts, as Googie later recalled: 'We took awful risks – going under moving trains and running on top of them, things like that.' It would prove to be her last film for the studio, but she and McCallum always had happy memories of the place. 'I can remember my father saying working at Ealing was like working for a really good repertory company or a small business,' says Joanna. 'It was very inclusive.'

Chapter Eight

Continental Charm

The next few films out of Ealing had something of a continental flavour about them. *Frieda* (1947) concerned an RAF officer returning home to a small English town with a German bride, the girl who helped him escape from a prison camp, but they both face prejudice and hostility. It was an interesting premise; the critic of the *Sunday Pictorial* thought the film, 'Something of a cinema rarity – a film which stimulates intelligent thought and argument.'

Director Basil Dearden, however, faced the problem of finding an English-speaking German actress to play the title role. When no suitable candidate could be found in Germany – no surprise given the fact their cinema industry had been decimated and inactive for years – Balcon happened to catch a screening of the Swedish film *Torment* (1944) at an arts cinema and was hugely impressed by the performance of the little known Mai Zetterling, and he brought her over to London.

Mai's English was poor at first but she quickly settled down, although she was dismayed by the behaviour of her co-star David Farrar, who she claimed always seemed to be late for his morning call. 'When we, on time, went to fetch him in the morning, we would find him idly sipping champagne.'

According to Alex Douet, who was the clapper loader on *Frieda*, Mai was very closely monitored during the whole of filming by her actor husband Tutte Lemkow. 'Mai was very young at the time and a very pretty girl, so Tutte never took his eyes off her.' Alex also remembers that the studio arranged for two different endings of the film to be shot, one in which Frieda stays behind in England with her husband, the other in which she returns alone to Germany.

Alex was just seventeen at the time of the making of *Frieda* and had only recently left school. Killing time before National Service, his mother, who worked as a secretary for Monja Danischewsky in the publicity department, managed to get him an interview with Hal Mason. Luckily someone in the camera department had been called up themselves and Alex was brought in as a replacement at £3 10 shillings a week; 'of which I gave my mother ten bob.'

At first Alex found the size of the studio a little overwhelming, and some of the people a bit intimidating, especially general manager Hal Mason. 'He was a bit of a toughie, but he was the sort of man that Balcon needed to deal with the unions and to keep productions on schedule. But to a seventeen-year-old he was a pretty godly figure, like a headmaster.' What lingers most vividly in the memory though is the sense of adventure of it all; not long out of the classroom, Alex was travelling abroad with film units and film stars. 'It was quite exciting for a teenager, I must say.' Straight after *Frieda*, Alex went to Belgium to shoot *Against the Wind* (1948). 'We did location work in a little town called Bouillon in the Ardennes and, at the time, the place was still pretty well ruined. It wasn't a very good film to be truthful. It was photographed by Lionel Barnes, who was a good solid photographer without being anything very brilliant.'

Against the Wind was a story about the Belgium resistance, so again Ealing required the services of a European actress. It was Françoise Rosay who recommended an unknown young actress who had recently appeared in a film directed by her husband, Jacques Feyder. Her name was Simone Signoret. Director Charles Crichton and the film's associate producer, Sidney Cole, flew over to Paris to meet with her at the bar of the Georges V hotel. The pair were so taken by Simone they phoned Balcon that night full of enthusiasm and she became the only leading actress Balcon ever cast in one of his films without a prior meeting or introduction.

Simone arrived at the studio with no pretensions to glamour whatsoever; she wore no make-up, dressed in plain clothes and was slightly overweight. 'But she immediately captivated all of us who came in contact with her,' said Balcon. *Against the Wind* was not a success, but Simone went on to have a distinguished career in French and international movies. Alex thought her to be something of a 'prima donna. But a rather splendid actress I thought. I also remember that she and Gordon Jackson, who in the film are supposed to be having an affair, there was such an extraordinary lack of anything between them. I think it was pretty obvious in the film actually. There was no chemistry there at all.'

Saraband for Dead Lovers (1948) was a milestone for Ealing, an impressive romantic period melodrama about a doomed royal love affair set against the backdrop of the seventeenth-century court of Hanover, it was the studio's first film made in colour. Over the years, filming in black and white came with its own unique set of problems as Norman Dorme recalls. 'In the early days the white collars on a dress suit were bright yellow because they would photograph more white in black

and white than white did!' On *Saraband* Ealing were using the Technicolor process and Norman remembers that a middle-aged woman by the name of Natalie Kalmus was on set every day. The wife of Technicolor founder Herbert T. Kalmus, Natalie was credited as the 'colour supervisor' of virtually all Technicolor features made from 1934 to 1949. 'A strange woman,' claims Norman. 'She had to approve what we were doing, but that was bullshit really. There were certain things that you had to be careful with, some colours would photograph stronger than others. It was about getting the balance right. But I think a lot of nonsense was talked about Technicolor because it was a relatively new process.'

The film's star was Stewart Granger, on loan from Rank, who, when he arrived on the set, was somewhat dismayed to see that producer Michael Relph had all the scenes sketched on a large board, including all the actor's positions and moves.

Granger's first scene was opposite Françoise Rosay. No sooner had director Basil Dearden consulted the drawings and given Françoise her instructions, that she had to move to such and such a spot on the floor on such and such a line, than the French actress hit the roof. She wasn't having any of it and refused to work under such restrictions. Granger quietly smiled to himself and suggested that it made better sense to do a quick rehearsal in order to work out the moves. For the remainder of the shoot the board of drawings was never seen again, the same went for Relph.

Location shooting took place in the city of Prague, where the historic cobblestone streets proved something of a hindrance due to the fact that hundreds of extras playing soldiers had been given cheap wooden clogs that made an almighty clatter when they had to march about. Costume designer Anthony

Mendleson and his staff had to stay up all night gluing felt onto the soles to render them silent.

Mendleson was often called at the last minute to a set to correct or fix some unexpected problem. A couple of years later on *Pool of London*, a drama about a pair of sailors on shore leave caught up in a diamond-smuggling racket, there was something wrong with actress Renée Asherson's cheap cotton dressing gown. Arriving on the set Mendleson couldn't for the life of him see what the problem was. The director was Basil Dearden, who Mendleson didn't find the easiest person to deal with, and when he asked what was wrong Dearden stared back blankly at him, 'Well look …' Mendleson took another look at Renée and it was then that he noticed it, her dressing gown and the wallpaper of the set were exactly the same colour and pattern! It was a chance in a million.

'Well, what do you want me to do?' asked Mendleson. 'I can change the dressing gown …'

'Oh there's not time for that!' said Dearden exasperatedly. 'Well then you'd better change the wallpaper.' Out came the spray gun.

One of Ealing's most prestigious films was *Scott of the Antarctic* (1948), another film shot using the Technicolor process. Charles Frend was looking for a subject of genuinely epic proportion and was drawn to the story of Captain Robert Falcon Scott's doomed expedition. From the outset Balcon wanted authenticity; survivors were contacted and interviewed and Scott's widow was fully behind the project. Original photographs taken on the expedition were studied carefully in order for the sets and costumes to be replicated exactly. Also many of the cast were chosen due to their resemblance to the

real characters they were playing: Kenneth More, James Robertson Justice, Derek Bond and a young Christopher Lee. For the role of Captain Scott himself, Balcon personally chose John Mills, the screen embodiment of stiff upper-lip Britishness. Mills accepted the invitation unequivocally; it was a role he had always wanted to play.

The cast and crew flew to Switzerland for location shooting on the Jungfrau, one of the main summits in the Bernese Alps. For the next ten days the actors trudged across treacherous snowfields at heights of 11,000 feet. It was exhausting work in spite of everyone having undergone strict training for weeks. Nothing can prepare for accidents, however, and Mills was almost killed shooting one particular sequence. On 'action' he simply had to walk fifty yards dead ahead across the virgin snow to a large rock, stop to surmise the horizon and then beckon his men with their sledges to follow. That part was easy: 'I then took one step forward and completely disappeared from view.' Mills had fallen down a crevasse. 'As I hung swinging like a pendulum from side to side I looked down: beneath me the drop must have been at least 200 feet.' Luckily his harness was tied securely to his own sledge and his fellow actors were able to pull him out.

To play Scott, Mills undertook rigorous research, speaking to the explorer's son Peter, the renowned ornithologist and conservationist, who allowed the actor unhindered access to family letters and documents. Mills reached the conclusion that Scott was, 'A fascinatingly complex character, a born leader, with tremendous physical stamina and courage.' He was also moody and prone to fits of temper that couldn't always be controlled. It was this side of Scott's personality that Mills was forbidden to portray, for fear of upsetting surviving family

members. Still, Mills later admitted that no other picture he made in his entire career had more of an influence and effect on him.

After Switzerland the unit moved to Finse in Norway, an isolated hamlet nestled within an expansive rocky valley 120 miles from Oslo where Scott himself had trained due to its arctic-like conditions. Some three decades later, George Lucas chose Finse to double for the ice planet Hoth in *The Empire Strikes Back*. On the camera unit was young Alex Douet.

> Finse was an amazing place, right at the foot of the Hardangerjøkulen glacier. The Norwegian army helped us with supplies and transport. I think we went there in October because it was just beginning to freeze and every morning we would toil our way up through the scree up to the top of the glacier where we did most of the filming.

The weather that Mills and the crew encountered was certainly formidable; packed lunches often froze solid and two of the cameramen were flown home with frostbite after they took their gloves off and their fingers became welded to the machinery. It was sheer drudgery for weeks, up at five in the morning and a ninety-minute hike up the glacier to the plateau. Some days were so cold with fierce blizzards that filming was impossible.

Other times, however, incompetence or poor planning resulted in delays. This was something that Mills took up personally when he wrote to Balcon:

> Conditions here are undoubtedly difficult. Charles is doing his best to get as much done as possible in the face

of odds. I feel – and please treat this confidentially – that the organisation could be better. Yesterday we wasted *hours* on top of the glacier (with good weather conditions for shooting) waiting for things and people that were *missing*.

Balcon replied:

Your letter of Sunday came as rather a shock to me. Of course I knew that the unit was facing difficulties. What does worry me, however, is the suggestion that the organisation is not all that it should be. This is something we rather pride ourselves upon at Ealing.

For authenticity, Frend shot the film in continuity and so by the end the actors' beards had grown to an absurdly bedraggled lengths so that they all looked like extras from a Viking film. On their last night in Finse, permission was given to shave them off and the actors all returned from their private bathrooms to the hotel bar, 'looking like a group of very young French poofs, with baby pink cheeks and scarlet lips,' as Mills described it. Their Norwegian guides, who'd worked closely with the cast for weeks, could hardly contain their mirth and everyone got sloshed, ending up under the table as dawn rose.

Returning to Ealing, the frosty landscapes had been painstakingly duplicated. Norman Dorme worked on the film and remembers the Antarctic cyclorama that was set up all around the stage to create the illusion. 'There was a ramp up to horizon height all round, so wherever you looked it went right up to the horizon and that created a forced perspective.' The special effects crew sprayed the set with an artificial mist that

made the actors gag and cough and they had to suck on foul-tasting lozenges to make their breath appear frozen. After experimenting with salt, the snow was replicated using a foamed urea-formaldehyde compound brought to the studio in slabs, broken up by machines and then blasted everywhere by a ten-foot diameter fan. Norman doesn't think anyone on the crew had to wear protective goggles. 'We didn't bother with things like that, Health and Safety didn't exist then, there was no such thing, you looked after yourself. Still, it wasn't a very pleasant set to work on.'

In total three cameramen worked on the film, Osmond Borradaile took a three-man camera unit to Antarctica returning with some spectacular exterior shots; Geoffrey Unsworth handled the location shooting; while Jack Cardiff took control of the camera in the studio. Alex remembers Cardiff, regarded today as one of the most remarkable cameramen in British film, whose visual brilliance added immeasurably to such classics as *Black Narcissus* and *The Red Shoes*, as 'an agreeable fella', and 'someone who knew exactly his own mind'. Charlie Frend, however, was different: 'I thought he was a slightly distant man.'

Robert Winter also worked on the film and recalls the afternoon in the dubbing theatre when they ran the rough cut of the film for Balcon. 'Mick turned to John Mills and said, "What do you think of it?" After a long pause John replied, "I think it's monumental." There was another long pause, then Mick said, "You mean it's a heap of shit!"'

Scott of the Antarctic was chosen as 1948's Royal Film Performance and premiered at the Empire, Leicester Square. A worthwhile film rather than a particularly distinguished one, there is no denying it is certainly well crafted and acted,

and the bleak white vistas are enhanced by a majestically desolate score from Ralph Vaughan Williams, which the composer wrote without watching a single frame of the film, relying only on photographs taken from the ill-fated expedition and reference books.

While Halliwell's indispensible *Film Guide* calls it a 'stiff upper lip saga par excellence', the film was not a box office success and performed particularly badly in America. 'The American public has no interest in failure,' wrote Balcon. 'Even if it is heroic failure, and certainly they do not easily accept other people's legends.' Early signs were not good when the script was submitted to the US censor, which at the time took a dim view of the portrayal of suicide on screen. Writing back they suggested that Captain Oates' gallant sacrifice, of walking out of a tent into a blizzard with the famous words – 'I am just going outside, and may be some time,' be amended. Hopefully Balcon told them where to go. In any event, the scene remains in the film.

Scott of the Antarctic proved to be Alex's last hurrah at Ealing as he was called up for National Service shortly after filming ended. He had enjoyed his time at the studio immensely; coming as he did from boarding school, the hierarchy of a film unit wasn't all that different, with everyone knowing their place. 'There was a hierarchy at Ealing, there had to be discipline, and people like Dearden, Crichton and the others were a cut above the rest of us. I thought it was fine, I thought it was comparatively easy going, but then I'd had ten years or more in a boarding school.'

What did surprise him though was the almost iron grip that the electrical union had on production. 'Everything would be slowed down in order to get another hour's overtime, "double bubble" they called it. What the ETU (Electrical Trade Union)

said governed to some extent the pace of the production. It was a very strong trade union. They were powerful people.'

When he came out of the Services, Alex did not re-enter the film business, realising it held no real charm for him. 'I didn't have any ambition to go into the cinema, which was just as well because I didn't have any aptitude for it either. The technical side of film-making I found wasn't particularly interesting and I certainly didn't have any creative spark that was going to produce anything very much.' Alex instead went into the business world and later taught history at a university. It's a decision he never regretted, but he looks back with fondness and a little pride at having contributed, however small, to a little piece of Ealing's history.

Chapter Nine

Low Wages – High Expectations

Peter Musgrave had been mad about the cinema since his earliest school days, when his father bought him a small projector and he began to collect sound-effects records to give voice to the silent images he projected onto the wall of the family home. When Peter was fifteen his father, who knew somebody at Ealing Studios, wrote to them on behalf of his son requesting an interview. Eric Williams, then head of sound, wrote back asking for the young Peter to come in and see him.

> He asked me lots of questions and seemed to be impressed. But after talking to me Eric said to my father, because I was mad keen to start straight away, 'Look, it's a dicey industry, stay at school till you're 16, take your school certificate so at least you've got something, then come and see us.' So with some disappointment I stayed on another year at school.

In 1947 Peter left school and presented himself at the gates of Ealing Studios with a letter of introduction from Eric Williams. Much to his disappointment Williams had been sent to Australia to work on a film, and his replacement Stephen Dalby

was left to explain that the studio could no longer honour the letter, due to the fact that several people had been demobbed and were back working in their old jobs. 'I'm afraid we just don't have the vacancy for a trainee. You'll have to go and find something else.'

Peter's father scurried around and found him a job as a camera trainee at Wembley studios. 'But it was on a rostrum shooting animation and I absolutely hated this because you were shooting a frame at a time. I think our general output was ten seconds a day, it was soul destroying.' It was a strange place to work; the studio had been bombed during the war but the government hadn't yet paid out any compensation so the main stage still had a big hole in the roof. 'Also, if you opened the back door of the camera room you could see the crowd all going from Wembley Park station processing up to the stadium to watch the Olympics.'

Determined not to give up on his dream of working at Ealing, Peter called Stephen Dalby every month to check if the situation had changed. Finally, after almost a year, a vacancy did come up and Peter took great pleasure in resigning from Wembley. The vacancy was for a trainee in the sound editing department and Peter arrived as *Scott of the Antarctic* was in the last throes of post-production, and he remembers the enormous time and trouble the sound department spent getting the sound right for the actors walking in the snow.

Another curious problem arose, mainly due to the fact that the film had been shot in colour. As Peter notes:

> It was still the old three strip camera where you had red, blue and green films running through the camera. The film went to the Technicolor laboratories and though

they could process the negatives overnight they couldn't print in colour overnight, which soon became the case with Eastmancolor. So cameramen had to be satisfied with a black-and-white print for rushes.

However, if a cameraman or director was insistent on seeing colour rushes and the budget was big enough, they might ask for a master shot to be printed in colour but they'd still have to wait at least five days. In any case, the cutting copy used by the editor would usually be something like ninety per cent black-and-white with the occasional colour shot. Quite often this would turn up unforeseen results.

I can remember on *Scott of the Antarctic*, the sound editor Gordon Stone returning from seeing the finished film and saying, 'Well, that'll teach me.' You see, everyone in the studio had only ever seen a black-and-white print, so Gordon didn't know that in one scene there was this little campfire alight because the flames didn't show up; he'd been caught out and not provided any sound effect for it. It's things like that which those working on the set might know about but in the cutting room you would never know.

The cutting rooms where Peter worked were compact. There was one long corridor of rooms for editors and their assistants, with a disused viewing theatre bang in the middle where people were allowed to go and smoke, an activity strictly forbidden in the cutting rooms themselves. 'Though some people did cheat a bit by saying to their assistant, I want this and this, while literally holding a cigarette out in the corridor,' recalls Peter.

'But I can assure you, cellulose nitrate film was very dangerous stuff, you touched a cigarette end on that or a match it went up very fast.'

The staff were memorable, to say the least. Gordon Stone was the boss and an ex-marine, and a pleasant man according to Peter. There was also Chris Greenham, who went on to become an excellent sound editor on many prestigious films including *The Guns of Navarone* (1961) and *Superman* (1978).

'He was at Ealing as an assistant. He'd been in the Special Boat Service or something in the war, apparently he used to creep in at night on rubber dinghies to the Greek islands and supply armaments to the Greek resistance and then creep out again.'

Another ex-military man was Nick MacDonald, who was something like a former wing commander. 'Quite rightly, Ealing would welcome back people who had paid their dues in the military or in the war,' says Peter. 'So Nick was a bit older than average to be working as an assistant and people tended to sneer a bit behind his back. On one occasion in particular he went to the public phone out in the corridor and was ringing the Air Ministry saying, where is my distinguished flying cross, or something like that, you should have sent it to me by now, and we all thought, he's doing this out loud to impress everyone. So there was a bit of that around. But I did enjoy working there enormously.'

Another memorable character around the editing rooms was Seth Holt, who had joined Ealing after working in documentaries, at the invitation of his brother-in-law Robert Hamer, and worked as assistant editor on *Champagne Charlie* and *Scott of the Antarctic*, in which he also featured as 'the voice of the Blizzard' on the soundtrack. Highly intellectual, Peter recalls

that Holt and a music editor called Alistair McIntyre would play mental chess together, in other words without the use of a board or pieces.

> I was so impressed. They would remember the moves in their heads and sometimes whilst doing a bit of work one of them would pop their head round the door and say, queen 4 to pawn 5. The other one would either respond immediately with their move or go round later and put their head in the door and say, right, I've got your bishop. Seth had a lot of charm and was very courteous. And even to a trainee like myself would listen if I did have something to say.

As for Balcon, Peter very seldom saw him. 'He was far too elevated a man for me to have any dealings with.' What he did know was that Balcon ran the rushes ahead of everybody else which was a bit unusual.

> I think it was at noon when…, Katie Brown [the cutting room manageress] would start ranting at assistants, 'Where are Sir Michael's rushes!', because he liked to see them at noon. Then perhaps privately he might say to a director, I liked yesterday's work, or I think you're doing too many close-ups of such and such, or I don't think we're really getting the comedy out of this. But he did see the rushes ahead of other people, because the unit themselves generally saw them in the lunch hour.

This is how Balcon tended to work at Ealing, very hands on. It's true to say that he controlled every aspect of a production,

from casting, budgets and costume choices. He would read every script and give notes and suggest re-writes where necessary. It was an immense workload, which more than once led to periods of ill health and nervous collapse.

And yet he was generous and egalitarian when it came to giving his creative staff their heads. Tibby Clarke said that Balcon was anything but dictatorial, that he would give a project the go-ahead if the consensus of opinion was in its favour. Although the creative talent at Ealing did devise ways of getting round Balcon's prejudices, or in the words of Michael Relph, 'became expert in producing ideas which catered for his restrictive preferences.' Balcon was a bit of a prude. He once said, 'None of us would ever suggest a subject, whatever its box office potential, if it was socially objectionable or doubtful.' Charles Crichton later recalled that Balcon would sometimes tell his staff to forget all about box office and just make the kind of pictures that they really believed in. 'But the very next day he would be shoving box office down our throat and telling us to learn much more about showmanship, how to bang the big drum.'

Above all he encouraged the cross-fertilisation of ideas. So all the associate producers and the directors used to read each other's scripts, criticise them, see each other's rushes, see each other's rough cuts. It was very much a team effort. After all, this was the studio with the 'team spirit' as the slogan proudly declared on one of the studio walls. Indeed, when Balcon was knighted in 1948, he told Monja Danischewsky: 'It isn't me, old boy. It's the studio that has been knighted.'

This sense of democracy was nowhere better symbolised than in the meetings that were held every week during which Balcon and his team of producers, writers and directors

consulted freely together. 'I read somewhere,' says Joanna McCallum, 'that Michael Relph said it was like the BBC used to be, fabulously talented people put together and then coming up with ideas and being supportive of each other.'

To fit them all in, Balcon had an enormous circular table constructed in his private dining room big enough to take about twelve people. 'It was a massive, handsome animal of a piece of furniture,' recalled Stanley Holloway. 'The studio must have been built round it because the legend goes that when the sell-up came it was too large to get through the boardroom door and so still remains as an Ealing echo.' This may have been the case for a while, but eventually the table had to be dismantled, broken up and, no doubt, put on a bonfire.

Peter Musgrave's only proper memory of Balcon occurred outside a small preview theatre that was next door to a rather daunting spiral staircase.

> As an assistant I often had to carry reels of film from my boss down this spiral staircase at great danger. One day Henry Cornelius had just come out of this little viewing theatre and Balcon was coming along the corridor and said rather bluntly to him, 'Oh, are you still here?' Cornelius mumbled something, and then Balcon said, 'I thought you had finished,' in a rather pointed way. Because like most directors Cornelius loved playing around and going on and on changing things, so it was obvious even to me that he had overstayed his budget.

Budgets, as we know, were important to Balcon, and it was the same with general finance. Peter's own wages were, as he is quick to point out, 'painfully low', so by the time you'd paid

121

travel costs and rent there wasn't a whole lot left over. However, it was felt by many that job satisfaction and security commonly made up for the modesty of the pay packet. You collected your wages at the front gate where you also clocked in, there was a little office there run by a husband-and-wife team. 'The husband was the accountant and he ran the pay department for years,' remembers Norman Dorme. 'Apparently he fiddled the books and later bought a hotel on the Isle of Wight, that was the rumour anyway.'

To save money Peter sometimes went without lunch. In those days Ealing stringently adhered to the union rates. If you were a first-year trainee, to the best of Peter's memory, it was £4 a week. At his interview for Ealing, Peter was asked how much he earned at his previous post, the documentary rostrum camera firm in Wembley that he spent ten months with. '£4 a week,' he said. 'Well, you'll be on £4 a week here, too, for two months and then we'll move you up to £4 10 shillings.' Which is what they did. 'Ealing hated spending money on anything,' admits Peter. 'They were very tight with budgets and even didn't like bringing in crowd artists to do the sound effects. Our little crew of sound people would do them and they would be recorded in Ealing's own theatre.'

Out on location, establishing shots such as people crossing a busy road, or whatever, were very often shot mute by a second unit cameraman, so there wasn't even a sound crew present. Back at Ealing the scene in question would be projected onto a screen and the required sound effects created, such as walking in time with the character. If it was a woman walking they'd get someone from the typing pool to oblige. Car noises could be obtained simply by taking a tape recorder out into the car park or going to Ealing's own sound effects and picture library.

'This was run by a very civil servant-type chap called Jack Middleton,' says Peter. 'Very buttoned-up shirt and business-like he was. If at the end of an Ealing film there was anything useful, say a shot of Parliament Square or Piccadilly or a train rushing past, then he would collect all the spares or outtakes and file them away.' Very often what happened was a couple of films down the line someone might enquire, 'Oh, Jack, we want an express train rushing past at night. And he'd say, yes, we've got a spare of that from such and such a title.'

Other effects or shots might not be so easily accessible. During one particular dubbing session a director had a very precise memory. 'I want a barge hooting here,' he said. 'We had a very good barge hooting in *Painted Boats*, reel 4.' Peter's boss Gordon Stone stood on a chair and grabbed hold of this big box up near the ceiling which held all the old dubbing charts and found *Painted Boats* reel 4 and, to his surprise, there it was. 'Oh yes, he's right, 610 feet, it will be on effects 5. Peter, go to the vaults and get it.' When a film was finished all the old tracks were stored in what had once been the air-raid shelter.

'This was a rather dank place,' Peter recalls, 'which was not maintained in any way. And there was a large pool of shallow water inside, because there was no longer a proper door, and that made the place really smelly. So I would have to go in and ferret around these piles of already rusting cans of film. And occasionally I'd have to go back and explain that I couldn't find this particular track, either because it had been stored incorrectly or destroyed, and there'd be hell to pay.'

Peter and his colleagues were also required to run everywhere; there was no saunter and have a cup of coffee on the way. And often they'd work their lunch hour, making do with a quick sandwich bought from the canteen.

It was resented, certainly amongst the dubbing staff, that if you'd worked your lunch hour why was it that the bosses were so strict about the time clock. A colleague would say, 'Hell, they've written me this note saying I've lost 13 minutes this week for arriving late, but what about the two lunch hours I've worked, that's two times sixty minutes.' But if you were asked to work the lunch hour, you worked the lunch hour.

It would especially grate with the staff when someone was sacked over poor timekeeping or being late. Peter once bumped into his former colleague Chris Greenham, who had just left Ealing. 'What happened?' Peter asked. 'I was fired because of bad timekeeping,' came the reply. The bosses had sent him repeated warning notes. 'Admittedly he *had* been a bad timekeeper,' says Peter. 'But he worked like a slave while he was there. But he had accumulated something that by Ealing's standards was a disgrace, which was something like twenty-nine lost minutes in a week. So they had fired him, and I said, 'What's happened to you?' And he said, 'I've never looked back, I get paid far more, and work on bigger pictures.' He wasn't at all sorry.'

This leads to another grievance that existed amongst some of the staff, the feeling that there was an air of superiority around the studio, that if any employee left they'd struggle to find work outside and that they really ought to be grateful to have a job at all; that kind of attitude, almost putting fear into people so they'd stay. 'There was this feeling while you were there of, don't leave, you mustn't leave,' claims Peter.

It's true to say that being permanently employed left staff free of worry between productions, a rare blessing especially in

so tumultuous and fragile an industry as the movies. 'The wonderful thing was that we had creative security,' Charles Crichton explained in a BBC documentary in 1970. 'There was enough anguish and misery about, the budgets were too low, some of our pet ideas got stamped on, but all the burden of setting up a picture was taken from our shoulders and we were relaxed.' The price one paid for that security was low wages, lower wages than probably any other working studio in Britain. 'We were paid less than other studios,' Charles Frend once confirmed. 'But on the other hand we were paid all the year round whether we were shooting or not. We didn't get any share of the profits, but the company used to say, you're not asked to share in the losses, either.' As a rule contracts were renewed annually. It was done automatically, without fuss. 'Astonishing as it seems now,' said Tibby Clarke. 'It was considered rather caddish for anyone on the creative side to employ an agent, who would doubtless have gained one better terms than one managed to obtain for oneself.

Eventually this situation reached boiling point, sometime in 1947, when everybody got to thinking, ok our contracts get renewed year by year, but we aren't getting as much money as we might be worth outside. And so a secret meeting of all the directors and all the associate producers was called which finally deputed Sidney Cole, the studio's crusading trade unionist, to go and talk to Balcon about money. Cole was the most politically engaged individual at the studio, having arrived at Ealing in 1941 first as an editor and then producer after making several left-wing documentaries about the Spanish Civil War and the working class. According to Cole Balcon was very concerned by these modest signs of revolt. Cole and all the rest were not being ungrateful, they knew that it was Balcon and no

one else who had promoted most of them. 'But Mick suddenly got, I think, very frightened at the idea that we might be deserting the ship.' In the end Balcon conceded and paid them more money. Still not very much and still a long way off what they might have got as a freelance. 'I think he was a very mean person in money terms,' admitted Charles Crichton, who before this mini revolt stirred things up was only getting £25 pounds a week for making features.

Under contract to Ealing one was also very seldom allowed temporary leave to accept a highly paid freelance job elsewhere. When Douglas Slocombe, who had aspirations to become a director, was approached by revered documentary filmmaker John Grierson to helm one of his productions he jumped at the chance. But there was one proviso. "I have to tell you that I'm under contract to Ealing. I have been there for years and hope to remain there. If you want me to do it, you will have to ask Ealing if they will release me for two or three months." The next day Dougie was walking through the main entrance foyer when he was grabbed by Hal Mason. "I would keep out of Mick's way if I were you Dougie." Through the thick wooden door of Balcon's office Slocombe could hear him shouting down the telephone at Grierson: "I won't have my people taken away from me!" And that was the end of Slocombe's directing aspirations. As Charles Crichton once observed: 'I think Mick was quite a jealous man. He did sometimes think he owned us.'

Something very similar happened when Tibby Clarke was courted by Hollywood. With several hits under his belt at Ealing, he was approached by William Wyler to work for a couple of weeks re-writing the script of *Roman Holiday* (1953). Surely working with such a film-making maverick would only

enhance his reputation at Ealing, plus the money was good, so Clarke asked Balcon's permission. Thinking about it for a few minutes Balcon said, "This offer from Paramount isn't good enough." Which came as a surprise to Clarke since the fee in question was six times his wages at Ealing. "It's your value to them we have to consider," said Balcon, before revealing his own figure of how much the Hollywood studio ought to be paying. It was an astronomical sum.

"That's ridiculous," said Clarke. "They'll never pay it."

"Nonsense old boy, you're worth it – to anyone except us," Balcon finished with.

Of course Paramount refused to pay, as Balcon knew only too well they would. Instead they asked Clarke's fellow Ealing scribe John Dighton, who had shrewdly not agreed to go under contract.

This all might be considered as unfairness on Balcon's part, but he was loyal to his workforce and he expected loyalty in return. One illuminating story from Monja Danischewsky has Balcon and himself in the projection theatre at Ealing watching a private screening of *The First of the Few* (1942) the stirring tale of R.J. Mitchell, the designer of the Spitfire, played by Leslie Howard. In one scene Mitchell unveils his plans for a plane prototype to the company board he works for. They reject the idea. Spurned, Mitchell says something along the lines of, "In that case, I'll take it elsewhere." At this point in the film Balcon suddenly rose to his feet and glared at the screen, jabbing his finger accusingly at Leslie Howard's retreating figure. "You come back!" he blasted. "You designed that plane in the company's time. It isn't your copyright. It belongs to the company." That's rather how he felt about his staff, he'd nurtured them, developed their talent and they belonged to him.

Arriving in 1947 at the studio was a young eager cameraman by the name of Ronnie Taylor, who had begun his career at Gainsborough in 1941 before going into the army. After the war he had returned to the studio but things had become a bit slack there, not a lot was happening. 'Ealing got in touch and asked the head of the camera department at Gainsborough if I could be loaned out to Ealing for a few months.' It turned out to be a much longer stay.

It didn't take Ronnie long to suss the place out.

> Michael Balcon ruled with a pretty firm hand, compared to Gainsborough which was a very relaxed atmosphere. The producer in charge of production at Gainsborough was Ted Black, the brother of George Black who was a famous stage producer. Balcon had a fella called Hal Mason in charge of production at Ealing, who dealt with the riffraff as it were. Hal Mason was very strict. He was on the floor more than Balcon. Balcon was hardly ever seen, at least by me, but he ran a very efficient studio. Although I didn't like the fact that we had to clock in and clock out. Ealing was run in a very strict manner in that regard, because I never had to clock in at any other studio I worked at.

This efficiency and discipline also extended to how one presented oneself. 'You had to be fairly tidy,' remembers editor Peter Tanner. 'Mickie Balcon used to say some of the directors were the scruffiest lot he'd ever seen. But we had to wear a tie every day there, and if you had screenings you had to wear a suit. I suppose that was how we got the image of Sir Michael's young gentlemen.'

As for the talent, Ronnie Taylor liked most of them. He thought Robert Hamer a fine director; he even courted his secretary and eventually married her. Some of the others he had less time for. 'Charlie Crichton was a bit grumpy actually. He had a good sense of humour but he was a bit of a grouch. But he made some fine films.'

As for the facilities, they were an improvement over Gainsborough, says Ronnie: 'The stages weren't bad, they were pretty good actually. And the camera and sound equipment was first class. It was quite modern for its time.' This wasn't the opinion of everyone, however. 'It wasn't hi-tech at all,' claims Robert Winter. 'You were lucky to have a telephone in your office.' Ealing was, though, the first studio in the country that had a gantry system, with all the electrics coming into the studio via the roof, not from the walls which was the norm at the time in British studios, leaving sundry cables all across the floor. 'There were these big girders and they hung gantries off them which were suspended on chains,' recalls Ken Westbury. 'The electric cables were dropped straight down, so there was virtually nothing on the floor. Ealing was the first studio in Britain to do that.'

Most people remember the stages at Ealing as well equipped but modest. Robert Winter recalls that the largest stage wasn't insulted against outside noise, 'so dialogue did prove a problem if an aeroplane flew over or whatever'. Another drawback was the size; they were somewhat small. This was always one of the disadvantages of Ealing's situation, it couldn't be re-developed or enlarged since it backed onto property and Walpole Park, so construction of sets and shooting schedules had to be meticulously timed due to the lack of stage space. This was fine since most of the movies made there never required a huge

amount of space. The lack of a backlot also necessitated a reliance on location shooting.

However, when large-scale sets were required, that's when a craftsman's or technician's skills came into play. A good example of this was when the Art Department was asked to re-create the interior of Beverley Minster for the film *Lease of Life* (1954) 'First of all we used a foreground model,' relates Norman Dorme. 'Anything that was bigger than the stage we'd use a foreground model, which is a hanging miniature. So that gave you the top half of the set. Then we built the first five or six columns and the first two or three rows of pews for the people. We had maybe five rows of people and then they went into painted cut-outs, rows and rows of just plywood cut-outs scenic painted. The trick was lining everything up, and also trimming the foreground miniature so it sat perfectly on top.'

That trick was often used. So, too, were glass shots, which were achieved by painting details on a piece of glass, which was then combined with live-action footage to create the illusion of a set or a background. Ealing used this method of optical effect quite often says Norman.

There was a scene in *The Cruel Sea* when these two NCOs from the *Compass Rose* ship visit the home of one of their sisters. They go back a few months later, walk down the same street, turn the corner and the house has been bombed, the roof has gone and everything. We shot both of those scenes on the same day with just a piece of painted glass from a scenic artist for the damaged building. Back in those days we didn't have special effects, there was no such thing, really. Special effects

was mostly run by the Art Department. It was only later on they became these huge empires.

Imagination played a huge part, too. On *Whisky Galore* (1949) Jim Morahan was art director and achieved a believable effect with an almost childlike simplicity. It was an establishing shot of a sailing boat anchored at sea. Morahan took with him to the Scottish location a small model boat. 'He lined up the shot with a rock out at sea,' recalls Norman, 'placed the model ship in the foreground and sat it on the water and it worked very well, done so simply, all in camera. Nowadays it would all be done optically and they'd be a special department set up to do it and it would go on for months. Then it was done on the day, on the spot.'

Ealing did possess its own model stage, which measured about 80 by 100 feet according to Tony Rimmington. 'Inside was a permanent tank that was something like 5 foot high, which they used a lot for the whacking great models we had to build for *The Cruel Sea* and other stuff like that.' The model stage was constructed during the war and according to Ken Westbury involved no machinery at all. 'It was built by just two workmen and was completely made of brick. One guy was the bricklayer, the other guy was his labourer who also dug the holes out for the foundations. I think they might have had some help to put the girder roof on.'

Chapter Ten

Ealing Goes Down Under

The success of *The Overlanders* had encouraged Balcon that the public wanted to see more 'open space' films shot in Australia. To this end he acquired a lease on a studio outside Sydney called Pagewood, which had been closed for a decade but which was still the best equipped in the country. Harry Watt was again dispatched down under and the result was *Eureka Stockade* (1949), which told the story of one of the great defining events in Australian history – the miners' resistance in Ballarat in 1854. It was a big production, the most expensive film yet attempted in Australia, with some seventy speaking parts and several hundred extras, mostly drafted in from the army.

Watt had spent months researching the story, comparing all of the written accounts, visiting Ballarat to talk to the descendants of some of the original miners, and amassing detailed material about life on the goldfields. But his presence in Australia was not welcome in some quarters, particularly the press. Word had got out about the low wages paid on *The Overlanders*, regardless of the fact that Watt had a moderate budget of only £40,000 to play with and he had to buy 500 heads of cattle out of that. Chips Rafferty, for instance, had

been paid just £30 a week, but the press failed to mention that this was Rafferty's own choice. Watt had asked him what he wanted and Chips had replied, "£30 a week, if I have that my wife and I will be fine." The press also failed to mention that Watt himself was only paid £40 a week. Still, when he arrived in Australia to start work the press were on his back, as he later recalled.

> Because the film had done well financially the press said, Harry Watt, the man who exploited the Australian actors and technicians has arrived back. He is a pure exploiter. And they started a campaign against me in the newspapers, they would ring me up at four in the morning trying to start an argument to get some quotes. Then I realised if you shut your mouth and refuse to say anything the thing dies in three days. And that's exactly what happened.

But it did leave a bad atmosphere hanging over the production.
 Then, just a few weeks away from shooting, the British government passed a short-lived law that slapped a 75 per cent duty on imported films. Watt was livid when he heard that his picture, even though it was being financed out of England, fell under this new tax rule, as a result of it being made in the Commonwealth. A deal would have to be thrashed out in order for *Eureka Stockade* to be classified as a British film made abroad. Watt later complained: 'For months Les Norman, my assistant director, and I sat on our arses waiting while the Board of Trade read the script from end to end and worked out line by line, and word by word, which lines had to be played by British actors to make its quota.'

As the leader of the rebellion Watt once again called on the services of Chips Rafferty, now a big star following the success of *The Overlanders*. And having previously been warned off using Peter Finch, Watt was determined to use him this time in the role of a pacifist miner. Finch thoroughly enjoyed working on the movie, especially the company of the many aborigines on the unit, who taught the young actor how to throw a boomerang and handle spears; Finch would go off hunting rabbits on his own.

Relations with the press were just as fraught on Ealing's next Australian venture, *Bitter Springs* (1950), directed by Ralph Smart, when the *Sydney Morning Herald* reported the poor treatment of aborigine cast members, who, it claimed, were made to travel in covered railway goods vans without seating, sanitation or toilet facilities.

Harry Watt had grown tired of the outback experience after *Eureka Stockade*, which had been plagued by shooting delays thanks to atrocious weather conditions. 'We were ready to shoot,' recalled Watt. 'And it rained for three weeks.' Roads turned into quagmires, sets were washed away and the miners' tent city was twice blown to the ground. At one point Watt was seen heading out into the woods with a rifle. He was going out to see if he could shoot himself a rabbit, but some of the crew rushed after him thinking he was going to shoot himself because he was so depressed. It got so bad that Watt suggested to Balcon that they abandon the film until the following year, but by that time so much money had been spent he was told to carry on.

The film's failure at the box office also did much to dampen Watt's spirits, as was its handling by Balcon, who after a screening declared it to be too long and wanted it reduced

to 100 minutes. The main casualty ended up being Peter Finch, most of whose performance ended up on the cutting room floor.

Back at the studio, Ealing was about to embark upon a series of comedies that would all be released within three months of each other and whose success did much to establish the studio's reputation around the world as the purveyor of a very definite type of English humour: *Passport to Pimlico*, *Whisky Galore* and *Kind Hearts and Coronets*.

Passport to Pimlico (1949) came about after Tibby Clarke read a newspaper article concerning Princess Juliana of Holland, who while exiled in Canada during the war became pregnant, thus raising concerns that the baby would not be eligible to sit on the throne due to having been born overseas. The problem was solved when the accommodating Canadian government passed an act of parliament making the delivery room Dutch territory. The plot of *Passport to Pimlico*, which Clarke always believed was the best he ever came up with, and the script for which he was nominated for an Academy Award in 1950, concerns the inhabitants of a London street who discover some buried treasure and ancient documents proving they are really part of the old Duchy of Burgundy. When the government tries to claim the treasure for the Crown, the Burgundians declare their independence, thus freeing them from the stringent rationing that had been in place since the war. The film beautifully captures those most quintessential English traits of individualism, tolerance and compromise. In the words of the grocer's wife in the film, upon learning she and all her neighbours are now foreigners, declares: 'We were always English, and we will always be English, and it's just

because we're English we're sticking out for our right to be Burgundians.'

Henry Cornelius was given the task of bringing Clarke's marvellous concept to the screen, making his feature debut. Born in South Africa, Cornelius worked for Alexander Korda before returning home to fulfil a dream of making films in his native land. Faring badly, when war broke out and he was deemed unfit for military duty, Cornelius was determined to get back to England and underwent a dangerous journey by ship at the height of the U-boat scare. Ronnie Taylor was a focus puller on *Passport to Pimlico* and believes Cornelius was the perfect choice to make the film, having already been associate producer on several Ealing pictures. 'He was a lovely, fairly elderly man but with a great sense of humour. I remember him as a very jokey kind of character, which came across in the film.'

Barbara Murray, a young actress, then just 18 years old, making her film debut, didn't exactly see things the same way. She didn't get on with Cornelius and working for him became a chore. Yes he was a brilliant man, she admitted, but he was also a perfectionist, ruthlessly determined to get exactly the shots he wanted at all costs. Nor did it help that he chewed on raw cabbage all day. And there was his temper. 'He had a vicious tongue,' revealed Barbara. 'And he would humiliate you in front of the extras.'

Ronnie Taylor also worked on the second unit that always attracted a large number of spectators whenever they arrived to start shooting. 'We did have to control the crowds sometimes who came down to watch us. It was something quite new to see a film crew out in the street.'

Back in those days you didn't need permission to shoot anywhere in London. 'There was no bureaucracy or form filling

or haggling with local councils,' says Ken Westbury. 'All you did was tell the police where you were going to be and just started filming.' It really was that simple. An assistant would call upon the local police station to say, "We want to film', and the constable on duty would reply, 'Well go ahead, but don't expect any help from us and if you get to be a nuisance we'll move you on.' If you were lucky you might perhaps get a couple of off-duty policemen to stand by the set to handle any traffic.

Like *Hue and Cry, Passport to Pimlico* relied heavily on location work. Not in Pimlico, strangely enough, but Lambeth, on a bombsite off the Lambeth Road. 'The thing that always amazed me about London at that time was the bomb damage, how much of it was still there,' says Norman Dorme.

> It took years and years to finally clean it up. At the end of the war with the Merchant Navy I was in Rotterdam, and that city had been bombed flat by the Allies, and I can remember looking out over the city and all the rubble had been cleared away. Back in London, all they did about these big holes in the ground was build a brick wall around them to stop people falling in, that's about all that ever happened and they just left it for year after year after year.

Cornelius skilfully cast his movie and there are delightful performances from Stanley Holloway as a shopkeeper-cum-councillor (in a role originally offered to Jack Warner, who couldn't take it due to prior film commitments) and especially Margaret Rutherford as an eccentric professor specialising in Burgundian history, wearing one of the long capes that would become her fashion trademark. Cornelius's first choice for that

role had been Alistair Sim, but when he proved unavailable various replacements were discussed until Cornelius hit upon the idea of the character being a woman. When he later saw the film, Tibby Clarke was surprised to notice that the professor's change of sex had necessitated the alteration of not one single line of dialogue.

While the film was in post-production, at its final mixing stage, the government ceased rationing on many items and a despondent murmur ran round the studio that the public would regard the film as outdated. Peter Musgrave recalls that it was Cornelius who came to the rescue by ordering a brief insert to be added just after the main titles which read: 'Dedicated to the memory of — ' before cutting to a shot of a laurel wreath surrounding an image of ration coupons and a clothing ration book. 'If you view the film or a DVD you will notice that the title music runs out early leaving the insert silent; that's because it was added after the music had all been recorded to the original timings. I saw the film in a public cinema soon after it came out and the audience laughed right away!'

The final touch to an instant classic was a whimsical score by French composer Georges Auric, who had already scored a number of Ealing films, including *Dead of Night* and *Hue and Cry*. Auric composed with remarkable speed, in part due to his fondness for opium, which may have stemmed from his association with Jean Cocteau, who was widely known to use opiates for artistic inspiration. Auric never became addicted, merely a casual and controlled smoker, and liked to boast to friends back in France that when working for Ealing or on other film assignments in London, he was able to maintain a steady supply of the drug in the form of a special dispensation personally sanctioned by King George VI.

Ealing's musical director, Ernest Irving, was one of the studio's great characters. He had been with the studio since the Basil Dean era and was approaching his sixties when Balcon took over. It always amused Balcon that Irving was a musicologist and classical scholar, and yet he kept his apartment in a complete mess. He remained, though, a die-hard traditionalist, once ordering the London Philharmonic Orchestra to, 'remove all the metal junk with which modern orchestral string instruments are bedizened and to substitute gut (strings), as used in the days of our forefathers.' Irving always arrived for the recording sessions immaculately dressed in an off-white tropical suit and his tie from the Savage Club, one of the leading bohemian gentleman's clubs in London. On one occasion it was believed that Irving, who suffered from arthritis, would not be able to conduct a session. A replacement conductor was brought in and as he took his place on the rostrum, facing the orchestra ready to start, the doors burst open and Irving was brought in on a stretcher, complete with white suit and tie. Propped up in a chair, he was able to complete the session.

Because Robert Winter played the piano and could read music he was often assigned the job of taking the film clips down to Stage 3B, where he would project them for the London Philharmonic to rehearse and finally record the music. This led to an almighty bust-up one day with Irving.

He was convinced that the music didn't fit the picture and wanted to know why. He pulled me over and said, 'What the hell have you been doing? Have you been re-editing it?' Of course I hadn't, I wasn't the editor, I was just an assistant. Anyway, he had a real go at me, I must have been about twenty-two at the time, and I was so angry I blasted

back, 'I'm not staying here for you to be rude to me,' and walked out. That left nobody else to work the projector and there was the London Philharmonic, something like sixty musicians, together with a choir, with nothing to do.

Finally the error was discovered; Irving had himself mis-timed all the music cues.

When he discovered the problem, I was sent a large box of Black and White Marcovich cigarettes, along with his apologies, and asked to return immediately because they had this bloody great orchestra getting paid and not doing anything. We actually became good friends as a result, and he later gifted me a month of lessons with Louis Kentner, the concert pianist. I liked Ernest, he was a great chess player and lived in a large apartment right next to the studio so was always around.

Upon release, *Passport to Pimlico* was highly praised by the critics. 'Every line, every gag, is a little masterpiece of wit; each character, and indeed every individual member of the cast, provides a gem of comedy acting at its highest and best,' raved the *Monthly Film Bulletin*, which went on: 'Too much cannot be said in praise of this film, since it is genuinely funny and the humour and pace never flag.' And this from the celebrated C. A. Lejeune in the *Observer*: 'One of the most felicitous and funny films since the age of the René Clair comedies.'

It also did substantially well at the box office, easily recouping its production costs. This was fortunate since the film had gone over schedule and over budget, largely due to poor weather conditions. Balcon also felt that some of the delays were due to

Cornelius' lack of directorial experience and according to Barbara Murray there was an awful lot of friction between the two men during production. 'Cornelius and Michael Balcon used to have the most terrible set-tos at the studio, which I used to secretly enjoy because you love to see a bully taken down.' Afterwards Balcon tried to persuade Cornelius that his talents perhaps lay more in producing and he should give up his ambition to be a director. Only years later did Balcon feel his lack of faith in Cornelius was an error of judgement. Indeed, so distraught was Cornelius by this that he walked out on the studio and never made another film for them.

There is another story that, on the back of the success of *Passport to Pimlico,* Cornelius demanded a raise, never a wise tactic with the frugal Balcon, and when he was turned down flat then promptly quit. Whatever the real reason, Cornelius formed his own production company and made *The Galloping Major* (1951), a sub-Ealing comedy about an ex-army officer who bands together with friends and neighbours to buy a racehorse, which unfortunately stiffed at the box office. Not long after, Cornelius pitched a comedy script to Balcon: it was about two couples involved in a veteran automobile rally from London to Brighton. Balcon found merit in the idea but his schedule for that year was already full so sent Cornelius over to Rank, who immediately recognised its potential and put it into production. *Genevieve* went on to become the second most popular film in British cinemas during 1953.

This wasn't the only British comedy classic that fell through Balcon's fingers. At one point the studio owned the film rights to Kingsley Amis's much-acclaimed novel *Lucky Jim.* The only problem was Balcon didn't particularly care for it and was only too happy to sell it to the Boulting brothers.

Chapter Eleven

A Comedy Bonanza

David Peers has never forgotten the advice his father gave him when he announced one day his intention to make the cinema his career – don't go into the film business, it's a mad world! So, of course, he did. David's father certainly knew what he was talking about. Victor Peers entered the film industry as a youngster in 1919. By the early 1930s he was production manager on several films for Gaumont-British, and for a time was general manager at Pinewood Studios. In 1946 he joined Sidney Bernstein and Alfred Hitchcock at Transatlantic Pictures and worked uncredited on *Rope* (1948) and *Under Capricorn* (1949). Much later he was one of the founder directors of Granada television. David had grown up around film people, it had been so much a part of his life that when he left the army in 1947 he really didn't want to do anything else, in spite of his father's warning. 'So I decided to follow in his footsteps rather than to follow his advice and I asked him if he would give me an introduction to get me started.'

The name he was given was John Croydon, who had recently been appointed head of a subsidiary company of Rank to make a succession of quick and cheap B pictures in a studio that had been converted from a former synagogue in Highbury. The

idea was to utilise the services of members of what became known as the Rank Charm School, actors such as Christopher Lee, Anthony Steel and Diana Dors. 'I got a job as third assistant director at £2 12 shillings a week. And of course I made the tea. But I also helped to make some pictures and began to learn the craft of film production.'

In the summer of 1948, Rank closed the subsidiary company down and David found himself out of work.

> After several weeks of unemployment I thought maybe my father was right and I should get out of the film business. Nothing much appealed to me. I was unqualified for any academic post and so I turned in desperation to the thing nearest to hand, an ironmonger's shop in Croydon. They turned me down saying I would never make a shop assistant.

Then, out of the blue, he was contacted by Elstree Studios, who were about to put into production a film version of the West End hit musical *The Dancing Years* by Ivor Novello. Again hired as a third assistant director, much of the shooting took place on location in Vienna, which at that time was still under four-power control; America, Britain, France and Russia, each controlling its own sector and movement between each sector was not easy. The film, which was directed by Harold French and starred Dennis Price, turned out to be a flop, but David found it enormous fun to make, save for one incident at a nightclub called Maxims. Still somewhat naive about the ways of the world, when a hostess joined David's table he allowed her to order champagne, which it turned out he didn't have the money to pay for.

The manager was called and I had to forfeit my passport, which was, in the circumstances, a crazy thing to do. The next morning I had to confess to the producer that I had lost my passport. Dennis Price heard about this and in a show of bravado went down to the club the next evening to reclaim it. The manager promptly called the police and Dennis was thrown into jail. For the film having its leading man in jail was not exactly a minor mishap and it was soon discovered I was the culprit. I thought my film days were over, but the producer coughed up the money and my precious passport was returned. And Dennis, enjoying the whole episode, came back the next day. For the rest of the shoot I kept a very low profile.

Returning to England, the search began for another film job. David's father was on friendly terms with Balcon and a few choice words on the right occasion led within weeks to David landing a job as second assistant director on *Passport to Pimlico*.

'In many ways the second and third ADs had the greatest fun. They would be concerned with ensuring the artists turned up at the right time for Make-up, Hair and Wardrobe. Often this meant a six o'clock call at the studio. They would also have to organise any crowd scenes.' David's main job on *Passport to Pimlico* was to look after the crowds of extras on location and there were often several hundred of them.

If large numbers of people were involved, we would divide them up into sections; each one having a crowd marshal. Communication was normally done by mega-phone or visuals, such as flags. Cues were vital and the

first assistant director started it off from his position next to the camera and it would be relayed down the line. Anticipation was the key, for an error by part of the crowd coming in too late or too early could mean the whole shot being done again; an immense amount of wasted time.

Ealing was nothing if not efficient; the schedule and, of course, the budget loomed large in everybody's minds. 'We tried to shoot about two and a half minutes of useable film a day,' recalls David. 'The key to success was getting the first shot of the day in the can before nine o'clock. That would then set the tempo for the rest of the day. So we tried to schedule the first shot as an easy one. Today in the commercial world one might get ten seconds in the can if one was lucky. The number of takes, too, was much more disciplined in the old days. Today forty or more takes is not unusual. Whereas back then ten takes would be near the maximum.'

David had enormous fun making *Passport to Pimlico* but when it finished there was no permanent job for him at Ealing, so he found himself once again unemployed. But he would soon find a way back to the studio.

According to Balcon, Monja Danischewsky 'Did as much as any of us to put Ealing on the map'. The youngest son of a Russian émigré family, Danischewsky joined Ealing in 1938 as their publicity man, at first on his own and then heading his own department. He was mercurial, highly intelligent, a renowned wit and infectious company. Michael Pertwee, a scriptwriter at Ealing, recalled a dinner party at an exclusive restaurant when Danischewsky's wife fainted and laid her head

in a plate of fish. 'Don't worry, everybody,' said Monja, quick as a flash. 'Brenda's motto is: There's no home like plaice.'

Friends with the most influential editors in Fleet Street from his days as a journalist, to whom he fed stories about the studio and its productions, Danischewsky also did much to raise the whole level of cinema advertising, particularly in regard to Ealing's highly original and innovative poster campaigns, which became some of the most striking and recognisable in the history of British film. According to Michael Relph, 'Balcon could not move without him'.

After ten years in the job, however, Danischewsky wanted a change, having grown bored over in the publicity department. He'd seen friends and colleagues from sundry other departments get promotion and direct or write films but never him. 'Monja always wanted to be a scriptwriter,' claims Alex Douet, whose mother worked for him. 'He was a very flamboyant character.'

Over the years Danischewsky, or Danny as everybody called him, had threatened to resign on numerous occasions, only to be talked into staying. This time he was going to walk unless he could produce his own movie. Even though that year's production slate was at bursting point, Balcon didn't want to lose his erstwhile friend and told him that if he could find a good enough subject, he'd squeeze another one in. Danny had recently come across a wonderfully whimsical book by Compton Mackenzie called *Whisky Galore*, a fictionalised account of a real event that occurred in 1941 when a cargo ship laden with 50,000 cases of Scotch whisky ran aground off the coast of Eriskay in the Outer Hebrides and much of the booty on board was appropriated by a group of Scottish islanders.

With Ealing's stable of directors all busy, Danny had to look elsewhere and came up with a perplexing candidate, a man who

had never directed a feature before, Alexander Mackendrick. Born in Boston, Massachusetts in 1912, Mackendrick was only six years old when his father died and he was given over to his grandfather, who took the boy back to his parents' home city of Glasgow. He would never be reunited with his mother. Trained in graphic design, Mackendrick gained some film experience while attached to a specialist camera unit in Italy during the war. Back in civvy street he worked in advertising until Basil Dearden and Michael Relph brought him to Ealing to work as a storyboard artist. 'I can remember Mackendrick coming into the studio for his first interview,' says Norman Dorme. 'My early impression of him was of someone very confident, conceited almost. He turned out to be an excellent director.'

Balcon wasn't at all convinced of the choice. Yes, he did enjoy giving newcomers a chance, but this was a huge gamble, teaming a novice director with a novice producer, it was a recipe for disaster surely. 'You know nothing about production, dear boy,' Balcon said to Danny one day. 'And now you are proposing to have a director who knows nothing about direction. You go and get yourself a chap who'll make up for your own ignorance.' Looking beyond the studio walls, Danny offered the film to Ronald Neame but he turned it down. Eventually, he got his own way and Mackendrick was installed as director. Before leaving to start work Danny was called into Balcon's office to be told, 'For God's sake, dear boy, don't let me down.'

The entire film was shot on location on the Isle of Barra in the Outer Hebrides, at Mackendrick's insistence. A local church hall was converted into a studio with crude soundproofing. 'Many of the sets you see in the film were built and shot in this church hall,' confirms Ken Westbury, who

147

worked on the camera unit. Ingenuity was exemplified in other ways, too. For example, in a scene where somebody knocks on the front door of a house, the crew took a door frame and even a section of a set out onto a location, perhaps overlooking some picturesque bay, to do the reverse shot of the person opening the door from the inside; the original house itself was probably located several miles away.

For the crowd scenes local inhabitants were hired as extras. According to the actor Gordon Jackson, by the time they'd all packed up to go back to Ealing the locals had become complete experts about movie-making. 'I remember the postmistress. Sandy Mackendrick said to her, "You stand over there." And she said, "No, no, I wouldn't be in this angle, I wasn't established in the last shot." They were very quick to catch on.'

Ken particularly delighted in the shoot. It was rare for an Ealing film to stray further than the confines of London. And he especially enjoyed working with Mackendrick. 'He was absolutely brilliant, so talented. I loved just standing and watching how he did things, and being so nice about it all.' What impressed Ken most was Mackendrick's visual panache. 'He'd trained as a commercial artist and he would explain a setup he wanted, the framing of a scene, and if people couldn't quite get it he'd take his sketch pad out and draw it, absolutely perfectly, and they'd go, oh, I know what you mean now.'

He could be exasperating, however. Norman Dorme heard from the prop master on the film that some of the crew complained about how Mackendrick was always choosing locations that were almost impossible to get to. 'This guy told me, "He's up on this bloody mountain which only him and a mountain goat can get to and he wants us to put the camera up there!" Sandy was difficult in that respect, he knew what he

wanted and these old established Ealing people didn't want to put themselves out too much.'

There were also frequent clashes with Danischewsky over what the moral tone of the film should be. The Presbyterian Mackendrick held the view that the islanders were in the wrong and sided with Basil Radford's character of the harassed Customs and Excise official, while Danny held the more majority view that the islanders should be portrayed as the charming and feckless heroes of the story. There were other problems, too. Because Balcon had squeezed *Whisky Galore* into his scheduling, Mackendrick only had the use of a largely inexperienced crew. And then there was the script. Danischewsky had employed Angus MacPhail to write the first draft, but Mackendrick was never satisfied with it and Herbie Smith, the film's focus puller, remembers arriving on Barra, 'and the first thing was Danny tore up the script and said, "We've all got two days off, Sandy wants to rewrite it."' Gordon Jackson also recalled one day Mackendrick suddenly announcing to the unit, 'I've decided I'm not making a comedy, I'm making a documentary of island life.'

The curse of all films made on location struck next, the weather. It rained almost incessantly. The plan was if it rained, filming would take place indoors, but the weather was so bad that eventually the cast and crew found themselves inside the converted church twiddling their thumbs with nothing to do because all interiors had been completed. It wasn't long before they were behind schedule. Mackendrick was convinced the whole thing was doomed. 'It was absolutely terrifying and I remember getting up in the middle of the night and crawling on my hands and knees to the only public phone box on the island to call my fiancée to complain that I was thinking of committing suicide. Instead of sympathy I got a bawling out.

"It's only a stupid bit of film." So I went back to sleep thinking, an ideal wife for a movie director.'

Given how much the film is revered today, *Whisky Galore* came within a hair's breadth of being an unmitigated disaster and not being seen by anyone, according to Robert Winter who worked on the editing.

> When the rushes were assembled, Ray Dicks and myself, who were assisting the editor Joseph Sterling, tried to put the film together according to Sandy's shooting script, but it didn't make any sense. Mick Balcon asked that the completed rough cut be presented and then called in Robert Hamer, Harry Watt, Charles Frend, Charles Crichton and Sid Cole, who was the supervising editor for Ealing. Mick asked Sandy about not only the structure, but where missing shots were. He then asked Sandy to go to Paris for a couple of weeks and got Sid Cole and Charles Crichton to try and get a picture for him. Ray Dicks and myself ordered all the outtakes and N.G.s ('no-good' takes) to be printed up. Sid Cole spent time creating the montage sequence of hiding the whisky and the love scene on the beach with Joan Greenwood.

Once the rescue job was complete, Balcon still didn't think he had much of a film on his hands. *Whisky Galore* was never intended to be a prestige production. According to Robert Winter, after the large financial layout on films such as *Saraband for Dead Lovers* and *Scott of the Antarctic*, which had not done well at the box office, Balcon wanted *Whisky Galore* to be made as cheaply as possible. He also intended to release it with little fanfare or expensive marketing. This came as something of a

shock to many of the staff at Ealing, who liked Mackendrick enormously and thought he had huge potential. It was decided to take action. John Jympson was a young editor at Ealing whose father Jympson Harman was film critic for the *London Evening News*. 'Harman got to hear about *Whisky Galore*,' recalls Robert, 'and asked whether it was going to be trade shown at the Odeon Leicester Square, as some of Ealing's films were. And Mick said, "No, no way. It's not a big film at all. And we won't be able to sell it in Europe or America." This got back to John, so he invited his dad and some of the press down to Ealing to take a look at the film and Harman and the rest of the critics wrote glowing notices and the thing just took off.'

Whisky Galore followed *Passport to Pimlico* into cinemas just two months later and was another hit. 'Ealing never really had a profile before then at all, not at all,' believes Robert Winter.

> It was only after we made *Whisky Galore* that people started talking about us. Mick Balcon always wanted Ealing to have the same presence as MGM had, or Paramount, any of those other studios. He wanted to have the same kind of status. Nobody realised the popularity the public would give to these comedy films, and it really kicked off with *Whisky Galore*.

Mackendrick, however, always looked back on the film with a degree of disappointment. 'It looks like a home movie,' he once said. 'It doesn't look as if it was made by a professional at all. And it wasn't.'

Danischewsky was to call the film, 'The longest unsponsored advertisement ever to reach cinema screens the world over.' Indeed, The Distillers Company Limited, a leading Scottish

drinks and pharmaceutical company, were so happy with the film's success and the resultant increase in usage of its product, they laid on a lavish dinner for everyone connected with it at the Savoy hotel. A bottle of whisky was given to each guest as they arrived, which they were expected to drink before the end of the evening.

What really surprised everyone was how popular *Whisky Galore* turned out to be in America, the first Ealing film to achieve any real measure of box office success there. The *New York Times* called it, 'Another happy demonstration of that peculiar knack British movie makers have for striking a rich and universally appealing comic vein in the most unexpected and seemingly insular situations.' Balcon remembers being somewhat thrown when a visiting American film executive described his film as a 'sleeper'. Unfamiliar with the term, Balcon thought the executive meant the picture was putting the audience to sleep. He must have also been amused by reports that the American censor had insisted on a coda being inserted at the end of the film stating that the stolen whisky brought nothing but unhappiness to the islanders, even though quite the opposite was true in real life!

In America the film had played under the title of 'Tight Little Island', which worked quite well. Years later Danischewsky bumped into the American humorist James Thurber. 'I wish I'd known you at the time, Monja; the right American title for the film is "Scotch on the Rocks".'

The last of Ealing's triumvirate of comedy masterpieces released in 1949 was the best of the bunch and widely viewed as one of the finest British films ever made, *Kind Hearts and Coronets*. In 1947 scriptwriter Michael Pertwee came across a forgotten

Edwardian novel in a second-hand bookshop entitled *Israel Rank* by Roy Horniman. It told the story, with full-blown 'Wildean' excess, of a half Jewish, half Italian anti-hero who murders six people who stand between him and a dukedom. Pertwee gave it to Balcon to read in the belief it would make a highly original comedy. Balcon expressed severe doubts, but told Pertwee to write a treatment. The result was enough to convince Balcon of the project's merits and Pertwee began work on a screenplay.

It was when Robert Hamer was installed as director that things began to unravel. For a reason that Pertwee was never able to find out, Hamer took an instant dislike to him. 'He hated me. He despised me as a writer, and detested me as a person. We only had to be in the same room and he would start to twitch.' It soon became apparent that the two men would not be able to work together and Pertwee quietly withdrew. Despite the fact that he had found the source material and worked on early drafts of the script, Pertwee would end up with no screen credit. The final screenplay is credited to Hamer and John Dighton. Hamer's hope for the film was, 'to escape the unshaded characterization which convention tends to enforce on scripts'.

Not long afterwards, Pertwee left Ealing to go freelance. He had written a thriller play called *Night was our Friend*, which Balcon had promised to buy the film rights to and get Margaret Lockwood to play the murderous lead. When news reached Pertwee that Lockwood had passed on it, he got very drunk at the Screenwriters' Club and poured out his woes to a gentleman he had previously never met. 'I finished with the line, "And now that bitch Maggie Lockwood has refused to do it!" He listened courteously, which is more than I would have done in his place, for he turned out to be Margaret Lockwood's husband.'

In the hands of Hamer and Dighton, the novel's psychopath, Israel Rank, changed into Louis Mazzini, a Clapham draper's assistant and distant heir to the D'Ascoyne dukedom, who decides to murder everyone standing between him and the family title in revenge for their cruel treatment of his mother.

The entire film is told in flashback from a prison cell, where Louis is waiting to be executed and is passing the time writing his memoirs. The result of Hamer and Dighton's labours was, in Balcon's words, 'Surely the first "black" comedy made in this country.' Indeed, writing in the influential *Sequence* magazine, Lindsay Anderson wrote of the film upon release: '*Kind Hearts and Coronets* is a very funny film and it gets away with a great deal. With so much, in fact, that its makers deserve salutation as pioneers in the little-explored territory of adult British cinema.'

In retrospect, the decision to ask Alec Guinness to play every member of the D'Ascoyne family can be seen as a masterstroke. And for that we have to thank Balcon himself. The producer was a keen admirer of the actor, having seen him many times in the West End and believed him to have great potential as a cinema actor. Following his film debut in 1946's *Great Expectations*, Guinness had been put under contract to Rank, going on to play Fagin in David Lean's *Olivier Twist* (1948), but the film was mired in controversy when Guinness's portrayal was accused of being anti-Semitic, particularly by pressure groups in America. When Balcon heard that Rank didn't have much in the pipeline for the actor, he requested his services for *Coronets*. Ealing's deal with Rank entitled them to occasionally draw on the larger company's pool of contract artists, and so this was simply arranged.

It was with some amusement that Balcon would later recall an encounter with a film executive at a social function at the

Dorchester hotel. '"Mick, do you really believe you can make a film star out of Alec Guinness?"

"Yes, I believe that in the right parts he has a quality comparable to Chaplin."

"Then you must be out of your bloody mind!"'

Guinness's performance in *Kind Hearts and Coronets* is exceptional and the success of the film did much to propel him to the forefront of film character actors. Playing eight different roles did come with a unique set of challenges, however, as he told one contemporary reporter. 'Quick transformation from one character to another has a disturbing effect. I had to ask myself from time to time: Which one am I now? I had fearful visions of looking like one of the characters and thinking and speaking like one of the others. It would have been quite disastrous to have faced the cameras in the make-up of the suffragette and spoken like the admiral.' Indeed, during production Guinness often visited the cutting rooms to remind himself, by listening to sound loops, of the different voices of the various characters he was playing.

Perhaps the most famous scene in the film is where six members of the D'Ascoyne family, all played by Guinness, are seen together in one shot seated side by side in a church. With optical work still quite primitive, cameraman Douglas Slocombe made the decision to do the effect in-camera. How he achieved this was to place the camera on a specially built platform so it would remain completely still. He then shot a sequence with Guinness as one character and then rewound the negative, masking off what he had already done, before carrying out the same operation with the next character. It took several days to complete, largely because Guinness had to be made up each time and was often busy

shooting with the main unit, so they would have to wait until he became available.

Above all, though, the camera had to remain rock steady. 'Nobody was allowed to touch it,' recalls Ken Westbury. 'I used to sit next to it all day making sure nobody knocked into it, while Dougie used to sleep in the studio overnight next to the thing. One slight movement on that camera would have ruined the whole effect.'

The only negative about Guinness's acting tour de force is that it totally overshadowed Dennis Price's superb playing of Louis Mazzini. Indeed, Price, at times, dons disguises to seek out his foe, at one point wearing ecclesiastical robes to play the Bishop of Matabeleland. Bizarrely, in 1957 Balcon received a letter of complaint from representatives of the 'real' Bishop of Matabeleland, who had recently been appointed. It read:

> We have to inform you that we have been instructed by the bishop … who is very aggrieved and indignant by the portrayal (in the film). Our client appreciates that there was no Bishop of Matabeleland when the film was produced, but considers it should not have been exhibited in its present form after his appointment in 1953. He has endured extreme embarrassment in southern Rhodesia.

The film ends on a wonderfully ironic note. Louis walks free from prison and is accosted by a reporter (a very young Arthur Lowe) who wants to know if he intends to write his memoirs.

Suddenly Louis is gripped by the thought that he's forgotten them and, as the credits roll, we see them resting on the desk in his cell. It's up to the audience to conclude whether he gets

away with it or not. In the American version, however, due to their tough censorship laws, most stringent of all being that crime must not be seen to pay, a specially shot sequence was inserted showing the damming papers being handed to the authorities. 'Censorship in those days was particularly tough,' says Peter Musgrave.

I did find though that the British censor was not only very strict, but also very learned, above where you'd expect your average audience to be. For example, in the film Dennis Price has had an affair with Joan Greenwood before she gets married to this oafish stockbroker. Nevertheless, Price has the cheek to turn up at the wedding reception. He walks in the room and there's a slightly double-edged look between him and Joan Greenwood. The camera then tracks down this long table loaded with wedding gifts stopping at a pair of antlers, and there's a close-up of a card saying they are from Mr Louis Mazzini, so he's given the newlyweds a pair of antlers. Now to me, everybody else in the cutting rooms and I'm sure to the public this is totally lost; what's the point of this. But it's actually an old Italian sign for a cuckold. So Louis has presented this to the couple, having cuckolded the guy before she's even married him, which in those days was utterly shocking. And the censor took the close-up out.

A streak of Puritanism ran right through the British censor at this time. Take this example from *Passport to Pimlico*. There was a shot of a sparrow resting on a loudspeaker that is constantly blasting out. The joke was that this little bird's tiny

act of rebellion against the bane of its life was to fly away and leave behind a little deposit. The censor wrote to the studio after watching this commanding, 'The small white mark on the loudspeaker is not acceptable.' It had to be removed.

With the release of *Kind Hearts and Coronets*, which *Time* magazine hailed as, 'One of the best films of the year', Ealing was operating at the peak of its powers. Its films, especially the comedies, had become renowned around the world. The *New York Times* described the studios as having 'a genius for civilized humour'. For Balcon, the secret behind the success of the Ealing comedy films was the fact that they took place against a realistic background audiences understood and could relate to and, he wrote: 'For the most part reflected the country's moods, social conditions and aspirations.' They were also seen by many as a reaction against post-war restrictions and government-enforced austerity. The British public had had enough of it and wanted to throw off the shackles of wartime restrictions and move to greener pastures. As Balcon said: 'The country was tired of regulations and regimentation, and there was a mild anarchy in the air. In a sense our comedies were a reflection of this mood, a safety valve for our more anti-social impulses.'

Though the Ealing film-makers were radical in their points of view, in no way did they want to tear down the institutions they so gleefully mocked in some their comedies. They were merely a mild revolution, populated by the odd stray eccentric, also daydreamers, mild anarchists, and little men who long to kick the boss up the backside. 'We had a great affection for British institutions,' said Balcon. 'The comedies were done with affection, and I don't think we would have thought of tearing down institutions unless we had a blueprint for what we wanted to put in their place.'

Chapter Twelve

A Very Male Preserve

Christopher Barry had been a script reader for a couple of years now, but it was well known around the studio that his ambitions lay on the production side. 'I tried pushing it all the time, but the Association of Cinematograph Technicians (ACT) was in my way.' This went on for quite some time according to Ken Westbury. 'Chris kept trying to get an ACT ticket so he could go onto the floor, but he kept getting rejected by the membership. Somebody took a dislike to him. I think they mistrusted him because he was friends with the management.'

This kind of blackballing happened back then, as the unions continued to wield a lot of power at the studio. Ken can still remember the shop steward for the National Association of Theatrical and Kine Employees (NATKE), known today as BECTU. 'He was a real scruffy old stagehand with a dirty old waistcoat with food stains down the front. I'm sure for the management it must have been terrible having to negotiate with this guy.'

Eventually Christopher's application was accepted. 'I became a second assistant on account of my (by then) great experience working with producers and directors as non union-grade "assistants to", and having had many opportunities of visiting

the stages and observing work in progress.' Christopher's first credit on an Ealing picture was *A Run for Your Money*, a film that is totally forgotten today due to having the misfortune of being the fourth comedy film released by the studio in 1949, and paling into insignificance in comparison with its illustrious predecessors. The slender plot revolved around two naive Welsh brothers, played by Donald Houston and Meredith Edwards, who win a competition to the bright lights of London to see an England v. Wales rugby game and get up to all sorts of high jinks. The wild and unruly Hugh Griffith appeared in a small role and Christopher remembers spending most of his time trying to entice him out of pubs and back onto the film set during location shooting. There was even room for Alec Guinness, wasted as a newspaper reporter following the brothers around town. 'I do recall Guinness, who didn't drive, having to be rope-towed by scene hands outside the Tower of London,' says Christopher. 'Fortunately for him, he was not yet then publicly well known!'

Ealing's other release in what was probably their most glorious year was *Train of Events*. Like *Dead of Night*, this was another portmanteau film handled by three directors: Charles Crichton, Basil Dearden and Sidney Cole. Starting with a train crash, we are introduced in flashback to a range of characters who, by the climax, may or may not end up as passengers on the doomed train. The cast was impressive, with Valerie Hobson, Jack Warner and John Clements headlining. There was also a small role for Peter Finch in his first British film.

Following *Eureka Stockade*, Harry Watt had become a firm champion of Finch and when he learnt the actor was in London brought him over to The Red Lion pub, where he introduced him to his fellow Ealing directors as his protégé. With a bit of

persuasion, Watt managed to get Finch a screen test at the studio. Dearden directed it and suggested the budding actor do his test with a scene from *Train of Events*, playing a Shakespearean actor who attempts to murder his wife. As soon as Balcon saw it, he was so impressed that he cast Finch in that same part in the film. Finch researched his role of a murderer by spending a day at Scotland Yard's infamous Black Museum.

Upon arriving at the studio for his first day's work, Finch was told, 'For God's sake, don't tell them in Australia what we're paying you.' Ealing had plans to continue making films in the country and didn't want to have to pay London film rates. 'You don't know the Aussies,' replied Finch. 'If I don't tell them, they'll imagine I'm getting twice as much as I am!' When the film opened, Finch was especially singled out. Film critic C. A. Lejeune in the *Observer* described him as, 'A young actor who adds good cheekbones to a quick intelligence and is likely to become a cult I fear.'

Train of Events was written by Angus MacPhail, the last screenplay he would ever produce for Ealing. An unsung hero of British film, beginning his career back in the days of silent movies when he supplied sub-titles, MacPhail had written or co-written credits on many of Ealing's films, certainly more than any other writer. He also provided script advice, often uncredited, on most of the scripts produced at the studio.

Tibby Clarke called his knowledge of film 'encyclopaedic'. A Cambridge man, Balcon had appointed MacPhail as scenario editor at Gaumont-British early in his career and issued the instruction that, 'No film shall be considered for production until it has his approval … from a story point of view'. MacPhail pretty much performed the same function at Ealing; script conferences were always carried out in his office, during which

he chain-smoked incessantly. 'But his influence was considerable', according to Michael Relph.

Michael Pertwee said of MacPhail that he 'possessed a penetrating ability to detect weaknesses in story line, a fund of ideas to replace them, and an unquenchable thirst for alcohol, which he never touched before six in the evening, but you could set your clock by him'. Stella Jonckheere, Ealing's literary editor during the 1940s, had one abiding memory of MacPhail from the war years wearing his Home Guard uniform, whisky bottles protruding from each pocket of his greatcoat, playing poker with his fellow fire-watchers on one of the sound stages.

Sadly, alcoholism was to force MacPhail into semi-retirement by the early 1950s. At the end of each day he would be driven home to his elegant Bayswater flat in a block that was dubbed 'Hangover Towers', since many of Ealing's film-makers lived there. After a meal cooked for him by a helper that he barely touched, MacPhail would drink solidly for two hours and fall into bed insensible. 'He was a true neurotic who could not face life outside his work,' said Relph. 'He ended up drinking himself to death alone in an Eastbourne hotel.'

With Rank now providing a healthy slice of the budgets for Ealing's films under their joint agreement, the enormous success of the 1949 trio of comedies was certainly encouraging. However, the recent appointment of John Davis, an accountant by trade, as managing director of Rank had caused strain in the previously cordial relationship. Balcon thought Davis unnecessarily frugal in outlook and had grown impatient by his constant asking of questions about 'minutia such as plywood and canteen costs'. Rank had also started to intervene more directly in production choices, much to Balcon's annoyance.

There was something else, too. Rank had begun making cinema sound equipment. Up until then the two main firms in this market place had both been American – Western Electric and RCA. Peter Musgrave, who worked in Ealing's sound department, confirms that the studio used RCA equipment.

> But when Ealing signed that deal with Rank, part of the deal was, if you want new equipment you have to buy it from one of our companies. I remember later when I was demobbed and I sauntered round the studio saying hello to old friends, they had bought some Rank sound equipment and somebody whispered to me, 'It's not as good as the RCA stuff', but they had to take it.

The year 1950 started well for Ealing with the release of one of its most popular films, *The Blue Lamp*. Based on an unproduced play by Ted Willis and Jan Read, with contributions from Tibby Clarke, who was able to draw upon his experiences as a wartime constable, this was an attempt to show the work of the London police as realistically as possible and in a pseudo-documentary style that would later heavily influence British crime television drama.

Director Basil Dearden received full cooperation from Scotland Yard and some senior officers appeared as themselves on screen. The Metropolitan Police Commissioner at the time, Sir Harold Scott, often visited Ealing to see rushes and to give advice on any technical inaccuracies so they could be corrected.

Jack Warner stars as PC George Dixon, your ordinary, honest copper, who within half an hour of the film is shot dead by a young thug played by Dirk Bogarde, on loan from Rank. Warner later admitted to some misgivings about taking on the

role; indeed colleagues warned him against doing it – it was rare in films for the star to die so early on – but instinct took over and Warner accepted. It was a fortuitous decision, because his character would be resurrected by the BBC and made into one of the most successful and long running of all British TV cop shows, *Dixon of Dock Green*.

Years earlier Warner had learnt a valuable lesson; that sometimes it is the small roles that linger longest in the memory.

In Ealing's *The Captive Heart* he had played a Cockney corporal POW. Early in the film he is seen carving a small boat out of a piece of wood. It's a bitterly cold winter and the stove in the hut is burning low due to lack of fuel. Everybody is looking at Warner and he knows it. Finally this boat he's worked on for weeks is finished, but he opens the door of the stove and throws it inside. Just then there's a cry from outside; the Red Cross parcels have arrived. His fellow prisoners rush out, leaving Warner all alone staring at his beloved boat crackling in the flames. Ten years later, Warner was a guest at a party thrown by Rank for some visiting Hollywood dignitaries. 'I hadn't met any of them previously but I noticed Richard Widmark staring intently at me from the other side of the room. He walked across, hand outstretched, and said, "You're the guy who burnt the boat, aren't you?"'

Again the film made extensive use of London locations, notably Paddington Green police station and a climactic chase shot during a greyhound derby at White City Stadium. None of the 30,000-strong crowd were notified that a film unit was shooting that evening and Bogarde had to run the gauntlet of what at times was a mob, some carrying razors. 'My clothes were torn to shreds,' the actor later claimed. In another scene, chased by Jimmy Hanley's policeman, Bogarde had to cross

over a live electric railway track. 'I can remember the faces of the train drivers coming out of the tunnel and seeing a man and a policeman in uniform, standing between the tracks. We never got any danger money in those days!'

The Blue Lamp was the most successful film of the year at the British box office (applicants to join the police force went up as a result), and it was also critically well received. Dilys Powell in her *Sunday Times* review commented: 'Its style seems to me at least as distinctive, and as well worth study, as the celebrated "documentary" style of Hollywood's *The Naked City*.' The day after the positive reviews appeared in newspapers, a delighted Bogarde phoned up his bosses over at Rank, who since signing him a few years ago had made him play a steady stream of bland film roles. 'Have you seen the notices?' The voice at the other end of the line agreed they were good but then dryly went on to say, 'Unfortunately we haven't any more mixed-up delinquent parts at the moment.' Even so, *The Blue Lamp* represented a huge step forward in Bogarde's career and growth as an actor. As a Rank contract player he'd always been told not to move a muscle in his face or make any grand gestures in front of a movie camera – 'Remember, this isn't the theatre!'

Basil Dearden, an early supporter of Bogarde's, told him that was all nonsense. 'Don't be so self conscious about not acting. I'll tell you when you're going too far.'

The Blue Lamp marked the return of Tony Rimmington to Ealing after two years of National Service. He was glad to be back in the art department and would stay for the remaining years of the studio and carry on in the film business until the ripe old age of seventy-seven. Ealing, he says, was very much a

part of the reason for that longevity. 'It was a terrific apprenticeship. Jack Shampan, the chief draughtsman, made me do stuff over and over again until it satisfied him, so he was a bit of a hard taskmaster, but he knew the business and he taught me a lot.' There was discipline, too, a certain code among the workers that had to be obeyed. 'You called everyone "sir" back then,' says Tony.

> I'll never forget Jim Morahan, who was my governor, three pictures before they closed the studio down he came up to me and said, 'Will you come into the office, Tony.' I go in there. He said, 'I'm not telling you this in front of the other people, but you can stop calling me sir from now on, my name's Jim.' I said, 'Thank you very much indeed, Jim – sir.'

Despite the discipline, Tony and the others were allowed a certain amount of freedom to have a bit of fun, although sometimes this could go a bit too far. One 5 November Tony let off a couple of bangers in the office, just for a giggle, and from then on was frisked for fireworks every bonfire night.

The one day everyone could really let their hair down was the annual Christmas party. 'It was traditional that the art department held a party at Christmas and invited everybody,' recalls Tony. 'We used to put money into a pot and just before Christmas went out and bought a load of beer and whisky, nibbles and food. All the separate departments would also hold its own party for their staff; the Plasterers' Shop, Stills, Editing, and then afterwards all roll up to the art department, which was always the biggest party.' In the end, though, the management called a halt to it all. 'They stopped them because

people were just getting too drunk,' recalls Joan Parcell. 'They were worried about them driving home.'

The next film to go on the floor at Ealing was *Dance Hall* (1950), directed by Charles Crichton, and Tony Rimmington remembers an unusual encounter with one of the film's stars.

> I was walking to get my wages one day and coming towards me was a beautiful looking blonde bird. Cor blimey, I thought, I think it's Diana Dors. I averted my eyes because I didn't want to ogle her and walked past. Suddenly she stopped and said, 'I say, you!' I turned round. 'Yes,' I said. She asked, 'Do you know who I am?' I said, 'Yes, I think you're Diana Dors.' 'Oh,' she said. 'I'm glad you recognised me, thank you,' and walked on. That was one of my first very short introductions to a star – funny people.

Diana Dors appeared in the film, along with an equally young Petula Clark, as one of four factory girls who leave behind their monotonous jobs to go dancing every Saturday night. Seen very much as an emerging sex bomb-type figure in British cinema, Diana was disappointed to be told she had to stuff cotton wool down her bra to prevent the imprint of her nipples through her tight sweater. The film was rather dismissed by the critics. The *Sunday Express* opined: 'Story is trite but atmosphere authentic. I could almost smell the cheap scent and perspiration.'

Dance Hall was written by Alexander Mackendrick and Diana Morgan, the only woman on Ealing's staff of writers; indeed one of the few female writers working in any British film studio at the time. Diana felt the studio was a tough place

to work at but very enjoyable. 'As the only woman writer I had to be very tough,' she later recalled. 'And I was. It was very much like the boys of St. Michael's. It was like a school.' She remembered one incident on that film. There was a scene where the actor Donald Houston has a row with his girlfriend and storms out of the dance hall and just stands there alone outside. Mackendrick and the other writers were all convinced that he was contemplating suicide. 'How do you know?' said Diana. 'Do you have a balloon coming out of his head saying – I'm contemplating suicide. Is there a special look on his face.' This went on all day between Mackendrick and Diana, Angus MacPhail, everybody. At a quarter to six Mackendrick looked at his watch and realised that the Red Lion pub was opening. 'The bitch is right,' he declared, and everyone went for a drink.

Next up was *Cage of Gold* (1950), a showcase for the charms of Jean Simmons, who plays a young bride who remarries again believing her husband to be dead, only for him to return with a dastardly plan to extort money. A big star at the time, Ken Westbury recalls that the actress celebrated her twenty-first birthday on the set. 'Stewart Granger had a thing about her in those days and as a birthday present he bought her a Bristol car, which in those days was a pretty pricey sports car.'

This routine melodrama was enlivened by some location shooting in Paris and the unit were given permission to shoot inside a busy bank. 'But the manager was having a job getting his customers inside so, in the end, we got thrown out,' relates Ken.

'There was Basil Dearden on the dolly being pushed out through the doors saying, "What's going on? You can't do this to me!"'

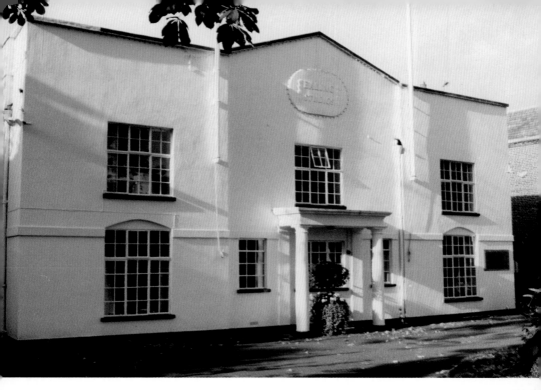

Top: Ealing was not your typical film studio, at first glimpse it looked like some fancy Regency manor house.

© *Olive Limpkin/ Associated Newspapers/REX*

Bottom: Michael Balcon's presence and influence dominated the entire fabric of the studio. 'He was like some kind of benign God,' said one worker.

© *Picture Post/Hulton Archive/Getty Images*

Top: One of Ealing's first successes was George Formby, but Balcon disliked him personally.

© *Everett Collection/REX*

Bottom: Will Hay made several popular comedies at Ealing before ill health forced him to retire from the cinema.

© *Hulton Archive/Getty Images*

Top: The canteen was the social hub of the studio with many workers meeting their future wives and husbands there.
© *Associated Newspapers/REX*

Bottom: One of Ealing's most politically aware films was *The Proud Valley* (1940), starring the celebrated American actor/singer and Communist sympathiser Paul Robeson.
© *Hulton Archive/Getty Images*

Top: The supernatural chiller *Dead of Night* (1945) is today best remembered for Michael Redgrave's haunting portrayal of a ventriloquist who believes his dummy is alive. © *Hulton Archive/ Getty Images*

Bottom: With its cast of children and filmed amidst the bombsites of post-war London, *Hue and Cry* (1947) was the first of the 'classic' Ealing comedies. © *Moviestore Collection/REX*

Top: Ealing was criticized for its lack of strong roles for women, but Googie Withers excelled as a barmaid out to kill her husband in *Pink String and Sealing Wax* (1945). © *Courtesy Everett Collection/REX*

Bottom: The screen embodiment of stiff upper lip Britishness, John Mills as *Scott of the Antarctic* (1948). © *REX*

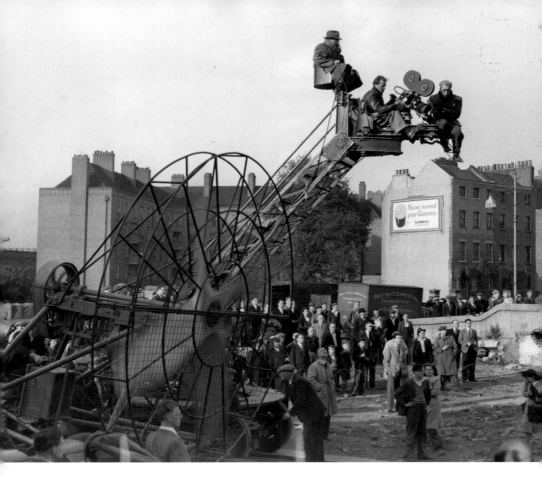

Top: Ealing became well known for using outdoor locations, following the example of the Italian neorealist movement. Ironically *Passport to Pimlico* (1949) was shot in Lambeth.
© *Richard Woodard/Ealing Studios/Getty Images*

Bottom: Whisky Galore! (1949) turned out to be one of Ealing's most famous films but came within a hairsbreadth of being an unmitigated disaster. © *REX*

Top: Alec Guinness' tour de force performance as the entire D'Ascoyne family in *Kind Hearts and Coronets* (1949) elevated him to the forefront of film actors.
© *Picture Post/Hulton Archive/Getty Images*

Bottom: The Blue Lamp (1950) was the most popular film of its year at British cinemas and made a star of Dirk Bogarde. © *Courtesy Everett Collection/REX*

Top: Director Charles Frend and producer Sidney Cole in the props department at Ealing. © *Picture Post/Hulton Archive/ Getty Images*

Bottom: Director Charles Crichton gives instructions to his young stars Petula Clark and Diana Dors in *Dance Hall* (1950). © *Picture Post/Hulton Archive/Getty Images*

Alfie Bass, Alec Guinness and Sid James star in *The Lavender Hill Mob* (1951), the inventive bank heist screenplay that won Ealing regular T.E.B Clarke a deserved Oscar. © *StudioCanal/REX*

Top: Appearing briefly at the start of *The Lavender Hill Mob* was unknown actress Audrey Hepburn. Ealing, however, failed to recognise her potential and two years later she won Hollywood fame in *Roman Holiday.*
© *Everett Collection/REX*

Bottom: Directors Leslie Norman, father of film critic Barry, and Harry Watt, who when angry on set would tear his shirt in half.
© *Picture Post/Hulton Archive/Getty Images*

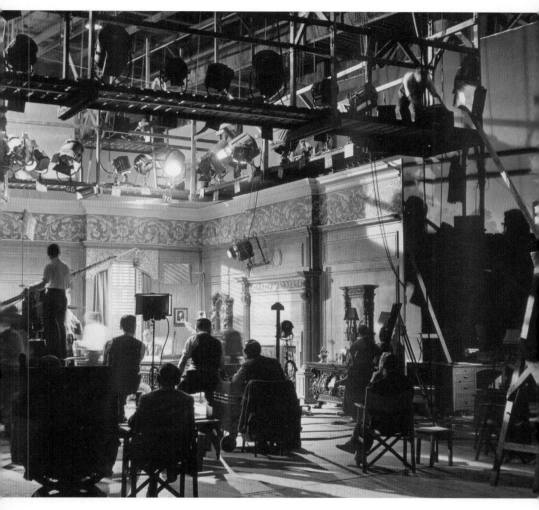

A fascinating glimpse behind the scenes showing an Ealing film crew at work.
© *Picture Post/Hulton Archive/Getty Images*

Top: Another Ealing classic, *The Man in the White Suit* (1951), satirized both boardroom idiocy and trade union intransigence. © *Moviestore Collection/REX*

Bottom: The courtroom drama *I Believe In You* (1952) gave early roles for Laurence Harvey and an 18-year-old Joan Collins. © *Moviestore/REX*

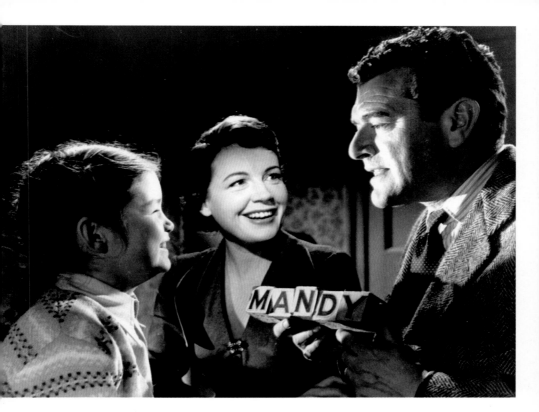

Top: The heart-rending drama *Mandy* (1952) featured a remarkable performance from seven-year-old Mandy Miller.

© *StudioCanal Films/REX*

Bottom: On location for *The Titfield Thunderbolt* (1953), Ealing's celebration of the bygone age of steam.

© *Daniel Farson/ Picture Post/Getty Images*

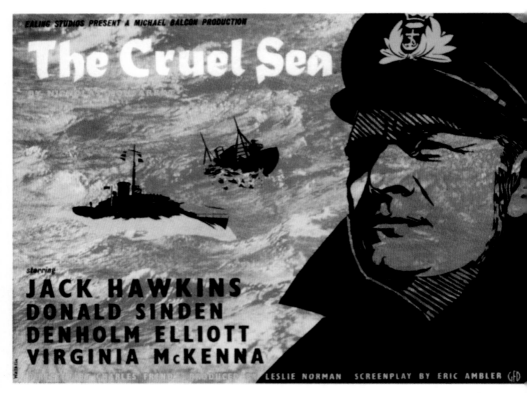

Top: Ealing turned Nicholas Monsarrat's bestseller *The Cruel Sea* (1953) into one of British cinema's greatest war pictures. © *Courtesy Everett Collection/REX*

Bottom: A consummate comedy cast for *The Ladykillers* (1955). Years later Peter Sellers and Herbet Lom would lock horns again in the Pink Panther movies. © *ullstein bild/Getty Images*

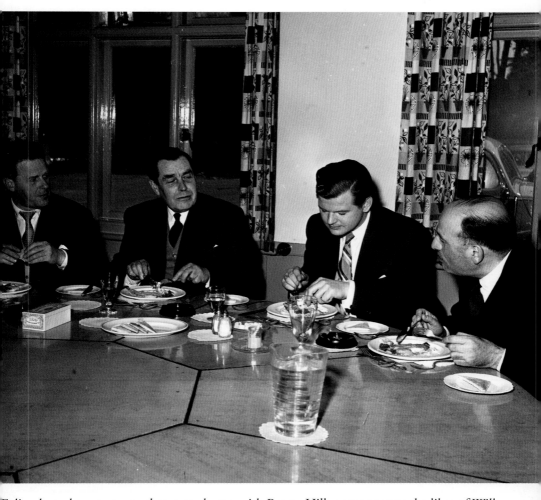

Ealing hoped to create another comedy star with Benny Hill, a successor to the likes of Will Hay, but *Who Done It?* (1956) flopped. Here Benny enjoys lunch at Ealing's executive dining room with Balcon and writer T.E.B Clarke. © *Popperfoto/Getty Images*

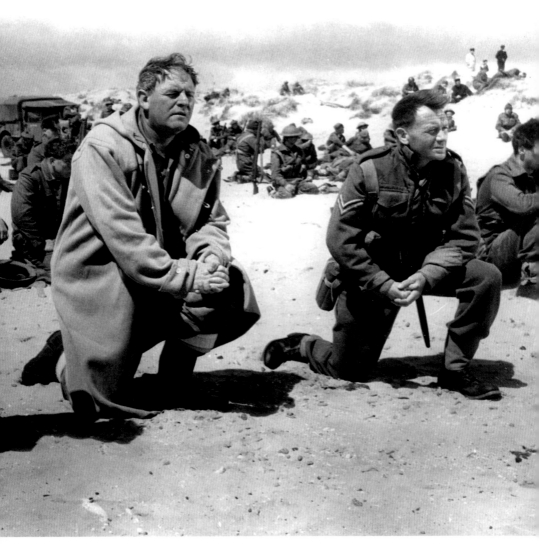

Bernard Lee and John Mills in *Dunkirk* (1958), Ealing's underrated war epic and one of the studio's final pictures. © *Moviestore Collection/REX*

Ken enjoyed working with Dearden, without doubt Ealing's most prolific and professional director.

> He was a lovely director. He always did his homework so was always on top of things, especially from a technical point of view. He was very good at doing long, complicated takes where the actors are moving around and the cameras are following them. If we were doing tests on actors for the next film he used to practise on those. And he knew exactly how he was going to edit a film. He was a real character, too, he used to stroll around the set like a peacock.

This was Maurice Selwyn's recollection of Dearden: 'He was very dapper. He was always dressed as if he was going to a ball.'

Dearden had something of an outsider status within the studio, not being a university man like so many of his colleagues. He was very much a self-taught man and had worked as a manager at several theatres owned by Basil Dean before joining Dean at Ealing when the theatrical impresario took over the studio. 'He always used to say to us that one of his jobs around Ealing when he first arrived was to make sure there was toilet paper in the lavatories,' recalls Ken Westbury. While not looked down upon by the other directors, there was a feeling that he was not quite 'one of them', a feeling reinforced by his non-participation in the lengthy drinking sessions over at The Red Lion, unlike his partner Michael Relph who was a regular member of the drinking fraternity. Douglas Slocombe once described Dearden as 'a loner'.

* * *

After the success of Ealing's 1949 comedies, the public were eagerly awaiting more of the same. In June 1951 they finally got it with the release of *The Lavender Hill Mob*. This now classic Ealing comedy outing had a strange beginning. Tibby Clarke had been contracted to write a drama called *Pool of London* (1951), which was to have the River Thames as its backdrop. The plot dealt with the theft of gold bullion from the Bank of England. After discussing the matter at length with the director, both were stumped as to how the villains could smuggle the bullion overseas without the authorities being alerted. At home that evening Clarke noticed an Eiffel Tower paper weight that a friend had brought back for him from Paris. A light went on inside his head, what a perfect ruse, remoulding the gold into innocent-looking miniature Eiffel Towers for the European black market. The only drawback was that the idea seemed more attuned to a comedy film than a semi-realistic drama. Just for fun, Clarke wrote out how the plot would work as a comedy and after a couple of hours he had a two-page story outline. The next morning Clarke bumped into Balcon getting out of his car.

'How's *Pool of London* going?' he asked.

'There's been quite an unexpected development,' Clarke answered.

'Come in and tell me about it.'

In the office Clarke explained what he'd been up to. Balcon wasn't best pleased. 'Why the hell haven't you been doing what I told you to do and get on with the *Pool of London* story? How dare you alter the whole studio programme.'

Clarke placed his story outline on the desk and requested that Balcon merely read it. 'No! Take it away.' Clarke left rather sheepishly, but his storyline remained behind.

Once his anger had subsided, Balcon took the sheets of paper and began to read. The idea was inspired and he immediately called Clarke back in. 'I've read that outline of yours,' Balcon began, as if their altercation of a few hours ago had never happened. 'I think we have a comedy there. Show it to Charlie Crichton, see what he thinks.'

'What about *Pool of London*?'

'Oh you'll be no good at that,' said Balcon. 'I've picked another writer.'

With *The Lavender Hill Mob* now a go project, Clarke began his research in earnest. He had the means of smuggling the gold abroad but no idea how to steal it in the first place. The logical answer lay with the experts and the Bank of England itself, so he decided to pay them a visit. Told to fill in a form stating the nature of his business, Clarke wrote: 'Information required on means of stealing gold bullion'. Forgetting to say that he wanted the information for a film, his enquiry caused, not understandably, a great deal of concern. After a lengthy wait, Clarke was shown to a rather grand office. 'This,' said an officious-looking man seated behind the desk holding his form, 'is the most extraordinary request I have ever had to deal with. Tell me, are you personally proposing to steal our bullion?'

When Clarke revealed the information was needed for a film, the relief on the man's face was palpable. 'We'll get the manager of the bullion department up here,' said the man, reaching for a telephone. 'He's better qualified than I am to advise you on this robbery.' In the end several heads of department were called into the office, forming something of a committee to work out the best way to rob its own vaults. All Clarke had to do was sit back and listen, making the odd note.

'The method used in the film is entirely the result of their willing cooperation,' Clarke revealed in a 1988 interview. 'I don't suppose security would allow anything like that today.'

During the course of his research Clarke also managed to gain access to a gold refinery on the Thames and was amazed to see gold bars being treated with casual indifference, as if they were tins of baked beans. Even so, upon leaving the premises his boots were washed down in case they had any gold dust on them.

Still, Clarke had great trouble with the script, which had to be written and rewritten several times before it satisfied all concerned. In the end it would win him an Academy Award. The basic plot has a timid bank clerk, another plum role for Alec Guinness, teaming up with an enterprising maker of souvenirs (Stanley Holloway) to pull off the perfect robbery. At one stage Clarke was going to ignore these two characters once the robbery has been committed and instead follow what happened to each gold Eiffel Tower, thus incorporating a whole host of new characters. Quite rightly, associate producer Michael Truman said this would be disastrous and to keep the focus of the story on Guinness and Holloway.

For a long time Clarke couldn't come up with a suitable ending, either, until he remembered an incident that occurred during his days as a reserve policeman in the war, when one night his superintendent's car was stolen from outside the police station. This incident leads to the frenetic car chase that concludes the film. Ronnie Taylor was on the second unit and worked on this famous sequence. 'We filmed all round the back of Shepherd's Bush and Notting Hill, a lot of the car stuff was shot round there. We had to get permission and cooperation from the police because we had to close a lot of roads.'

Another classic scene is one in which Holloway and Guinness have to escape from the top of the Eiffel Tower. During rehearsals Crichton called over to Guinness, 'Alec, there is a trap door over there – where it says "Workmen Only" – I'd like you to run to it, open it and start running down the spiral staircase. Stanley will follow.' Guinness obeyed and later wrote about what happened next.

> A very dizzying sight to the ground greeted me. But I completed half a spiral before I noticed that three feet in front of me the steps suddenly ceased – broken off. I sat down promptly where I was and cautiously started to shift myself back to the top, warning Stanley to get out of the way. 'What the hell are you doing?' the director yelled. 'Down! Further down!' 'Further down is eternity,' I called back. No one had checked up on the staircase and no one apologised; that wasn't Ealing policy.

Instead it was decided to replicate the characters' rapid descent down the tower back at the studio. This represented something of a challenge for the art department. In the end a section of the tower's spiral staircase was built at the studio, which went up to about twenty-five feet, with a vertical axel going through the middle of it, behind which part of the Eiffel Tower structure was replicated in timber painted black. On action, the crew revolved the axel and all Holloway and Guinness had to do was run up and down, literally on the spot, to create the illusion of movement, thanks to back projection. For many of the technical boffins and craftsmen working at Ealing, this was one of the joys of working at such a place, responding to a problem and coming up with a viable solution to make it work. 'We all

saw it as a challenge,' says Tony Rimmington. 'And when you saw it working you got terrific satisfaction; well, we've beaten that one, I wonder what they'll come up with next?'

A big financial success, *The Lavender Hill Mob* won the Best British Film at that year's BAFTAs and was highly praised by critics. In the *Observer*, C. A. Lejeune wrote: 'An outrageous comedy, but the observations of detail and character are so true, the sense of a familiar place so sharp, that few will resent the gusto with which the outrage is perpetrated.' Guinness put much of the success of the film down to Crichton's astute direction: 'He had a feeling for the idea of getting away from drab reality into a world of fantasy.'

Again, the supporting cast are wonderfully chosen, with Alfie Bass and Sid James as a pair of Cockney spivs hired to be part of the gang. James had made sporadic appearances in British films and did one day's work on *It Always Rains on Sunday*, but *The Lavender Hill Mob* represented his first big breakthrough. Crichton cast him after seeing his distinctive face in a B picture at his local cinema. Two years later, a pair of TV scriptwriters called Galton and Simpson were looking for an actor to play Tony Hancock's pal in a BBC radio series. They knew the actor they wanted, could see his face in their mind's eye, but for the life of them couldn't come up with the name. They remembered seeing him in *The Lavender Hill Mob* and so began a search to see if it was playing anywhere. They tracked it down to a cinema in Putney showing it on a re-release. 'We had to sit through the entire film until the credits came up,' recalled Ray Galton.

The film also boasted early appearances by two actors who were to go on to win international fame. Guinness had recently starred on the London stage in a poorly received production of

Hamlet, featuring a young actor he considered his protégé. His name was Robert Shaw and Guinness arranged for him to appear in *The Lavender Hill Mob* in a small, uncredited role as a police chemist. It really is a blink-and-you'll-miss-it appearance, but nevertheless it marked Shaw's film debut.

There was also a small role for a twenty-one-year-old actress who had only recently begun in films – Audrey Hepburn. Alas, no one at Ealing noticed anything special about her. Balcon later admitted that she 'struck nobody as star material'. Actually that's not strictly true. During their short scene together, Guinness did recognise something. Yes she might only have had one line, in the film's Latin-set opening sequence, which she didn't say in any particularly impressive way, 'but her faun-like beauty and presence were remarkable'. After the scene was shot, Guinness got on the telephone to his agent. 'I don't know if she can act, but a real film star has just wafted on to the set. Someone should get her under contract before we lose her to the Americans.'

Nobody did. In fact actresses on the whole were pretty shabbily treated at Ealing and there was a conspicuous lack of really solid parts for women in many of their films. The critic Kenneth Tynan categorised Ealing's output as, 'men at work, men engrossed in a crisis, men who communicate with their women mostly by post-card.' This was a little bit unfair, but Ealing did seem to shy away from films that dealt with female issues or sexual politics. Diana Morgan felt that her fellow scriptwriters just didn't want anything to do with such matters. 'The boys were so terrified of any trace of sentimentality that if you wrote a love scene with any feeling in it you had it thrown back at you and they said – nauseating!' As Bryan Forbes joked: 'Sex was buried with full military honours at Ealing.'

And the reason for that was very simple. Balcon was an extremely moral person and a little parochial, and this heavily coloured the kinds of film subjects he undertook. Certainly it can be seen as one of his failings that he distrusted any approach in story values to what might be called sexual themes and when that kind of material came up, he was very inclined to soft pedal and play it down in a rather genteel attitude. 'And that morality applied to not just the sexual side of life but to all aspects of life,' says David Peers. 'He was quite clearly the boss and you had to submit clear-cut ideas for the films that were made under him.'

It was the same behind the camera, where men dominated the top positions. Ealing's sole female contract scriptwriter was Diana Morgan, and while she enjoyed working there admitted it was 'a very male studio'. Her rather unsavoury nickname among her male colleagues was 'the Welsh bitch'. When Kay Mander, a blazing presence in the British documentary movement, who had won a British film award for her 1948 French-language film *La Famille Martin*, approached Balcon for work, he turned her down flat saying a woman director would not be able to control a male film crew. This was an attitude that pervaded the whole industry at this time, not just Ealing.

Back at the studios and working on *The Lavender Hill Mob* was Maurice Selwyn, who had left the studio in 1947, when he and his twin brother Lionel were called up for National Service. The army were keen to keep the twins together, but they separated out of choice when each had the opportunity of joining different units doing photographic work. At the end of his army service, Maurice returned to Ealing to ask for his old job back but there

was nothing for him. 'When I left Ealing to do my National Service there were four camera crews. When I came back there were only two, with an occasional third. I was devastated.' Instead, Maurice decided to go freelance and, as it happened, worked a couple of times at Ealing, notably on *The Lavender Hill Mob*. It was a memorable shoot. 'We stayed in Paris for three weeks, and it was a wonderful experience. I remember shooting Stanley Holloway and Alec Guinness on the steps of the Eiffel Tower. The unit hired the Eiffel Tower for two or three hours a day; a figure that has always stayed in my mind is £30 for each session, which at the time was a lot of money.'

When film work began to dry up towards the end of 1951, Maurice reluctantly left the business. He had married and, in an attempt to seek a more stable income, became a store manager for Marks & Spencer, working in a vastly different atmosphere.

On a personal basis, Ealing Studios was very relaxed. I never addressed the directors by their first name, but cameramen and camera operators would always be on first-name terms. And appearance-wise, too, nobody cared what you looked like; all they cared about was how you did your job. So going from there to the discipline of Marks & Spencer was quite a culture shock, suddenly wearing a suit, with a white shirt and stiff collars. I've always been grateful for the fact that my first five years of working life was in a job which I absolutely loved. It got under my skin and it stayed under my skin ever since.

While Maurice's brother Lionel remained in the film industry as a sound editor, Maurice never went back to the business. But his memories of those times remain strong.

There was a phrase that used to be bandied about to describe some of Ealing's personnel, 'Michael Balcon's young gentlemen'. And I was asked once, are you one of Michael Balcon's young gentlemen? And I probably replied, well I'd like to be, but I'm a nobody. Because I was never anybody that was terribly important in the studio, but I like to think that I was recognised as someone who was enthusiastic, and energetic and reliable.

In the 1990s, Maurice and his wife were invited to a private tour of Ealing Studios. As they came upon one particular corridor that Maurice instantly recognised, he looked up at the door fitting which was exactly the same; it hadn't been replaced after all these years.

I said to the young woman who was taking us round, this door will open better if you push the handle down but give it a slight push before you pull it open, and sure enough that's what she had to do. There is a unique smell about a film studio, certainly that was true of Ealing, which is I think a mixture of plaster and paint, and on the odd occasion I've been back to Ealing, walking past the stages there is that same wonderful smell that takes me back instantly to the good old days.

Chapter Thirteen

Union Trouble

For sheer endurance and perseverance, Rex Hipple's own personal journey to Ealing is unlike anyone else's. As a local lad he would pass the studio every morning on his way to school and often dreamt of one day working there.

> It was a wonderful thing to just gaze down that road and watch all the activity going on. I remember one day there was a huge 60-foot-long low trailer going in. How it got round that corner I will never know because Ealing had a very small front entrance. Only recently I was sent a DVD copy of *The Big Blockade* with Will Hay, and I couldn't believe it when I saw this bloody great Hampden bomber. At last, I thought, I've found out what it was that was being delivered to the studio all those years before.

Rex left school at fourteen in 1942 and tried several times to get a job with the studio, but couldn't even get past the front gate. 'The commissionaire, Robin Adair, I got stopped by him all the time, I couldn't get past him.' Unlike others mentioned in this book, whose father happened to belong to the same gentleman's club as Mick Balcon, or happened to be on friendly

terms with such and such who could put a good word in for them, Rex was a nobody really, just an ambitious working-class kid anxious to get on.

> But I had no introduction, I had no one to talk to. If I could have gone in as a post boy, because several of the chaps I met in there started as post boys, that would have been all right. I was trying to go in as something, anything, but I couldn't get past the gate and I couldn't get past the unions. They were very tough at that time.

Coming to the realisation that Ealing was perhaps beyond his reach, Rex looked elsewhere and got a job at the Q theatre in Richmond, just as a general help, not knowing the first thing about theatres. A year later he became assistant stage manager at the Theatre Royal in Brighton, before going on to work at the London Coliseum. Still determined to work in films, Rex decided the best thing to do was to try and find employment as a cinema projectionist, 'because it was the nearest thing to movies you could get and it was a wonderful place to watch films and get an insight into how they were made'.

After working for both the Gaumont and Odeon chains, in some of those huge old picture palaces that could seat 1,500 people and had their own restaurants, Rex heard there was an opening for a projectionist at Denham Studio's preview theatre. He ended up staying there for two years, progressing to working on the scoring stage with people such as the acclaimed conductor and composer Muir Matheson. Out of the blue one day, as his term of employment was coming to an end, Rex was asked if he fancied doing a fortnight's holiday relief over at – would you believe it – Ealing. 'So I finished at Denham on the

Friday and on the Monday morning I was over at Ealing running music rushes. So that was wonderful, I was finally at Ealing, even though it was only a fortnight's holiday relief, which incidentally turned into six years. I just stayed there.' It was a case of once you were in, you were in, as he'd secured his union ticket already while at Denham.

For the majority of his time at Ealing Rex worked at re-recording and sound effects, anything that could be done live, like footsteps, falls, etc. 'I did all the screams in *The Cruel Sea* for the sailors on the *Compass Rose*,' he reveals. 'I did it live and then the dubbing editor took it away and just cut it into the print where Jack Hawkins slams the voice pipe down when he hears the screams of the sailors in the water.' Again on *The Cruel Sea* the boss of the sound department, Gordon Stone, collected about twenty of Ealing's staff, many of whom had been in the army, to march up and down outside so it could be recorded for a scene in the film of a company on parade. 'Well,' recalls Rex. 'We were marching down this road between the stages when one of the crowd artists came out and started complaining that this was their job, they should be doing that, and Stone replied bluntly, "None of you can march, these guys are all ex forces. Buzz off!"'

These crowd artists could get quite militant at times. During the filming of *The Captive Heart*, there was a scene of the POWs staging a bonfire to celebrate the end of the war. This was done in the studio with a real fire provided by the effects people. Among the extras were a few genuine soldiers and airmen. Actor Jack Warner was standing next to an ex-pilot and they were chatting away when there was a disturbance. A bunch of the crowd artists were holding a meeting and after a couple of minutes they all walked out en masse. Warner went

to find out what was wrong and came back to tell the pilot that the crowd artists were asking for danger money because of the fire. It was then that Warner noticed the medal ribbons the pilot was wearing. 'He shook hands with me, turned around and walked straight out of the place. Who could blame him? He had seen more danger than the others were likely to see during the whole of their lives.'

Rex found there to be a great atmosphere at Ealing, and got on well with many of the people who worked there, most of whom were genial and easy going sorts. 'I saw Michael Balcon every day. He was a charming man who seemed to be approachable, not for me, but for those who needed to I think his office door was always open. And there were people like Seth Holt, a lovely man, very unassuming, no airs or graces. They were just very nice people and you worked in a lovely environment on what I think generally were very good products. Ealing was a special place. For me personally, nine years of queuing up to get there and when I did get there it was exactly what I'd hoped it was, a joy. So for me it was the end of the rainbow.'

Following the haphazard *Whisky Galore* shoot, Alexander Mackendrick believed he'd blown his chances of ever getting another directing job. At the studio's weekly round table meetings Balcon would turn to everyone getting opinions until he got to Mackendrick, then his face would slightly drop, 'And Sandy ... er, ye-e-es ... Ah, what were we talking about, everyone?', and carry on the discussion. When *Whisky Galore* was put into post-production and Balcon pondered on what its fate was to be, Mackendrick was demoted to second unit work. This turned out to be a blessing in disguise, because it was now that he really began to learn his craft, working for other directors

without the burden of responsibility. Then when *Whisky Galore* became an unexpected hit, his confidence returned and preparations began for his next film.

The result arrived in cinemas barely two months after *The Lavender Hill Mob* and was another classic Ealing comedy. *The Man in the White Suit* (1951) manages to satirise both boardroom idiocy and trade union intransigence in its tale of hapless scientist Sidney Stratton (a brilliant Guinness again) whose invention of an indestructible fibre has the result of putting millions of textile workers' jobs at risk. It was based on a play by Mackendrick's cousin Roger MacDougall and adapted by John Dighton of *Kind Hearts and Coronets* fame and Mackendrick himself.

As usual, the script was sent for approval to the British and American censors. In this instance, the American censor proved itself to be unduly prudish in their attitude, as demonstrated in these written observations sent to Balcon: 'We direct your particular attention to the need for the greatest possible care in the selection and photographing of the costumes and dresses for your women.' It continued: 'The production code makes it mandatory that the intimate parts of the body – specifically the breasts of women – be fully covered at all times. Any compromise with this regulation will compel us to withhold approval of your picture.' They even baulked at the image of 'a stout man' on his way to the toilet. 'We ask that the unbuttoning of his waistcoat be eliminated.' The words 'damn' and 'bastard' were also frowned upon. As was the scene in which Sidney's flame, Daphne (Joan Greenwood), is more or less asked by the textile industrialists to prostitute herself to prevent him from marketing his product. Balcon must have used all his persuasive skills here because the scene was ultimately allowed to remain intact in the film.

Mackendrick was of the opinion that slapstick of the kind he was attempting in *The Man in the White Suit* was frequently unsuccessful, either failing to work out as intended or taking too much time to shoot, because the effects, props and physical action were not fully prepared and rehearsed in advance. To this end he approached the physical comedy elements of the film with the utmost meticulousness. Ronnie Taylor, who worked on the camera unit, was particularly impressed by Mackendrick's professionalism. However, Ronnie did observe how sometimes his approach to film-making did ruffle a few feathers.

> When Sandy was given the film to make he came out with some fairly outrageous ideas and he was a bit snubbed by the establishment of the old Ealing gang of directors. Here was this new boy on the block, coming up with new ideas and he was slightly put to one side and people ignored him slightly and said he's a bit barmy because he'd got these radical ideas. There was a feeling that he was a mad young director. But I and many others like me thought he was fairly advanced in his thinking.

One wonders if there wasn't an element of mischief-making with some of the characters in the film. It has been suggested that Guinness's scientist is really Mackendrick himself, the free-thinking auteur whose vision is held back by the staid conservatism of Balcon and the Ealing old guard. Birnley, the paternalistic mill owner, is said to be based on Balcon. Indeed, on set Mackendrick reportedly guided the actor playing the role of Cecil Parker to 'model yourself on Mick'. There was also talk that Mackendrick based Frank, the shop steward, on Sidney Cole.

184

According to Rex Hipple, Mackendrick also liked to populate his films with members of Ealing's own staff in small background character parts. One of the more colourful members of staff used by Mackendrick in *The Man in the White Suit* was the studio nurse, Sister Ross. 'She was an ex-Eighth Army nurse,' recalls Rex.

My God you didn't waste her time. You weren't a malingerer around her. She was very tough. She always wore her Eighth Army cape over her ordinary nurse's uniform, and she would come into the canteen at lunchtime and the first thing she'd do is go round and open all the windows to get some fresh air in because it was always a bit fuggy.

One of the real headaches that faced the film-makers was the film's final scene where Sidney's suit disintegrates as he's running away from an angry mob. Anthony Mendleson, Ealing's costume designer, tried everything to make the effect work – cotton wool, pouring acid on the material – with absolutely no success. At the point of giving up, someone in the art department came across a huge roll of corrugated, compressed tissue paper, the kind you have on the top of chocolate boxes. It was ideal, and several suits were made out of the material and each came away into pieces perfectly. 'It saved my life,' Mendleson later confessed. 'But what on earth was it there for in the first place?' Apparently it turned out that this huge roll of compressed tissue paper had been left in the studio stores for years by some war department. It was what they had made sanitary towels out of for the Wrens.

Once again the critics were full of praise for Ealing's latest product: 'More ambitious than some recent Ealing comedies,'

opined the *Monthly Film Bulletin*. 'It will certainly remain one of the liveliest and most interesting experiments in British films this year.' And Richard Mallett in *Punch* thought: 'The combination of an ingenious idea, a bright, funny and imaginative script, skilful playing and perceptive brisk direction has resulted once more in a really satisfying Ealing comedy.'

Christopher Barry also worked on the film, as assistant to associate producer Sidney Cole, chiefly setting up location visits to cotton and fabric factories, as well as other location scouting in and around Lancashire. 'Sid Cole was a likeable-enough chap and very approachable but he and I did not get on too well on a train journey up to Lancashire during which he tried to persuade me to join the Communist party.'

Christopher's memories of Mackendrick are altogether more pleasant, especially his friendliness and approachability and, of course, his creativity and the intensity of his work.

These were feelings very much shared by Alec Guinness, as both men had the same devotion to painstaking detail. It was the kind of professionalism that Guinness felt was lacking in other areas of Ealing, especially in their treatment of actors. Although he referred to the studio as having 'a cosy atmosphere', Guinness always felt that Ealing was the domain of directors, writers and producers, and that the actor came very low on the list of importance. On several occasions Guinness almost died on the set of an Ealing film due to what he believed to be lack of concern for the wellbeing of the artist. We have already heard of the time he nearly fell from the Eiffel Tower, but there are two other prime examples; both took place on *Kind Hearts and Coronets*. First is the famous balloon sequence where he was playing Lady Agatha D'Ascoyne. At first Guinness was quite excited by the prospect of going up in a balloon, but

wasn't entirely convinced by the safety of the exercise and went to speak to the producers to see if he was properly insured. 'You're well covered,' they said. The sum was £10,000, not nearly enough, Guinness thought, should the unthinkable happen and his wife and son needed to be looked after.

Guinness informed the producers that he wouldn't go up more than fifteen feet in the air unless they raised the insurance to £50,000. It was at this point they got a bit huffy and said, 'You will have Belgium's greatest balloonist concealed in the basket with you so you can't possibly come to any harm.' Guinness couldn't care less, and when it came time to do the shot he insisted on being let down once the balloon had ascended a mere few feet. 'Contempt was written on all faces,' Guinness later confessed.

And so Belgium's greatest balloonist had to get into Guinness's costume and take his place as Lady Agatha. The cameras rolled, and all looked to be going well until a fierce gust of wind whipped the balloon away at great speed and completely out of sight. 'The poor man was found some fifty miles away,' recalled Guinness, 'floundering in a long skirt in the Thames estuary, where he had been forced to ditch.'

The second incident was, if anything, even more calamitous. In the scene where Admiral Lord Horatio D'Ascoyne goes down with his ship, nobly saluting until he is engulfed by water, Guinness had to have his feet attached by wire to the base of the tank in order for the effect to work. Robert Hamer thought it would be a nice touch to keep the camera lingering long enough to see the Admiral's cap float away. Asked if he could hold his breath for thirty seconds, Guinness boasted that as a keen practitioner of yoga he could hold his breath for something like four minutes. Suitably impressed, Hamer left

to set up the shot. When it was completed, the crew began to pack up the equipment, when someone suddenly remembered Guinness was still under the water. Four minutes had almost passed before he was released using wire-cutters. It's hard to believe this actually happened, so breathtaking is the negligence involved, but it was a tale Guinness often told.

Again, on *The Man in the White Suit* Guinness came close to serious injury. The scene called for him to be suspended on a wire. When he raised concerns about the stunt – that he thought the wire inadequate to carry a man's weight and that it might snap – the technicians laughed and told him to mind his own business. It will come as no surprise that the wire did snap and Guinness fell to the studio floor with a resounding thud. 'All they said was, looking a bit surprised, "It shouldn't have happened." But they didn't say sorry. That was the way it was.'

Returning to Ealing for *Man in the White Suit* was David Peers, who since *Passport to Pimlico* had gone freelance and worked on several pictures shooting in such far-flung locations as Egypt and South Africa. 'It was a great life for a single chap with no commitments, and enabled me to continue travelling round the world at somebody else's expense.' Closer to home he worked on the second unit for David Lean's *The Sound Barrier* (1952), shooting the aerial sequences. On *Man in the White Suit*, David was promoted from second to first assistant director, a job that entailed a great deal more responsibility.

The first assistant director was a mixture of organiser, enabler, communicator, trouble-shooter and pourer of oil. It worked better if his relationship with the director

was close and sympathetic. I have worked with directors where there was very little empathy between us and I therefore did a bad job. But when there was a meeting of minds and a rapport, one could often second-guess the director's intentions, anticipate his moves and guide the unit along smoothly.

Like many who worked with Mackendrick, David came away from the experience impressed. On his very first day on the film, and not knowing anything at all about the man, David walked onto the studio floor and saw a blackboard on an easel with a flipchart. He lifted it up and there was a drawing by Mackendrick of what he was going to shoot that morning.

As the first AD I had a number of questions to ask Sandy, but the answers were all in the drawing. He came from the world of advertising where they draw almost every frame of a proposed film for themselves, and for the client who might want to see what was going to happen. Sandy just transferred this from the advertising world to the film world. He did it every morning and, after a while, everybody would go and look at the flipchart and it was a wonderful help to all of us.

A few weeks after Mackendrick finished *Man in the White Suit*, Betty Collins came to work for him as his secretary. Betty had left school a little over six months before, not quite yet sixteen years old, and had gone to work in a fashion bureau in Bond Street. While there, she saw an ad for a job in a film distributor's in Wardour Street. 'I got that job and it was the most miserable job I've ever had in my life. The man I worked for was a real

bully, and everything I did was wrong or I had to do again.'

Feeling miserable, one day Betty took a stroll in Walpole Park, which backed onto Ealing Studios, and through a wire mesh fence could see a hive of activity. 'It was a very hot day and they had the stage doors open and you could see inside everybody was moving stuff around and pottering about and I thought, I'd like to work there.'

Emboldened, Betty wrote to Ealing asking if they had any jobs. After a few weeks she got a reply, asking if she'd like to come in for an interview. 'And the next thing I knew, I was working for Sandy as a secretary, I think they call them PAs now.' The very first assignment Betty remembers him giving her was to hunt down a particular book. 'He gave me a small newspaper cutting, it must have been about an inch wide by about an inch long, and half the book title was missing. Then I had to go and find what the book was, where it was and where he'd seen it and then get it. So my first job was a little bit of detective work.'

Betty liked Mackendrick enormously, even though he was a little difficult to get to know, a bit withdrawn, 'but very nice and very pleasant. I'm sure he had a temper but I never saw it'. And while he couldn't be described as a taskmaster, he could be quite vague. 'You'd have to be a bit of a mind-reader at times.'

One thing that Betty liked was how well prepared Mackendrick was before he shot a picture. Not only would he have his flipchart on the set, as David Peers has described, but his own personal copy of the script would have the dialogue on one page all typed up and then there would be little drawings on the left-hand side illustrating every scene he was working on. 'And he did them all himself. They were like a doodle to him but they were lovely little visuals.'

When she first started at Ealing Betty did feel a little intimidated arriving at such a prestigious and well-known studio, but was quickly made to feel at ease. 'It was very friendly, and it did have a family feel to it, you knew everybody who worked there because it was all mainly permanent staff, there was nobody you didn't know.' Her office was situated alongside one of the big stages, upstairs on the first floor, which housed all the directors and their secretaries. In the first office were Leslie Norman and Harry Watt, then it was Betty, Sandy and Seth Holt, who Betty recalls with great fondness. 'He was lovely, a nice man and great fun, we had lots of laughs. He had a great sense of humour and was very laid back.' Next door to them was the office of Basil Dearden and Michael Relph. It was very compact and close-knit with everyone always popping in and out of each other's offices. 'You did move around quite freely,' says Betty. 'And you were quite welcome to go in and say hello and have a chat, because you knew them well enough to do that, to have a little gossip.'

Working mostly in the office, Betty recalls only ever going out on location with Mackendrick the one time and that was for *The Maggie* (1954) in Scotland. 'They'd already started shooting, but the script wasn't finished so I went up there to help tighten it up.' That meant long nights sat at the typewriter as Mackendrick dictated. Being on location for *The Maggie* is one of the clearest memories Betty has of her days at Ealing, especially the time one of the film's stars, James Copeland, took her out night fishing.

Betty would also be required sometimes on the stage when Mackendrick was making a film. Sat in the office one afternoon, Mackendrick called through asking for Betty to come down onto the set and bring a typewriter with her because he wanted

to do some work. 'So I'm busily going down carrying my typewriter, when suddenly I had the union men coming up to me, "Put that down! You're not allowed to carry that. It's not your job." My God, you'd think I'd stolen the crown jewels.'

Nor was this Betty's only run in with the unions.

> The studio used to close down every year for two weeks and everyone would go on holiday. I think it was either Leslie Norman or Harry Watt who came to me, they were trying to get some script in shape, to ask if I would do a couple of days' typing for them in the holidays because I wasn't going away anywhere. I said, 'That's fine, I'll do it.' Anyway, when everybody got back I was called into the personnel manager's office, Bill Beck his name was, and he'd got the union man there, who was a great big fat man, a bit of a bully, and he was rather dirty, I'm afraid, and smelt dreadful. And he was raging about me, saying they should sack me because I ran with the management, for doing these couple of days' typing. Bill Beck was trying to calm him down. Anyway, it didn't come to anything. That's how it was.

There were three unions operating at Ealing. 'There was ETU, which was the electricians' union,' recalls Norman Dorme. 'There was NATKE, and then there was ACT, which was us, the art department, also the camera department, production department, all those. When you arrived at Ealing you were made to join one of the unions; you had to join if you wanted to work there. You weren't given an option, really, they just said, join the union, and that's it. This was resented, slightly, as you never felt that the union was there because you wanted it

and it was there to protect you, you felt it was there just to be a bloody nuisance.'

Directors tended not to rock the boat when it came to the unions; all they were interested in was getting their pictures done, they certainly weren't interested in getting into anything as vulgar as politics. 'I remember fairly frequent ACT meetings in lunch hours,' says Christopher Barry. 'But I think that as long as the agreed working hours were stuck to and overtime was strictly controlled, life seemed pretty peaceful. Although I do recall one incident that happened on a film when a piece of a lamp fell off one of the gantries down onto the set. I instinctively called out 'Watch it!' and almost caused a strike, having the temerity to talk like this to an ETU member. There were also several left-wing people among the work force, notably communists Sid Cole and Ivor Montagu.' Robert Winter recalls a lot of people in the studio distributing copies of the *Daily Worker* newspaper. 'It was handed around in the cutting rooms. I didn't know what it was all about. It was in sympathy with Russia, I suppose.'

Chapter Fourteen

Drinks At The Red Lion

Some people's lives are already mapped out before them, their career path chosen ahead of time. Certainly Michael Birkett always believed he was destined for the diplomatic service, a situation encouraged by his father Norman Birkett, one of the three British judges who presided over the Nuremberg trials. While studying at Cambridge, Michael became an avid cinemagoer. 'I was seeing seven films a week and I was hooked, so I said to my father, I'm awfully sorry but I'm not going to follow you into law. I want a career in movies.'

By a stroke of good fortune Michael just happened to be at Cambridge with Balcon's son, Jonathan. As chairman of the university's film society, Michael managed to persuade Jonathan to get his father to come down and give a talk to its members. At the end of the lecture Balcon opened the floor up to questions. Michael raised his hand. He wanted to know how one got around the tricky task of acquiring a union card. Back then a catch-22 situation operated in that you couldn't get a union card unless you were working in films, and you couldn't work in films unless you had a union card.

During the course of the evening and his dealings with Michael, however short these might have been, Balcon had

made a positive appraisal of the young man, and so answered the question with an offer of work. His current assistant Tom Pevsner (who would later work as associate producer on the Bond films) had just received his union card and moved to the production side. 'I have to find somebody else,' said Balcon. 'So it can be you.' That was it, no interview, no nothing.

Taking on Michael was no mere whimsy on Balcon's part. The producer did have a policy each year of fishing around for a couple of bright young sparks out of the universities. He was also a complete snob, and, as we've seen, was content to give jobs to the sons of his gentleman's club friends, while other applicants toiled for years to get through the gate. Alfred Shaughnessy, for example, was given a job by Balcon after his demobilisation in 1946 as a 'reader' in the script department because his application arrived on Windsor Castle writing paper; his mother was living there at the time. One of Shaughnessy's contributions was to secure Leeds Castle as the D'Ascoyne residence for *Kind Hearts and Coronets*.

When Michael Birkett left Cambridge he began his job as Balcon's PA. 'It was a lovely job. I did all sorts of things for him. If he had to make a speech I wrote it and if he had to do a contribution to a periodical I wrote that, too.'

One day in the office Balcon announced that a magazine had invited him to write a small piece about his favourite picture. 'God, you've got a lot to choose from,' said Michael.

'No, no, it's not our kind of pictures,' Balcon answered. 'It's art, those kind of pictures.'

'I see. Well, what is your favourite picture then?'

It was obvious that Balcon hadn't given this any consideration whatsoever. 'I thought I'd leave that to you, dear boy.'

After much foraging and research, Michael decided that Balcon's favourite picture would be *A Cornfield by Moonlight* by Samuel Palmer. 'I said to Sir Michael, "Your favourite picture is … ", and he was quite happy with that, and I wrote a frightfully good essay about it. He was a sweet man and we became great friends.'

Michael agrees with the theory that Ealing's philosophy for making films was to project a certain image of the country to the rest of the world, and that this was an idea that came very much from Balcon himself. 'It was a romantic view of batty old England. And it's true that Balcon was very traditional in his outlook, but don't forget at the same time he was the one who encouraged all sorts of people like Sandy Mackendrick, so he can't have been that conventional.'

Still, there was more than a whiff of Balcon as headmaster while the creative talent he'd assembled around him acted as the unruly pupils. He never bossed anybody about personally, though; he left that to his right-hand man, Hal Mason. A nice man by nature, it was always Mason who would come on to the set to pick up the pace if it was slacking or give the odd bollocking if it was called for. 'He was quite a strict guy but very approachable,' remembers Maurice Selwyn. Certainly Balcon trusted him implicitly since he and Mason would always attend rushes together every day. According to Michael Birkett, Mason was 'very much in awe of Balcon, very much under his influence. He once said a marvellous thing about some schedule that we were talking about, when to shoot and all that. He said, "We're going to shoot it on what I like to call Thursday." And this became a famous expression we all liked to use.'

One curious fact about Hal Mason's pre-Ealing career, which was mercilessly exploited by staff, was that he had done

some male modelling for Brylcreem. 'Some of the lads used to cut these advertisements out of the *Picture Post* and stick them up on the door by my printing machine,' recalls Tony Rimmington. 'So along with the obligatory pin-up girls we used to put pictures of Hal Mason advertising Brylcreem. And every time we did this they got torn down, so we'd put them back up again. Nothing was ever said, and he left the pin-up girls untouched.'

Mason also knew full well that most of the crews regularly flouted the stringent no smoking policy. 'Hal always knew very well that we would stick cigarettes in our coat pockets when he came on set to hide them away,' says Michael Birkett. 'So he always used to say good morning and give us a resounding pat on our right-hand side pocket, which made us go "Ouch".'

Pretty much everybody smoked like the proverbial chimney in the 1950s and to prevent disaster, especially on one of the sound stages, Ealing had its own fireman who used to wander round the studio keeping his beady eye on people. 'Ted the fireman, that was his name,' says Ken Westbury. 'He was quite an officious character, liked to make himself heard.' After years of demonstrably instilling into everyone the need to stub out cigarettes and the hazards of fire, his moment of glory came one afternoon when some old tyres caught fire in the car park. Michael Birkett was on hand to watch what happened.

When finally the fire people arrived and shouted – right, here we are, stand by for the jet – we all waited for the water to come gushing out, and what actually came out of the fire hose was about half a dozen old cigarette butts and a mouse. That was it; that was all that emerged from the nozzle. It was a classic piece of comeuppance, because

this firefighter was always being so smug and rather grand about his importance, more grand than he needed to be, and we said, serve him right.

For years afterwards it was said, rather unkindly, that Charlie Crichton was seen pushing his car towards the flames, for insurance purposes. 'It was a very old motor car,' says Michael.

The studio itself Michael found a warm and inviting place in which to work, with a nice, homely atmosphere and lovely co-workers.

> Some of the directors were a bit scary, though. Charlie Frend had rather a bad temper, as did Harry Watt. Harry had a great habit of losing his temper and reaching over his shoulder and tearing his shirt in half. Later, as his assistant, I would try to discourage Harry from tearing his shirt off in a fury, because I made sure that he was perfectly all right and happy and didn't need to do that kind of thing. All the others were charming. Sandy was absolutely lovely and he and I became firm mates.

Most of the directors, after a hard slog at the studio, would retire at the end of the day to the nearby Red Lion. 'That was a famous watering hole,' recalls Ronnie Taylor. 'It was right opposite the entrance to the studio.' It was where almost everybody went, at lunchtime too, mainly because Ealing, unlike other studios such as Pinewood and Shepperton, didn't have its own bar. 'That's where most of the heavy drinking went on,' confirms Alex Douet, who lived just down the road from the establishment. 'With Tibby Clarke very much at the centre of things.' Jim Morahan, one of Ealing's most-respected

art directors, went straight to The Red Lion after work and stayed drinking there until ten o'clock when he got the bus home to Kingston, having lost his driving licence years before. But that was the culture back then. 'In those days drinking was a common thing with most of the people I remember at Ealing,' says Norman Dorme.

> Drinking was a deeply ingrained habit. It was odd because you wouldn't have thought people could function in the afternoons, but the directors and producers, all of those people would invariably be over in The Red Lion at lunchtime, and they weren't drinking half pints of beer, it was brandies and scotch and so on; it didn't seem to have any effect.

A little bit further down the green was another pub, the Queen Victoria, and while charming in its own way, this was really the workers' pub. The creative talent all drank at The Red Lion.

The stars, too. 'I remember Peter Sellers going there,' says Michael Birkett. 'Also people like Tibby Clarke and several of the other writers were always in The Red Lion. Actually, a lot of ideas and stories were formulated during drinking hours at The Red Lion.'

One evening Monja Danischewsky, who was always in The Red Lion, said to the assembled company, 'Now, here's a nice opening scene and what I need to know from you lot is what the story could be.' Everyone put their pints and wine glasses down and listened intently. 'Well, it's an antique shop in the West End of London,' began Danny. 'And in the window is a twelfth-century illuminated manuscript, obviously very valuable and very beautiful, just alone in the window. Then

6

suddenly there is the revving sound of a motorcar and a brick comes bang through the window, a hand reaches in and seizes the manuscript, and we whip the camera round and we're just in time to see the getaway car screeching off and on the running board of this getaway car is a bishop in full ecclesiastical robes.'

Danischewsky paused for effect, looking at his captivated audience. 'So there's your opening sequence, what's the story?' Michael Birkett remembers everyone looking at each other and finally saying in an exasperating tone, 'Come on Danny, if you can't imagine a plot out of that, how can we?' One is left to wonder just how many of Ealing's golden film gems began life over a pint at The Red Lion.

Back in the early 1950s, your average person leaving school or college didn't take off on a gap year, you went to work or you didn't eat. When Maureen Jympson left typing college at sixteen, she worked in a succession of jobs, ending up at a factory in West Acton, typing out all the orders. She hated it. One of her duties was to take orders down to the basement, where an elderly gentleman was one of the packers. 'I've always called him my Wizard of Oz,' says Maureen fondly.

We became friendly and one day he said to me, 'Why are you working here if you hate it so much?' I said, 'My dad told me I had to get a job.' It turned out this old fella used to work at Ealing; he'd retired and was only working at this factory in his spare time. He told me that I ought to write to Ealing and ask for a job. 'They wouldn't want me,' I said. I was very shy in those days. 'Why don't you try it?' He was very insistent. Anyway, I

didn't do anything for a couple of months, but I hated my job so much I thought, what have I got to lose?

Maureen didn't hear back for something like five months. Then suddenly, out of the blue, a letter arrived saying would she go for an interview.

So I got my best bib and tucker on and went up to Ealing Studios. And I'm sitting in a line with five other girls and one by one they go in, until I'm sitting there all by myself, and I'm thinking, they've bound to have got someone by now. But all these girls came and went until finally this lovely lady ran out of the office and said, 'I don't care if you can do shorthand or not, I want you!' And I started my job at Ealing and it was amazing. It was a magical place. And so to this day I call that man in the packing department my Wizard of Oz, because he steered me towards Ealing and my life changed overnight.

Maureen was just seventeen when she started at Ealing and was 'as nervous as hell' on her first day. Her job entailed ordering cars for the important artists and she worked in a tiny office with three other members of staff. She loved the work, and there was the added bonus of bumping into stars.

Alec Guinness was the very first person I ordered a car for and he was absolutely charming. I remember seeing people like Anthony Steel, Audrey Hepburn, Joan Collins – she was the sexiest-looking little thing you ever saw, with this hourglass figure and long dark hair – I remember thinking, wow. I fell madly in love with Dirk

Bogarde; he was just gorgeous. And he was also immaculate, often walking with a cane. Audrey Hepburn, she was just not of this world. I used to see her walking in and out of the canteen. She seemed to be ethereal, not like a normal human being at all. She was not a star then, but these people have charisma, it's a kind of magnetism, and they all have it those big stars, they really do.

When Maureen realised that part of her job would entail meeting stars, she didn't quite know what to expect; someone with two heads or something.

But when I first saw these people I thought, my goodness, they look just like the rest of us, apart from Audrey of course; they just had this special something that the camera captures. They didn't mingle with us, though. I found that the stars did keep themselves to themselves. Stewart Granger was gorgeous looking as well, but Dirk had my heart.

While stars tended not to mingle much with the general staff, they were also not pampered. Certainly there was no such thing as star dressing rooms or anything of that nature. 'They weren't given star treatment,' confirms Michael Birkett. 'Ealing didn't go in for that sort of thing. They were respected and regarded as stars, but there was no adulation.'

Maureen's journey to the studio from where she lived in Hanwell followed a regular daily pattern, a ten-minute walk to the bus stop where she caught the 207 that took her up to Ealing Broadway.

Then I usually had to run like hell because I was always late, and they used to stop our money in those days for being late. I used to earn £3.15 for the week and they would dock me 25p every time I was 10 minutes late, so I ended up with not much money at the end of the week. If I didn't get the bus I would ride my bike to work. There weren't so many cars around in those days so it was quite safe. We used to clock in and clock out. Not the stars, of course, I don't think they asked Alec Guinness to clock in.

Maureen's office was next door to the canteen, which was the social hub of the entire studio. It acted almost like a dating agency, with a large number of people meeting their future husbands and wives there. 'I remember going out with one boy from the cutting rooms who chatted me up in the canteen,' recalls Maureen. 'I drank far too much, I mean I wasn't used to it, and when he took me home and went to kiss me goodnight I threw up all over him. My mum was so disgusted with me.'

Maureen has never forgotten one of the secretaries, a very glamorous girl, who had her eye on one particular director and was determined to catch him.

One day we were queuing up at the canteen to get our tea and coffee, and this girl managed to manoeuvre herself so she was standing next to this director and then fainted in very melodramatic fashion right in front of him. He ended up marrying her, of course, and she used to come into the canteen wearing this mink coat which she used to drag across the floor, and us girls would watch open-mouthed going, 'I want one of those'.

Maureen herself met her future husband in that canteen, second assistant editor John Jympson, who in the 1960s was to become one of the country's most in-demand editors, working on films such as *Zulu* (1964), *A Hard Day's Night* (1964) and *Where Eagles Dare* (1968). 'I used to say to my friends over lunch, that boy keeps looking at me, and that boy eventually became my husband. So he asked me out, we had egg and chips and a cup of tea; no drinking this time.'

When the studio shut up for the day, the canteen was turned into a sports club every night with table tennis tables and darts. It was also utilised for the occasional do and, of course, the Christmas party, where Maureen was chased up and down the studio by various male members of staff. 'But it was all quite innocent, there was no nastiness.'

As for the food served in the canteen, in the words of Michael Birkett, 'it was nothing special; nothing too awful either, we ate it without too many complaints.' Maureen classes it as being quite good, homemade fare like shepherd's pie, nothing very exotic. 'And I remember things like big white rolls with ham and cheese in them. I lost a tooth on one of those. It had a stone in it. It was like a school canteen, you got a tray and went up to the counter where all the food was laid out and you collected what you wanted.' Or if you so desired you sat at a table and took advantage of the waitress service.

As for the top brass, directors and the like, along with top-ranking actors, they had their lunch in a small private dining room just off the main canteen. 'The dining rooms were very, very structured and divided up into sections,' Norman Dorme recalls. 'There was the workmen's canteen down the far end where you sat on stools along a counter. And then the rest of us, the technicians, we sat at tables. And then there was a

directors' dining room where senior staff, or heads of department or special guests had lunch, and the door was always shut.' Betty Collins seems to think they had exactly the same food as the rest of the staff, 'just served rather more poshly. I don't think anybody felt put out by it'. Even so, it smacks of segregation. Madge Nettleton does recall during her time at Ealing seeing John Mills and his wife sitting quite happily at one of the canteen tables. 'They weren't going to bother to go in the private room. It didn't sit well with some people.'

Incredibly there was even segregation in how everyone arrived to work. Most of the staff were required to clock in and out every day at the front gate office. Of course heads of department, directors and senior staff did not have to clock in, perish the thought. 'They were trusted,' says Peter Musgrave. Even more revealing is the fact that there was a back gate where the blue collar workers – the carpenters, the painters, electricians et al. – were required to clock in; none of them were allowed to enter the studio by the front gate.

More than one of the veterans interviewed for this book spoke of a very definite class system operating at Ealing. Rex Hipple saw the studio as almost a microcosm of England. 'Jim Clark, one of the editors, said that it was a bit like a boys' school, which I suppose in a way it was. It was clubby as opposed to clique, if that isn't a contradiction.' Robert Winter did feel that the creative talent were seen as being above everyone else. 'The people who were the heads of department, you had to recognise them as a sort of superior being.'

Jim Clark, who later worked as John Schlesinger's editor on several of the director's films including *Midnight Cowboy* and *Marathon Man*, started in the business as a runner in a documentary production company until he was unexpectedly

invited to join Ealing as a cutting room assistant. He never really warmed to the place, not finding it as cosy and maternal as many of his other colleagues did. 'Ealing was fine if you'd been to boarding school because it was run on the same hierarchal lines. It was class-ridden. You knew your station and stayed in it, or incurred wrath in high places.'

Betty Collins, however, doesn't agree. 'I got the sense at Ealing that it was totally classless, you never felt that somebody was above you. You could say hello to Alec Guinness as much as you could say hello to the fellow that was sweeping up on the stage, you felt no different about it.' Betty has more sympathy for those who found the practice of clocking in to be a burden, and the fact that you were fined for being late. 'If you arrived at five minutes past nine, you lost a quarter of an hour's pay. If you got there at sixteen minutes past nine you lost half an hour's pay. It was quite strict, but you got used to it. A lot of people did resent it, though, it really did irk a lot of us.'

Chapter Fifteen

Hello And Goodbye To Audrey

After *Eureka Stockade* Harry Watt had travelled to South Africa in search of new subjects to film. In Cape Town he wanted to make an adventure story about diamond smuggling but the script never worked out. From Cape Town he went right through Mozambique, crossed the Kalahari desert in a jeep and ended up in Kenya. On safari there he came across a hunter shooting zebras. Apparently the man was planning to turn the area into a cattle ranch and the zebras ate the grass, but Watt was appalled at the sight of these beautiful creatures lying around rotting and being eaten by vultures and gave the man a piece of his mind.

'You sound like Mervyn Cowie,' said the man.

'Whose Mervyn Cowie?' asked Watt.

'He's some guy up in Nairobi trying to get a national park to save the animals.'

It was, thought Watt, a terrific basis for a film. The result was *Where No Vultures Fly* (1951), a fictionalised account of Cowie's story as a game warden so disgusted by the ongoing destruction of wildlife in East Africa that he decides to create a national park to protect them.

In the leading role Watt had Anthony Steel forced on him, an actor Rank were currently building up into a star. 'I didn't like

him and didn't want him,' Watt admitted later. 'He was just a stiff, beefcake bum. And a drunk at the same time.' Playing opposite Steel, Watt and his producer Leslie Norman cast an actress who had appeared largely in B pictures and was currently out of work, Dinah Sheridan. But Balcon wasn't enamoured with Dinah and, as the unit began preparing to shoot out in Africa, an order came through from Ealing to replace her. 'We cabled back,' said Watt. 'And wrote, right, change Dinah Sheridan and you can change Harry Watt and you can change Leslie Norman, we'll chuck our hand in.' Balcon backed down.

The film was shot almost completely outdoors on location. However, close-ups for one exciting sequence, where Steel is up a tree threatened by a leopard, did have to be shot back in the studio. The art department built an exact replica of the tree used out on location and a leopard was brought in from London Zoo. For safety purposes the entire scene would be enacted inside a large circus cage that had been hired and erected on the stage and which had just the one entrance door. The plan was for Anthony Steel to climb up the tree while the leopard, which was to be drugged, would be placed on a flattened platform near to the actor, with a sheet of thick armoured glass between them. To get the animal used to the tree and the smell of the place it was decided to leave it at the studio overnight. 'So they let it into the cage,' reveals Tony Rimmington. 'Shut the door, came back the following morning and it had torn the bloody tree to shreds.'

After the tree was hastily rebuilt, the dangerous scene was ready to go before the cameras. Steel climbed the tree, the drugged leopard was hauled back up onto this platform, and the sheet of glass positioned between them. 'At ten o'clock they brought the tea trolley in for the morning break,' recalls Tony.

'So there they all were, the crew and everybody else inside the cage drinking their tea and eating cakes and buns. I was up in the art department when suddenly there was a bloody furore, everybody went to the windows and people were running out of the bloody stage like mad. The leopard had lost its balance and fallen out of the tree onto the bloody tea trolley with a terrific roar and of course everybody was trying to get out of this one little door in the cage. There was no Health and Safety in those days. It was mad.'

Chosen for the Royal Film Performance, *Where No Vultures Fly* was one of the top British money-makers of its year. Its success with the public Balcon put down to, 'years of difficulties and restrictions on travel had created a rather claustrophobic feeling in Britain, and when they were over we felt an urgent need for the wide open spaces'. It was also an adventure story that appealed to the entire family, and that's perhaps another reason for the studio's success over the years. 'The great thing about Ealing was they were family movies,' believes Rex Hipple. 'You could go to any one of their movies and take your mum or aunt and you'd never be embarrassed. That was basically the code of Ealing and, particularly, the code of Mick.'

Next up was *His Excellency* (1952), directed by Robert Hamer, a disappointing comedy about a former leader of a dockers' trade union, played by Eric Portman, who is appointed to the post of governor of a British Mediterranean island colony. Working on that film, in strange circumstances, was Peter Musgrave. After his arrival at Ealing, Peter worked for just a year as a trainee sound editor before he got his call-up papers for National Service at the age of eighteen. Employers could seek permission from the government to allow them to keep an apprentice on in order for them to complete their

period of training. They were still going to have to do their National Service but it could be deferred. 'Now one or two clever people like Jonathan Bates, who was the novelist H. E. Bates' son, Ealing valued him enough to get deferment,' claims Peter. 'And there were a few others, too. I knew I wasn't valuable to the studio so I didn't ask for deferment.'

When his National Service came to an end, Peter returned to Ealing ready to work again.

And the cutting-room manageress, who was a fake genteel woman called Katie Brown with a phoney genteel accent said, 'Oh no, no, you left us.' I said, 'I was called up you know.' And she said, 'Yes, but you left before you need have,' because I said I wanted a month's holiday before I went into National Service. So she used that as a reason for not re-employing me. I went back home with my tail between my legs.

A furious Peter rang the union, 'because in those days union membership was absolutely compulsory. Ealing didn't like the union but they had to accept it as all studios did'. Peter explained his case to the union representative and received a very sympathetic hearing. 'This is disgraceful,' the man on the phone said. 'They're obliged to re-employ you, and of course they've got to pay you the correct rate. The two years you spent in the RAF count towards your promotion, so you are now to be paid as a fully qualified assistant.' The rate was something like £4 for the first year, £4 10 shillings the second year, £5 the third year, then you jumped to around £7. Fantastic, thought Peter, he'd hit the big time. 'That's what Ealing should have paid me had they re-employed me.'

A couple of weeks went by and Peter began to worry. It was obvious Ealing weren't going to take him back so what was he going to do; he'd no other contacts in the business, how was he even going to start to find a job? As it turned out, the union ran an employment register that people like Peter could submit their name to and it wasn't long before the phone rang. Ironies of ironies, the first job offer came courtesy of Ealing Studios.

'Are you available to go to Italy?' asked an anonymous voice.

'I think you're speaking to the wrong person,' Peter answered politely. 'I'm waiting to come back into the cutting rooms.'

The voice carried on, 'No, no. We know who you are. Come and see us.'

Ealing had just bought a new British machine called the Leevers-Rich recorder; indeed they were the first feature studio to buy one. Up until then everybody had recorded on 35mm black-and-white film. Sound stock was a different stock to picture stock but it was still 35mm and ran at exactly the same speed, which is why you have clapperboards so you've got a clap on the picture and a clap on the sound and the editor knows where the two synchronise. This all meant that you had to have an enormous sound truck wherever you shot on location, pretty much the length of three cars, complete with its own dark room and heavy cables running out from it to the microphones. So Ealing thought, what a great idea this Leevers-Rich recorder was, brilliantly compact, just two cases, making things a lot easier out on location. *His Excellency* was going to be the first film to utilise the new system.

Ealing contacted the union telling them that because they'd bought this new machine they would only require two sound people on the picture. The union official almost had a seizure.' The union agreement clearly states that there are to be four

people on camera and four people on sound, so we don't care what you've bought, it says here four people.' Ealing tried stamping their foot and appealed to the British Film Producers' Association, which as an employer's group were on Ealing's side, but unfortunately they couldn't help; Ealing had signed this agreement and therefore had to abide by it. In an attempt at compromise, Ealing told the union they were prepared to take three qualified sound people, 'Plus we'll take Peter Musgrave because he's the cheapest around.' Steady on, thought Peter, reminding Ealing of his time at the studio and that he really should be on proper rates. 'No, no, no,' they said. 'This is a separate contract, we're not recognising that you had anything to do with the cutting rooms here, we are employing you for this one film only and we'll only pay you what you were getting when you left us.' So Peter got a depressing £4.50. 'They were that mean.'

At least he was given the same location allowance as everyone else, which was something like a fiver a week, and he was put up in the same hotel as the crew in Palermo. 'But I was strictly told, you are not to come out on location each day. So I would hang around the hotel grounds, which went down to the Mediterranean. I learned to swim, it was lovely.'

On the one morning Peter did decide to venture out, the unit were shooting in a villa just across the street from the hotel. He spotted Stephen Dalby, Ealing's head of sound, and another man he recognised as George, a very good sound engineer. George was sweating buckets and on seeing Peter a flood of relief came over his face. "Thank goodness you're here," he said, and asked if Peter didn't mind helping a bit. 'So I started to wind up these cables and Stephen Dalby beckoned me over and said, "Go back to the hotel at once, you are not to

lift a finger on this production." Steve was very much management now and if it had got back, or if I'd been able to say to the union, yes I did do a day's work, ah, that proves you need four people, whereas the studio was determined to prove they did not need four people. Anyway, that was my very last contact with Ealing. They paid me off and never took me back into their cutting rooms.'

Peter continued to work in a freelance capacity as a sound editor and managed to carve out a highly successful career working on Orson Welles' *Othello* (1952), *The Innocents* (1961), *The Hill* (1965), *Alfie* (1966), *Legend* (1985), *The Living Daylights* (1987) and *GoldenEye* (1995), among many others.

His Excellency represented Robert Hamer's last film for Ealing. For the man who directed the classic *Kind Hearts and Coronets*, Hamer had never attained such creative heights again, largely due to his addiction to alcohol. Peter Musgrave recalls that on *His Excellency*, during lunchtime if the unit were shooting near to the hotel, but more usually at the end of the day when everyone came back absolutely sweating, Hamer would be the first in the bar.

> He would drink something called a Negroni. And one day, because I was paid this location allowance, I thought I'd try a Negroni, and it nearly made me sick, it was absolutely vile. But Hamer would be in there and you could see that he was the worse for wear, I'm afraid. He did become an alcoholic. On *Kind Hearts* I don't know if he was drinking, it's such a well-directed picture, maybe he wasn't yet an alcoholic, but sadly he did go downhill.

Ken Westbury tells a story about Hamer on *His Excellency*. They were shooting nights and it was a fairly large-scale sequence involving a mob rioting and attacking some dockyards. The assistant director called for quiet before yelling, 'OK, turn over. Action.' All hell was let loose, the extras playing the rioters went berserk, fires were lit in the background, guns went off and explosions. At the end of the shot the assistant director called Cut and looked around at his crew to see whether they had captured the action. "All right, camera, OK? Sound, OK? OK Robert … Robert? OK Robert?" Hamer suddenly bolted upright in his chair. 'How the fuck should I know, nobody bothered to wake me up.'

Balcon always considered Hamer, 'one of the most remarkable of the young men I gathered around me at Ealing'. But also held the view that as an individual he 'rarely came to terms with himself, and it almost seemed that he was engaged on a process of self-destruction'. All around the studio he was well liked and respected. So what went wrong? Part of the problem was that after *Kind Hearts*, Hamer could never persuade Balcon to back any of the projects he wanted to make. One of these was an adaptation of Richard Mason's novel *The Shadow and the Peak*, which he wanted to do on location in the West Indies with Vivien Leigh in the title role. Balcon bought the film rights but later decided it was a risky and expensive venture, not to mention the fact that sex was a pivotal element in the story, and just as it was about to start pre-production announced, 'On second thoughts I'm not going to do this', and scrapped it. That happened at least twice to Hamer; Balcon changing his mind almost at the last minute about doing one of his projects. According to Harry Watt, when Hamer was told the film had been rejected, 'He went on the bottle and he never recovered'.

Leaving Ealing after *His Excellency*, Hamer's next film was *The Long Memory*, which was made for Rank in 1953. Its star, John Mills, recalls during a night shoot on a barge Hamer falling into the Thames as he walked backwards with a viewfinder attached to his eye. With very little work on offer, Hamer's friend Diana Morgan remembers him regularly going off on drinking binges, then ringing her up after weeks of silence to announce, 'I've been found'. By the 1960s *School for Scoundrels*, Hamer was replaced by Cyril Frankel after collapsing drunk on the set. He never made another film and died three years later at the age of just fifty-two. According to esteemed film critic David Thomson, Hamer's career 'now looks like the most serious miscarriage of talent in the postwar British cinema'.

Joan Parcell had been working in Hal Mason's office for a while before she got her chance to work on the studio floor as a production secretary. She'd been waiting for a chance to move into a more creative job and some of the people in Mason's office she'd grown friendly with managed to get her union card. 'That was the hardest thing to do, to get into the union. You couldn't get a job as a production secretary unless you got into the union.'

There were usually three production secretaries working on whatever production was on at the time and much of their work was aligned to the continuity girl.

She gives you information every day as to what's taken place, what scenes they've shot, what actors worked that day, any particular problems they'd had that day. They keep a daily record of all this and the production secretary has to type all that up. Then I had to do a progress report

every day. The script itself was typed up by the typing pool, but if there were changes during shooting, which there were all the time, then I'd type those pages up and then between me and the assistant director we had to make sure that everybody got any new changes that were made.

Joan enjoyed her new job and the atmosphere and camaraderie that existed on the studio floor. 'I loved it. It was really a family there. It really was.' They were quite a sociable bunch, too.

Once a week some of us went down to the local swimming pool. We also used to play darts at some of the local police stations against the policemen. The studio had good relations with the police. We had dances every once in a while at one of the local halls. We also did a lot of sports, track and field, because there was a competition, once a year I think it was, against the other studios. It was held at Kodak's main laboratories because they had an athletics field, and so we'd compete there against Pinewood, Shepperton, all the other studios. It was like a big sports day. To be honest we weren't all that good, but it was a lot of fun. There was running, high jump, relays, hurdles, all kinds of things. Ealing also had a cricket team at one time, because I remember going to watch them. Hal Mason used to play.

Out of the many films made at Ealing, *Secret People* (1952) is perhaps the only film to have begun life outside of the studio. This political thriller was conceived by Thorold Dickinson,

who after *Next of Kin*, rather than join the Ealing 'family' had decided to go freelance, directing amongst other pictures a version of Alexander Pushkin's *The Queen of Spades* (1947), which Martin Scorsese has called a masterpiece. After several abortive attempts to interest other companies in *Secret People*, Dickinson brought it to Balcon who happily took it on as 'a welcome blood transfusion, a stranger bride in a family tending towards inbreeding'.

A largely forgotten film today in the Ealing canon, its principal importance is that it gave the young Audrey Hepburn her first substantial film role, playing a young refugee in London who gets caught up in a political assassination plot. Some twelve actresses were tested for the part but at Audrey's first audition Dickinson and his creative team all sensed that here was something out of the ordinary. Betty Collins remembers seeing Audrey that day.

> She was in the corridor in the offices where I worked. I was walking along and saw her standing there, just by herself, looking very shy and demure, looking exactly as if she'd been interviewed but asked to go outside while they discussed it. I can see her now, standing there all by herself, waiting to be called back in. And I think, my God, the red carpet would have gone out a few years later.

Camera operator Ronnie Taylor remembers Hepburn on the film. 'She was lovely. She was very inexperienced in those days, but you could tell there was a star in the making. In many instances it's the cameraman more than the director who can recognise stars because something happens in the camera.'

Whatever impact she may have made in *Secret People*, Ealing allowed the young Audrey to fall through their fingers. 'No one really knew how special she was,' says Ken Westbury. 'No one at Ealing realised her potential.' To be fair, Ealing's casting director, Margaret Harper-Nelson, did suggest to the studio that they put Hepburn under contract but she was told: She won't go very far. A few months later, Dickinson directed a screen test of Audrey, which was sent over to William Wyler in Hollywood, who instantly fell in love with the actress and cast her in his forthcoming picture. A little over a year later *Roman Holiday* was released and Audrey was launched as one of cinema's greatest ever stars.

Secret People ended Ronnie Taylor's association with Ealing, and quite frankly he was happy to be leaving.

> It was very cliquey. They were all nice people but I didn't really like the atmosphere there. It was very strictly run. And the Ealing cameramen were a bit more concerned with their position than those I worked with at Gainsborough, there was a bit of politics going on at Ealing and that came from the top. You also had the feeling that someone was looking over your shoulder all the time. I wasn't miserable at Ealing, but there wasn't the same freedom there was at Gainsborough.

After Ealing, Ronnie's reputation as a camera operator continued to grow as he worked on a succession of major films such as *Saturday Night and Sunday Morning* (1960); *The Devils* (1971), *Barry Lyndon* (1975) and *Star Wars* (1977) before going on to become a director of photography in his own right, winning an Oscar for *Gandhi* (1982).

Ealing featured two other future stars in their next film, *I Believe in You* (1952), directed by Basil Dearden, a drama that focused on the workings of the probation service. An eighteen-year-old Joan Collins was given her first major film role, following three screen tests, as a working-class girl gone bad, opposite another relative newcomer in Laurence Harvey as her spiv boyfriend. *Hue and Cry*'s Harry Fowler also appeared, preparing for his role by staying in a real borstal for two nights, 'That was an experience to say the least.' So, too, was acting opposite Miss Collins, an actress he described as 'oozing something that was dangerous to have in British films at that time. One thing you were never allowed to be in British films was any hint of sex.' *Brief Encounter*'s Celia Johnson also starred as a schoolmarmish probation officer.

Next to go on the floor for Alexander Mackendrick was *Mandy* (1952), a sensitive melodrama about a child diagnosed as profoundly deaf and the conflict this brings into her parents' lives. The film came about after Balcon's daughter, the actress Jill Balcon, read the true story of a deaf girl on the BBC's *Woman's Hour*. At first the corporation received a flood of complaints, mainly from expectant mothers upset that the subject was being trivialised, at worst exploited. However, as the readings continued, the reception changed from anger to praise as the story became one of hope and achievement as the child slowly learnt how to speak.

Ealing had a fine track record of representing children on screen and eliciting wonderful performances from them, notably *Hue and Cry* and *The Magnet* (1950), a minor comedy from the pen of Tibby Clarke about a young boy (the eleven-year-old James Fox in his film debut) who cheats another child

out of his prized magnet only for his guilt to lead him to believe he is a fugitive from the police. *Mandy*, however, was very different; no carefree evocation of childhood innocence, this was hard-edged, and for such a daunting and challenging role a large number of child actors arrived at Ealing for screen tests, under the supervision of Mackendrick. Among them was a familiar face, someone Mackendrick had used a year earlier as the little girl who aids Alec Guinness's escape from an angry mob in *The Man in the White Suit*.

Mandy Miller was barely six years old when she made that film, and only got the part through a colossal piece of luck.

My father, together with being a radio producer, also founded a square-dancing group who, with a band, would perform at a huge variety of events – it was very popular in the early 50s. And at one such occasion he met Michael Balcon who, when being told how keen my older sister was to become an actress, invited her with my father to visit his studios. When the day arrived, my mother was ill and so I had to 'tag along' too. During the morning we all went to the canteen and as luck (fate) would have it, Sandy Mackendrick was also in there having a coffee. And the story goes that he was in the throes of casting *Man in the White Suit* and when he saw me – probably across some enormous sticky bun – said, 'That's a funny face, I could use that funny face in my next film!' How ironic that I was the one 'discovered' when all I was really interested in was ballet.

On the set for just one day, Mandy retains few memories of it, none of which are of Alec Guinness, with whom she played her

scene. 'But I do remember Duncan Lamont being really warm and nice and, most importantly, the generous supply of toffees (sugar rationing still in force then, remember!) which Charlie the props man kept doling out in order to muffle my Home Counties accent and hope it sounded more Lancashire!'

Returning to school and her beloved ballet, it was many months later when the casting agent from Ealing contacted Mandy's parents to ask whether she would come in and do a screen test. Mandy admits to having been terrified by the prospect, but Mackendrick was never to forget the impact she made on that day. 'Mandy's performance was so astonishing that the unit was struck rigid, holding its breath, with this electrifying silence on the floor. I was in tears. Douglas Slocombe was in tears. And afterwards both of us said, cancel the rest, she's it.'

As filming got underway, Mandy doesn't think she felt in any way overwhelmed by the studios or the activities taking place. 'Each department was small and cosy and I remember being made to feel as one of the family.' A tutor was always on hand on the set and Mandy was required to undergo a study period each day in her dressing room.

As the film was shot during the winter months, I do remember the cold, the bomb-sites and the very particular atmosphere of the School for the Deaf in Manchester where we did a lot of shooting. But we could take cover whilst on location in what seemed to me HUGE Humber saloon cars and eat amazing bacon rolls.

The most vivid memory of the whole experience for Mandy was Sandy Mackendrick: 'A most extraordinary man with a

kind of wildness about him which I had never encountered and found a little awe-inspiring. But he was incredibly patient and gentle with me.' However, during the rehearsals for the scene in which the deaf child makes her very first sound, a primeval scream, Mandy opened her mouth and nothing very much came out of it. Mackendrick wanted something dramatic at that moment, with the rising tension, so let out a loud and powerful scream himself. 'I remember being scared out of my wits when HE screamed – it produced the desired results from me though!'

As for her co-stars, Mandy remembers Jack Hawkins, who plays the gifted teacher of the deaf school that the child attends, as 'very kind and quiet and grandfatherly in a way', whereas Phyllis Calvert, who played her mother in the film, was 'warm and glamorous, even in purple lipstick for the exterior shots because of the brilliant arc lights I guess'. As for Terence Morgan, who played her father, Mandy admits to having fallen madly in love with him all decked out as he was in his Hawaiian pancake tan. 'It was a bit of a letdown to see him pale-faced and unshaven in make-up first thing in the morning. The innocent joys of not requiring make-up at that age, although my plaits were always a problem for the continuity girl from take to take!'

When it opened, *Mandy* proved highly popular with audiences and was one of the most successful films of the year at the British box office. In the *Sunday Times* Dilys Powell thought it, 'an extremely touching film, in spite of occasional obviousness in a plot never dull, and in spite of its subject never saccharine'. Much of its success is due to Mandy Miller's quite remarkable performance, one of the most touching and heartrending ever given by a child actor. Looking back now,

Mandy doesn't think she felt daunted at all by acting in the film or faced any real challenges. 'At seven I don't think there were any. I guess I was just a child with an easy-going nature and a very vivid imagination!'

For the next ten years Mandy worked regularly in the cinema, and later on television. She also recorded the hugely popular song 'Nellie the Elephant' in 1956. In the early 1960s, after guest appearances in *The Saint* and *The Avengers*, Mandy retired from the business to begin a family and one gets the impression she never regretted the decision.

> Those years of my participation in the magical world of film-making were so wonderful, though, and I have nothing but the happiest of memories of everyone I was fortunate enough to meet. I was treated, I think, probably a bit specially, but my mother was adamant that I was just a normal, VERY lucky little girl, and life returned to normal once filming was completed. I do remember the premieres, though, when I would have a special dress made, meet famous people of the period and often present flowers to Royalty … can you believe it?

One memorable souvenir from the *Mandy* shoot was that the pale-blue satin dressing gown she wore in the film was given to her on the final day of shooting. 'And, of course, most amazingly, the title of the film was changed to my name.'

Chapter Sixteen

All Hands On Deck

The inspiration for *The Titfield Thunderbolt* (1953) arrived after Tibby Clarke visited a friend in north Wales who suggested they went to see a railway run by local enthusiasts. During the visit Clarke spotted a sign asking for volunteers, which got him thinking: what would be the consequences of a bunch of village folk taking over a branch line after it was closed down? The result was a gentle comedy celebrating a bygone age of steam trains, warm beer and villages unburdened by traffic. Ironically, at the time he was writing the screenplay, Clarke's neighbour was Richard Beeching, who in the early 1960s, as chairman of the British Transport Commission, was responsible for the controversial widespread closure of local branch lines and stations with the loss of thousands of jobs. And local communities did rise up in protest at these government cuts, just like they do in *The Titfield Thunderbolt*, but without success.

A genuine 1838 Liverpool and Manchester railway locomotive, the Lion, was used on location, which drew a coal tender, a coach and a guard's van. 'We hired it from York Museum, I think,' recalls David Peers, who was assistant director on the film. 'And it was brought down to a railway line

near Bath.' The line was no longer in use and so it was ideal for the unit's purpose. The problem was that it was a single track and the only turntable was next to the London to Bristol main line. Whenever the crew needed to turn the train around so it could be seen going in the opposite direction, they had to get the locomotive to this turntable located at least a couple of hours away. 'We had hired an excellent driver who was retired from the Great Western Railway,' says David.

> His name was George and he was a Cornish man who knew all about these old engines. What we didn't know was he rather enjoyed his tipple, which consisted of cider laced with gin. He was reputed to drink seven pints every morning. Well, on this particular day the train had to be turned around, so off went George, but he didn't stop by the turntable and on he went to join the main express line, no doubt waving to all his old mates as they roared past him, goggle-eyed. Fortunately no accidents occurred, but we had to pay a heavy fine. George returned to Cornwall.

Another accident that no one could have foreseen involved the lethal combination of Sid James and a steam roller. 'I went straight over a camera with it,' he later recalled. 'Thousands of quids' worth of camera flattened with a steam roller. I couldn't control it, and the fellas on the crew couldn't move. The bloody steam roller did three miles per hour but they were petrified. That was popular.'

For the scenes where the locomotive comes off the rails and runs amok through a town and the countryside, casts were taken of the train's boiler and the side tanks and then secured

on the top of a three-ton Bedford truck. This dummy train had to be driven early one morning from Ealing to the location in Woodstock, Oxfordshire, where the sequence was due to be shot. The driver later reported a large number of cyclists falling off their bicycles as he passed them on the road.

Despite another cast of regular Ealing faces (Stanley Holloway, Hugh Griffith, Sid James) and the affectionate jibes at British customs and rituals and other familiar elements, *The Titfield Thunderbolt* didn't quite capture the glory days of the earlier Ealing comedies. The *Monthly Film Bulletin* were not alone in detecting that this entry was unfortunately below par. 'The script itself is disconcertingly short on wit, and some of its invention appears forced, and Charles Crichton's handling fails to supply the charm that could still have been the film's justification.' Even Tibby Clarke realised its limitations and the film struggled to earn back its production costs at the box office.

There was no such trouble with Ealing's next production. *The Cruel Sea* (1953) had been a huge international bestseller, based on Nicholas Monsarrat's personal experiences in the war commanding a corvette. 'There's a lovely story,' says Rex Hipple.

Apparantly Monsarrat was offered a bag of money by Spencer Tracy, who wanted to play the lead role, and Monsarrat said that if his novel was ever made as a film there was only one studio he wanted to make it and that was Ealing, and only one director and that was Charlie Frend, because of *San Demetrio, London*, which Frend directed and which Monsarrat had been enormously impressed with. So Ealing got *The Cruel Sea* for an absolute song.

Frend certainly didn't take his directorial duties lightly, according to Rex. 'I went on the floor from time to time when it was being shot and there was always a copy of the Monsarrat novel on Charlie Frend's lectern, alongside the script. He followed the book very, very closely.'

As for casting, Balcon personally selected Jack Hawkins to play Captain Ericson, having always liked the actor. Hawkins was one of those dependable types and Balcon had used him already in a couple of films, without giving any thought to his potential as a leading man. That was until the premiere of *Mandy* when Balcon witnessed the reaction of the crowd after the performance. It came as something of a surprise to the actor himself, as he later revealed. 'I looked around to see who they were applauding and realised with astonishment that they were clapping me.'

A couple of days later in The Red Lion, Hawkins happened to catch sight of Charles Frend across the crowded bar giving him the thumbs up. 'I've just seen *Mandy* and it was bloody marvellous.' Hawkins thanked the director for his kind words. 'Have you read *The Cruel Sea*, Jack?' Hawkins admitted that he hadn't. 'Drop into my office this afternoon and I'll give you a copy.' A couple of days later, Frend phoned the actor at home to see what he thought. The verdict was a positive one. 'That's good,' said Frend. 'Because you are going to play Ericson. It's all arranged. You are playing the part.'

As Ericson's second-in-command, Donald Sinden was cast after Bryan Forbes tested but was rejected by Balcon for not being 'officer material'. Frend had spotted Sinden in a play and thought him ideal, even though he had never made a film before or even tested for one. The rest of the cast were filled by names that would all soon become known internationally, such

as Virginia McKenna and Denholm Elliott. There was also Stanley Baker, who had made his film debut for Ealing ten years before. Baker had read the Monsarrat book and was desperate to play First Lieutenant Bennett, a braggart and incompetent martinet who bullies the junior officers under his command, thus endangering the ship's morale. 'I began to beg people to get me tested for the part,' he said. After telephoning Frend, Baker learnt an actor had already been cast, but his persistence was such that he was told to report to Ealing to test for another role. His audition went so well that Frend recast the part of Bennett with Baker and paid the other actor off. While Baker only appears in the early part of the film, he caught the attention of Hollywood studios and it launched his career.

Balcon approached the Admiralty and found 'considerable enthusiasm for the project', but what couldn't be provided was a corvette to represent the story's main character, HMS *Compass Rose*, a support vessel initially engaged in the Battle of the Atlantic, since all ships of that type had been disposed of sent mostly to foreign countries. Thus began a massive search for the right kind of ship. Just at the point of giving up, Ealing heard of a corvette called *Coreopsis* that was in Malta harbour. 'I think it had been leased to the Greek navy after the war,' recalls Ken Westbury. 'And there it was, lying rotting in Malta when Ealing picked it up. It was made seaworthy and shipped back to England where it was refitted to become HMS *Compass Rose*.'

The corvette was put under the command of Captain Jack Broome, who had also been hired as the film's technical advisor on recommendation of the navy. Broome had served in both world wars and had commanded the escort group of the ill-fated Arctic Convoy PQ-17 in 1942. According to Hawkins, Broome meted out hard discipline to the Merchant Navy lads

who had been brought in to crew the ship. For example, anyone getting drunk in the evening, which was quite often it has to be said, got an almighty bollocking. 'Naturally enough, this did not go down too well with the civilian sailors, and we almost had a mutiny before shooting a foot of film.'

Every day they would sail out from Plymouth with a film crew on board shooting sea footage around Portland Race, a famous strip of rough sea that perfectly replicated the North Atlantic. Returning to base one afternoon, with Hawkins on the bridge, the corvette was coming in far too close to a destroyer moored in the harbour that had just enjoyed a new re-fit. Hawkins watched in horror as his ship's anchor raked along the side of the destroyer with an ear-piercing sound, leaving a jagged scar. All eyes of the destroyer's crew fell on Hawkins, who did his best to look nonchalant. Then a porthole opened and a man popped his head out and blasted, 'Who's driving your bloody wagon, then? Errol Flynn?' That accident ended up costing Ealing's insurers a whopping £10,000.

For the exciting sequence where the *Compass Rose* spots a submarine and starts shooting at it, what was required were shell blasts hitting the water nearby and the submarine submerging. Ever cautious of budgets, it was decided that hiring a real sub from the navy was a tad too expensive, so it was left to the art department to build a fibreglass mock-up of a coning tower with ten-feet of sub at either end. The model was taken to Portsmouth harbour and, with the cooperation of the Admiralty, Ealing hired the top gunnery crew from nearby Whale Island, home of the Royal Navy's main gunnery training establishment. Aiming for total realism, Charles Frend wanted the shells to land as near as possible to the model. 'Right, do your best, lads,' he said. 'There is a bit of a choppy sea here

today, but try and hit that submarine. We're a long way off but do your best.'

The sailors were using a three-inch forward gun and had been given eighteen shells. The mock-up sub was sitting on buoyancy tanks and being towed by a minesweeper out of the view of the camera. Listening to all this, the chief gunnery mate asked, 'Do you want us to hit it?' Frend replied, 'Yes, if you can. Do your best.' Tony Rimmington, who had helped build the model, was later told what happened next. 'One of these gunners shouted out the range, deflection, sighting, all that, slung one into the breech, let go one round, it blew our bloody mock-up submarine right out of the water. Direct hit. Bang. Good night.' With the model destroyed, Ealing had no option in the end but to hire a real submarine and dummy charges were placed around it in the water. 'Which is what they should have done in the first place,' says Tony.

Back at Ealing a large section of the *Compass Rose* was replicated on the studio's largest stage, built on rockers that were mechanical rams that pushed the ship up and down using compressed air. The sinking of the ship was done at the open-air water tank over at Denham. 'There were water facilities at Ealing, but nothing like the size of Denham,' says Ken Westbury. 'So the *Compass Rose* sinking and the survivors in their rafts, that was all done at Denham.'

It was very uncomfortable for the actors, with much of the shooting taking place at night and tip tanks filled with several hundred gallons of water being poured over them. It was especially hazardous for Donald Sinden who couldn't swim a stroke. While an aeroplane propeller whipped up an almighty spray, the actors had to jump ten feet into the water on the sound of a whistle. Sinden jumped and hurtled like a stone to

the bottom of the tank. After the take everyone got out, but it was obvious to Frend that Sinden was missing. He was still struggling to get himself back up to the surface. 'Thank goodness Jack Hawkins dived in and brought me out,' he later revealed.

Another night Ken Westbury recalls getting a right telling off from Frend.

We were still shooting all the stuff of Jack Hawkins and everybody in the water. It was the middle of the night, and I'm being conservative on the film and we ran out before Charlie said cut. He really blew his top. But it was my fault. I was trying to save them money on film. Anyway, the studio was shutting down for the holidays for a couple of weeks and minutes after Charlie had barracked me in front of the whole crew and we'd completed the shot he was saying, 'Happy hols, everybody'. Charlie was actually a nice, pleasant fella but he did have a nasty temper, then it would blow over and he'd be back to normal again.

During shooting there was a genuine feeling amongst everyone that they were part of something rather special. 'We all felt that we were making a genuine example of the way in which a group of men went to war,' claimed Hawkins. Certainly the passage of time has proven them right since *The Cruel Sea* is often hailed as one of British cinema's finest war films. It was also much lauded at the time and dominated the British box office, catapulting Hawkins to stardom at the age of forty-two.

Chapter Seventeen

African Adventures

In 1952, not long after *The Cruel Sea* entered production, the studio lost its principal benefactor in Stephen Courtauld, a man Balcon had called Ealing's rock of Gibraltar. The studio had always worked within a very tight financial framework and had looked mostly to Courtauld for security. A member of a wealthy textile family, Courtauld was a keen patron of the arts and had helped the studio secure loans from the National Provincial bank. While remaining very much in the shadows, Courtauld did read all the scripts and his observations were always taken seriously by Balcon.

Approaching seventy, he had now decided to live in Rhodesia with his wife, saying to friends that his decision was partly based on escaping the climate in Argyll, where he lived, and partly due to his dislike of the welfare state. 'Our first sense of loss was purely personal,' said Balcon. 'Because of the respect and admiration in which we held him for his unselfish and altruistic support throughout the years. But there followed a reaction of alarm, as Reg Baker and I realised that the financial burden would from then on rest wholly on us.'

Over the years both Balcon and Baker had ploughed considerable amounts of their own money into Ealing, and yes

they still had the backing of Rank, but it was plainly obvious that if they were to continue making films a new source of extra capital would have to be found. After much discussion, Balcon approached the National Film Finance Corporation (NFFC) who agreed to a substantial loan.

There was also the shareholders to think about. While none of them had put in any further money other than their original modest investment, they had loyally remained with the studio despite the virtual absence of any financial reward. Over the years this had become a bone of contention with a large minority of them. 'I remember reading an article in one of the cinema trade magazines about a shareholders' meeting at Ealing,' says Peter Musgrave.

One of the shareholders had the temerity to say, you've never paid out any dividends. I've had shares with Ealing for X number of years. And a man called Reginald Baker, who was the company's secretary, stood up and said words to the effect of, how dare this man attack us like this. But it's quite true, they didn't ever pay dividends, and some of the films were very successful and must have made a profit. So I don't blame this shareholder for saying, where's our penny, but somehow it never filtered out to those that invested.

With this new source of capital from the NFFC, Ealing carried on making just as many films as before. There was *Meet Mr. Lucifer* (1953), a satire on television, which marked the last Ealing appearance for Stanley Holloway. With the glorious exception of Alec Guinness, few other actors fitted so perfectly into the whole Ealing milieu than Holloway. 'Oh Stanley was

adorable,' recalls Michael Birkett. 'He was a great friend of mine. My family used to go on holiday with him before the war, to the south of France. I thought he was a lovely fellow.'

Holloway had greatly enjoyed his time with Ealing, the studio held special memories for him for the rest of his life and he always spoke fondly of the place and the people who worked there. 'Ealing was a very friendly studio with a general air of family friendliness about it which stemmed from the governor – Michael Balcon', Holloway wrote in his autobiography. 'I once defined the "Balcon touch" as – human comedy, based on what human beings would really think and feel and do – or like to do – in odd situations. For this reason it is understandable and popular everywhere, at home and in France as well as America.'

Another comedy was *The Love Lottery* (1954), an interesting if flawed look at the power of celebrity and a satire on the Hollywood star system. David Niven plays a top-ranking studio star who, in a publicity stunt, agrees to be raffled off for a week. Peggy Cummins plays a young secretary who wins the lottery only to find that her screen idol falls somewhat short of her fantasy. Niven was a big star at the time but Christopher Barry, who worked on the production, says that he was a pleasure to work with. 'He was very easy-going and showed no star temperament at all.' Peggy Cummins remembers one incident from her time working on the film. She used to go in early to have her hair done before going into Make-up, and was always driven to the studio by her husband. 'This particular morning the hair person went to dry my hair but the hairdryer wouldn't work. My husband, who had nothing at all to do with the film business, picked up the dryer to have a look at it and was given a severe dressing-down by a union official. All he'd done was pick it up to see what was wrong.'

Beautifully photographed in Technicolor by Douglas Slocombe, the film was directed by the ever-reliable Charles Crichton. 'My chief image of Charlie Crichton was of a smiley, pipe-smoking man, very approachable and easy-going,' says Christopher Barry. 'And, of course, an excellent director, especially of comedy. I have to say I did enjoy working on this film immensely. Not only were the sets imaginatively designed with use of gauzes and clever lighting, but the dance dream sequences were well conceived, and being on the set with dozens of Peggy Cummins look-alikes was not unpleasant.'

The film's dream sequences are especially memorable and Betty Collins has cause to remember one of them in particular, for all the wrong reasons. Sometimes members of Ealing's staff were drafted in to make surprise film appearances. 'Recording footsteps is now a professional job,' says Maureen Jympson. 'But in those days they used to just drag us girls out of the offices and say, go on, we need a few feet, so I remember running up and down many a time on the cobbled street set at Ealing.' Poor Betty was likewise asked to contribute to a scene in *Love Lottery* where a crowd of girls all run through a park.

> Well, they wanted them all to have the same face and they asked me if I would do a mask for them, so I said OK and it was one of the most horrible experiences I've ever had. It was dreadful. They put this plaster on your face, and you can't move at all and you've got to keep your eyes shut and your mouth closed, and you've got two straws up your nose to breathe through. I should think it's the nearest thing to being buried alive. I was there for what must have been an hour but it felt much longer than that. It was horrible.

The film's biggest surprise is a cameo appearance at the end from Humphrey Bogart, of all people. 'A real coup du cinema,' as Christopher calls it.

The Maggie (1954) followed, directed by Alexander Mackendrick. Its story of a rascally skipper of a rusting cargo ship on the Clyde who tricks an American millionaire into transporting a precious cargo, did its best to emulate the classic Ealing comedies of the recent past, but it's a far cry for such fare as *Whisky Galore* or *The Lavender Hill Mob*. Even Mackendrick himself confessed it was the least successful of his Ealing pictures. Perhaps the studio's magic touch was beginning to wear thin, especially now in the face of stiff competition from other companies churning out genteel comedies that had not only managed to capture something of the spirit of Ealing's output but were turning them into box office smashes. Such examples include the St Trinian's films, the comedies of Norman Wisdom, and *Doctor in the House*, the first of a series of medical mishap films based on the books of Richard Gordon, which was the most popular film at the British box office in 1954.

Again, Mackendrick wanted to shoot *The Maggie* entirely out on location in Scotland, necessitating hand-picking a small crew to go up there with him. Having only recently joined the sound department, Rex Hipple knew he'd no chance whatsoever of being chosen, so simply sat back and watched with interest to see who got the job. A meeting was called where all twelve members of the sound department were told to return home and ask their wives if they could go to Scotland for three months. To a man the answer was a categorical no! 'We can't go,' they all said. 'Not for three months.' Someone Rex knew well by the name of Dick Dale was a bachelor and so didn't have any commitments.

I thought he would certainly go. Anyway, came the day and the last of the married folk returned saying how they weren't allowed to go, so they turned to Dick and asked, 'What about you?' And he said, 'Yeah, I'll go.' But to my astonishment L. C. Rudkin, the unit manager – and this is what I understood to be true – went up to the time clock, got this fella's card out and went, 'Look, he's late every morning. And if he's late clocking in here what's it going to be like up in Scotland?' So he got dropped. 'I'm really sorry, Dick,' I said to him. 'No, it's my own fault. I love dog racing. I go to the dogs every night. That's why I'm late in the morning sometimes.' Then, to my complete surprise, they turned to me and said, 'Well, what about you?' I told them I wasn't married but that I did have a mother to look after. She was ill at the time but said I shouldn't pass up an opportunity like this. So off I went and it was a truly memorable experience.

One of the most reliable writers at Ealing during this period was Jack Whittingham. Born into a life of privilege – his family owned a thriving wool business in Yorkshire – there were servants and holidays abroad and he was educated at a private boarding school. Jack went on to study Law at Oxford and during the war was stationed in Iceland. His work as a Fleet Street journalist brought him to the attention of Alexander Korda, before his move to Ealing, where Whittingham contributed six screenplays in total, including the highly acclaimed *Mandy*.

By far his most exciting project for the studio was a trip out to Kenya with Harry Watt on a location recce for *West of Zanzibar* (1954), a sequel to the hugely successful *Where No*

Vultures Fly, the only sequel Ealing ever undertook. Jack also hoped to acquaint himself with the region before settling down to write the screenplay. His stay out there turned out to be something of an adventure and luckily he kept a diary, which today may appear to fall on the side of political incorrectness, but nevertheless reflects the culture shock of a privileged 1950s Englishman abroad.

Getting out to the country proved exhausting in itself. Flying from London they stopped over in Rome ('very small airfield'), before heading on to Cairo and from there flying over the Red Sea into Aden, which didn't impress Whittingham at all. 'What land one can see looks godforsaken: it was! naked, empty desert.' They landed at 9 a.m. and even that early in the day the temperature was ghastly, 'Like a Turkish bath'. From Aden they flew into Ethiopia, which, from what brief look Whittingham got of it out of the window, he dismissed as, 'Grim, brown country, with dried-up rivers.' As they neared Nairobi, the scenery dramatically changed, 'The earth becomes really green again – lush.'

The general plot of *West of Zanzibar* involved a game warden, played by Anthony Steel, investigating a gang of ivory poachers, and very soon after arriving in Nairobi Jack and Harry met and spoke with the chief game warden and the head of the Kenya game reserves. Both were able to impart invaluable information on smuggling and raised points that were to add colour to the film. In the afternoon, Jack and Harry drove out to the game reserve. 'Almost at once we saw a rhino cow and calf. It was a chance in a thousand. There was a very awkward moment when she started to charge Harry's taxi, but luckily changed her mind and made off. They can overturn a truck – this small taxi would have been peanuts.'

After a couple of days the two men flew out to Mombasa. While the weather in Nairobi had been bearable, here it was cloying and sticky and unpleasant. The town itself was a sprawling mass of different cultures – African, Arab, Indian and English: 'Breakfast at the Carlton hotel where a monocled sahib is reading his *Times* newspaper with a tootling memsahib.'

After lunch they decided to wander though the Indian quarter. 'Some of it is absolutely squalid with filth. A main drain runs down the street. It is so extraordinary that in spite of all the filth and poverty, every now and again you see a quite ravishing young Indian girl in spotless linen.'

Next they drove around the African/Arab shanty town; again there was the putrid smell of poverty. 'How do a family of about twelve live in a hut the size of my study', Jack asks himself in his diary. That evening both men were invited to dine at the Mombasa club, which had the unfortunate disposition of being located almost next door to the main prison. 'And when the wind blew from the prison you could smell it.'

Out of Mombasa Jack and Harry travel by road and boat to towns and native villages looking for suitable location sites, driving along dust tracks, through coconut plantations and sugar cane fields and coming across the most picturesque fishing villages with huts on the bay made of palm leaves. In one village they ask a woman if they can go into her house but she refuses. 'Thought we were government spies come to see if her house was clean and tidy.'

After a little over a week they fly next to Zanzibar which from the air Jack describes as, 'A shimmering greeney-blue loveliness'. Once settled, Jack hires a guide and takes a stroll around the tangle of narrow streets, mingling with the crowds

made up of a multitude of races. While there, he speaks with a couple of poachers for storyline material.

Back in Mombasa Jack and Harry arrive to find they may be in a spot of trouble. Both are called to the provincial commissioner's office, who is in a bit of a flap, worried that the film might end up portraying Arabs as the main baddies. 'He had a letter from the Arab governor suggesting we might be making out the Arabs to be "slavers and thieves". He was perturbed from a government point of view by the chance of upsetting the Muslim world.' The governor made great play of the fact that it was only the Indians who smuggled ivory. In the end Jack and Harry tried to pacify things by promising to lay the blame at all or no doors.

A safari had been organised with a white hunter and twelve locals. A lorry followed behind loaded with water, petrol, camps and stores. 'All this country is still bare-tit,' Jack remarks, and mentions one memorable day while waiting in the truck when 'the most lovely pair of tits I've yet seen or ever hope to comes out of the bush. She is singing and carrying a gourd on her head.'

Chartering a plane to the island of Lamu, off the coast of Kenya, both stay in a hotel run by a seventy-five-year-old planter nearly deaf and going blind in one eye. 'His face is scarred all over from his fight with a leopard, which he killed. He only saved himself by thrusting his torn, wounded left hand down the beast's throat. But alas, the old bugger is a crashing bore.' The hotel was basic. 'The lavatory, which stinks, is a simple shaft that deposits its imports onto the sand below in the street. There is no water flushing, indeed no running water at all, and no electricity. There is also a bird's nest in my room with a very petulant noisy brood of chicks which prevent sleep

in the afternoon.' Jack felt like he was at the end of the world, completely cut off, which to some extent he was; the only way off the place was by charter plane or the weekly boat that brought supplies.

Formerly a large Arab settlement, Lamu felt very different from where they had just come from.

> After the bare-tit country, this place is a sharp contrast. All the women wear the veil – that is except the very old and ugly ones. An Arab who took us round said they really don't see their future wives till the wedding, and very often are <u>keenly</u> disappointed. Then, after four months, they divorce them. But the women keep this silly custom going. They keep veiled unless some prospective husband glimpses them and calls it all off!

Jack starts to explore the island. The town is mainly divided into the old Arab stone-built part and the native huts. It has narrow streets and goats and donkeys everywhere. Again, there is the pallor of poverty hanging over the place. 'Saw quite a number of Somalis. What magnificently handsome, dark, graceful people. But it is said they would knife you in a flash.'

Pretty much everywhere Jack and Harry go they run into expats, living a post-colonial existence. One such they find on an island by the name of Coconut Charlie, who arrived in 1910 to plant coconuts and stayed ever since.

> Unmarried, <u>very</u> English. And now a recluse. He never leaves his house, but is acutely alive and au fait. It comes of listening all the time to the BBC. He was very generous

241

with his gin. He told us that in the old days there was quite a big European colony, with many women. They all changed for dinner at nine, played tennis, and drank a hell of a lot.

Next stop is Garissa in Kenya, and with an Askari guide Jack and Harry go out into a game reserve. While driving they come across a herd of twenty-eight elephants. The driver quickly takes the truck off the road and goes downwind, but the herd has already sensed them. 'I could see they were going to charge. Frankly, I was scared. Scared, period. If the engine had stalled or we'd got stuck anywhere, we hadn't a hope. You can't stop a whole herd with one gun.'

In another village called Katwe in Uganda, elephants were a protected species and quite tame. There were so many of them in the area that road signs had been placed everywhere saying 'Beware of elephants'. One particular sign that Jack found amusing on the road out of the village read 'Elephants have right of way'. There were also plenty of lions about, but hippos were seen as the main danger. 'They will charge a car at night if the lights are on.'

Another fascinating place on this tour was Fort Portal in Western Uganda. 'The King of Toro lives in a palace on the hill top. He went to Eton and Oxford, and when he visits the hotel the boys fall flat on their faces and stay there till he tells them they may rise, which he is in no hurry to do.'

During this trip Jack and Harry faced their fair share of hair-raising moments. In order to cover as many miles as possible, they often chartered a tiny four-seater plane and landed in some hazardous spots, such as when they went to a place called Dar es Salaam in Tanzania.

The pilot couldn't land on the road because too many people on it. Circled several times round the travellers' hotel to let them know we wanted accommodation. Then to our horror landed on an abandoned airstrip upon which the grass was five feet high. The things we do for Ealing!!

Jack was never less than amazed at the lives of the people he encountered. In Kilwa, an island off the southern coast of Tanzania, after looking around the Arab town and the sultan's old harem, Jack popped into the local hospital. Two African boys had just come in with injuries from being mauled by a lion. Their father had managed to fend the animal off using an axe, but not before the first boy had suffered a lacerated arm, hand and thigh. The second boy had a torn left arm and thigh.

Now here's the incredible thing. The father carried those two boys four days through the bush into Kilwa. The Indian doctor told me they arrived with their wounds stinking, septic and badly swollen. They were in great pain – but pleased with themselves as heroes. They will recover.

By the end of the trip Jack had found the experience overwhelming and exhausting. 'The weeks of moving on, so fast, travelling so far, living on our nerves, are a hell of a strain. Harry is very tired, too. When we get back we'll have travelled over 16,500 miles in six and a half weeks. That's an average of about 400 miles a day.'

Harry Watt ended up directing *West of Zanzibar*, he was perfect for this kind of outdoor movie, since he was very

much a down-to-earth type of guy whom crews liked and respected. 'He was quite a character,' says Ken Westbury. 'When he lost his temper he literally used to throw his hat on the floor and jump up and down on it.' Yet he was also capable of enormous generosity.

> There was a local black guy working with us in Kenya and at the end of the picture, before Harry flew back to England, he gave this man the money to buy a small farm. It wasn't a lot of money by our standards, a couple of hundred quid, but it was enough for this guy to buy a farm and probably change his life. He was like that, Harry, the socialist type, though not overly so.

Ken particularly remembers filming on an Arab dhow, a traditional sailing vessel.

> The toilet facilities was a barrel that hung over the side they called 'the thunder box'. The other thing about those dhows was, whenever you wanted the sail put up or down, the Arab sailors had to go through this ceremony first called 'throwing away the wind', this big ritual. So you couldn't just say, OK let 'em down, they had to go through this whole rigmarole beforehand. And Harry Watt would sit on the thunder box with his copy of the *Sunday Times* and say, 'Let me know when you're ready, boys'.

The shoot was long and arduous and so Ealing had sent over one of their most experienced production managers to oversee it. 'However, within a few days he had gone stark staring mad,' recalls David Peers.

Apparently he saw black people as dangerous men who would kill him as soon as an opportunity arose. We had no choice but to ship him back home where he underwent treatment. And that is how I got the production manager's job. I stayed in Kenya for three months and had the time of my life. Kenya was a fabulous country, the red dirt roads were full of surprises, you never knew what was round the next corner.

The downside was that much of the shooting took place around the time of the Mau Mau uprising. 'Whenever we were in or near Nairobi we had to carry guns,' David confirms. He also remembers flying to Entebbe and from there making his way with the unit to the famous Murchison Falls to shoot game footage and Anthony Steel paddling his canoe. One unusual task was trying to get lazy crocodiles to move off the sandy strand that bordered the river. 'Many of them just lay there with their jaws wide open while little birds sat on the teeth and picked the remains of their last meal from them. We tried to stir them by throwing empty Coca-Cola bottles into their mouths, but unless you got a direct hit they had no effect.'

A professional hunter attached to the crew said that the only thing to do was to approach them from behind and make a hell of a racket as you ran towards them. David was deputised to join the hunter for the job.

We disembarked upstream and picked our way down towards the crocs. At a given signal we began to run holding a tin plate and a fork with which we tried to make as much noise as possible. I thought they would never move, but at the last moment they slithered into

the water and we just prayed that the cameras were turning and we were not in shot.

David was sorry to have to leave Kenya, it had become almost like a second home to him, and he had enjoyed life in the sun.

I landed back at a cold London Airport and went straight to the studios. As I walked into the canteen I saw a girl sitting up at the counter having her lunch. A newcomer and very attractive. I enquired who she was. Liz Webster, they said. I thought; I must get to know this lovely and interesting girl. I did. Eighteen months later we were married.

Chapter Eighteen

Shooting For Real

When Maureen Jympson turned nineteen, she contracted tuberculosis and had to be admitted to hospital. It was purely by chance that she was diagnosed in the first place. One of those mobile X-ray vans visited the studio and everyone was given free time to go and get checked out; Maureen was the only one to be called back. 'When I had to leave Ealing I was so frightened. But this is an example of the sort of place it was. I was away for about eight months and they took me back, they said, your job is here. How many companies would do that.'

On her return Maureen moved to the casting department, which was situated right at the front of the studio, and very nearly burnt her office down within weeks of arriving. Maureen worked for Margaret Harper-Nelson, Ealing's only casting director, and her assistant Thelma Graves. Margaret was one of the unsung heroines at Ealing, casting their films with a finesse and delicacy that greatly contributed to their success. She attended Cheltenham Ladies College and during the war worked for the forces entertainment group ENSA (wittily dubbed 'Every Night Something Awful' by the troops). Joining the studio in 1946 as an assistant, she was quickly promoted to casting director. It was a small office; there were never any vast

typing pools at Ealing. 'And Margaret was lovely,' confirms Maureen. 'She was a bit of a chain smoker, though, she always had a cigarette on the go. She lived in a flat in Chelsea but at the weekend would travel all the way up to Scotland where her mother lived.'

First thing in the morning Maureen always went into Margaret's office to light the gas fire.

> I lit the fire this particular day, thought the taper had gone out, put it in the waste paper basket, closed the door and returned to my little office just next door. All of a sudden I had a feeling something was wrong. I ran inside and the waste bin was absolutely aflame. God it was so quick. Anyway we got it out, thank God. But I didn't know what to do with myself. I was so ashamed for a long time.

The office itself Maureen remembers as,

> A bit shabby and well worn, shall we say. There wasn't paint peeling off the wall, they hadn't fallen into that kind of disrepair, it was just a bit dusty and musty, and in need of renovation. They probably were painted from time to time but I don't remember anything looking pristine particularly, it was all a little bit run down and care worn, but cosy in a way I suppose, comfortable.

The job was fairly straightforward but fun. If a director wanted a certain actor they would contact his agent and arrange for him to come into Ealing for a meeting. Or the search might entail shifting through the stacks of *Spotlight*, the actors'

directory, that were kept on a shelf in the office. For the smaller parts, open-casting sessions would be held. 'I would usually usher the actors into Margaret's office,' says Maureen. 'After that, the contracts would be written out and typed out and then sent out, because we never had emails or any of that stuff in those days, it was all done on the old Olivetti.' Carbon copies were made of everything and filed. 'As for making phone calls. I am horrified when I see people in offices today on their mobile phones. If we made a private phone call in office hours we had to ask for permission or do it once, sneakily, in a million years. You just did not do that kind of thing. You worked.'

Working mainly with actors, Maureen never really had any contact with Ealing's stable of directors. There was the one occasion she had to take some papers to Basil Dearden on the stage floor.

> I was so nervous that I was shaking, and he called me over and said, 'Sit down, dear, and tell me what's been happening to you,' and I was so in awe. That was the sort of place Ealing was; they were all gentlemen. I went on the set of *The Ladykillers* and *The Cruel Sea*, too, but we weren't really allowed on the set, for obvious reasons I suppose. They couldn't have everybody willy-nilly coming in and out. It was sort of an unwritten rule that you didn't go in unless you were asked to go.

Maureen also did a brief stint for Leslie Norman. 'He was a bit of a rough diamond, Les, frightened the life out of me. So that relationship didn't last very long. He was a gruff man but very kindly. Although he did not tolerate fools gladly. Whereas someone might modify their telling-off, he wouldn't. He told

me off once and reduced me to a jelly, a quivering wreck.' Maureen was typing a letter to Michael Balcon and had made a few mistakes and done her best to cover them up. It wasn't perfect work and there was nothing more she could really do, so left the letter on Norman's desk.

I was having my lunch with the girls when this figure came roaring into the canteen. 'You, outside,' he said. So I followed him out, I must have looked so pathetic. He got me outside. 'What do you call this?' I stood there with my mouth still full of undigested lunch and said, 'Sorry, I made a few mistakes.' He said, 'I can't send this to the boss of the studio.' I apologised and did it again. So our relationship didn't last. But he was well liked and was basically a lovely man.

Someone else who found Les Norman a little bit less than charitable at times was Ken Westbury.

I thought he was a bit of a bully if I'm honest. On this one film where I was still a clapper loader working on the second unit, it was quite normal for a trolley to come onto the stage for tea breaks, though everyone continued working. As clapper loader you had your own little tray and you got to know what the cameraman had for his morning break, what the assistants had and so on. Les was rehearsing quietly and I very gently came round the back with my tray and put a cup of tea down for him. He turned round and yelled, 'Who told you to bring that on the floor!' I mean; it was quite a normal thing to have a tea trolley. 'I'll see you never work in this studio

again!' He had a real go at me. And Gordon Dines, the cameraman, said to me, 'Just keep your head down for a while.' I heard later that Dines had a quiet word with the front office about Leslie's behaviour to his crew. The funny thing was, Leslie could be quite charming, as well.

And there is no denying that he was a capable director. 'He brought a refreshingly down-to-earth Cockney humour and wisdom to the predominately middle-class studio mix', was how Michael Relph described him. Beginning in the cutting rooms, Norman became a producer, notably on *Mandy* and *The Cruel Sea*. His first film as a director was probably his best for the studio, *The Night My Number Came Up* (1955), an effective thriller about premonition written by R. C. Sherriff, best known for his play *Journey's End*.

Ealing continued to forge ahead with its productions. *The Rainbow Jacket* (1954), directed by Basil Dearden, was the story of a middle-aged jockey, banned from racing, whose hopes rest on a young lad he's training to become the next champion. The unit visited several racecourses around the country (Lingfield, Sandown and Newmarket) and gathered tips from grooms and jockeys at numerous stables. Christopher Barry couldn't resist a little flutter. 'My first bet won me almost a week's wages and nearly hit the jackpot, missing by a nose. After that I lost and quickly retrenched.' The following weekend Christopher's wife came up to Newmarket and the stable boys let her mount a racehorse and gallop with them on the Heath, a thrilling experience she never forgot.

The Rainbow Jacket had everything for horse-racing enthusiasts: the colour, verve and excitement of the racetrack;

horses at exercise emerging from early morning mists; and even Sir Gordon Richards, fresh from winning the Derby on Pinza, making a special appearance. Alas, it didn't make much of an impact with general audiences, but it did inspire one twelve-year-old lad from a Scottish council estate, who for years had been teased about his small stature – Willie Carson. One afternoon, bunking off from school most likely as was his habit, he caught a matinee performance of *The Rainbow Jacket* and it literally changed his life. Coming out of the cinema he decided there and then to become a jockey and spent all his paper round money on learning to ride. Carson would go on to become one of the most successful and popular jockeys in the country.

Lease of Life (1954) starred Robert Donat as a middle-aged Yorkshire clergyman who, given only a few months to live, is determined to leave his mark. Donat hadn't made a film for three years due to a chronic asthma condition that had physically weakened him to the point where producers were reluctant to gamble on his health. 'That was Charlie Frend who brought Donat in,' says Rex Hipple. 'They managed to get the insurance for him, which was the great problem with Donat because of his asthma; he did suffer from asthma very badly. I think he lost several movies due to that because they couldn't get insurance for him.'

Christopher Barry recalls just how much of a sick man Donat was on that film. 'But he carried on professionally, though he sometimes emerged late onto the set because of the breathlessness he suffered. His dressing room was equipped with an air-conditioner that pumped ozone into it. I liked him a lot and he rewarded me at the end of the shoot with a handsome book token.'

Lease of Life marked the second occasion Christopher had worked with Charles Frend, but he blotted his copybook somewhat with the director by managing to lose half the cast. With location shooting up in Yorkshire, notably the beautiful Beverley Minster, it was Christopher's responsibility to make sure the actors caught their train from King's Cross to Kingston-upon-Hull. However, he was completely unaware that the train divided into two sections at Doncaster, the forward part going on farther north, the rear proceeding to Hull.

Unfortunately, some of the artists were up front in the dining car so it was a somewhat depleted cast that arrived in Hull. The stragglers eventually took a cab and arrived in the unit hotel before too long. 'But this really put me in Charles's bad books,' reports Christopher. 'And I became his whipping boy. On one occasion he told me off on location in front of cast, unit and gawpers for talking during a rehearsal. But as it wasn't me I answered him back and he had the grace to apologise later in the hotel bar. He was much more forgiving after this.'

The Divided Heart (1954) was a film that was ripped quite literally from a newspaper headline. During the war it had been one of Hitler's policies to seize babies in those countries his troops overran and send them back to Germany where they were brought up by childless women. This newspaper report concerned a Yugoslav mother who managed to trace her stolen son, and *The Divided Heart* is a fictionalised account of what must have been an agonising situation of the two mothers and the judge handling the case who had to decide what was best for the child.

Working on the film as assistant director was Gerry O'Hara, no more than twenty at the time. After working mainly on low-budget movies he had been recommended for the job by

Norman Priggen, who had worked at Ealing since the early 1940s as a production manager and then assistant director. Priggen was well liked in spite of his rather menacing demeanour. 'Norman pretended to be a tough guy and looked like a middle-weight boxer,' says Gerry. 'But he was a very decent guy and, after Ealing closed, he became Joseph Losey's right-hand man in films.'

Once installed at Ealing, Gerry reacted against the 'officers and other ranks' atmosphere that he felt pervaded Ealing. On location, he was made to feel a total outsider, never once invited to join the rest of the crew for dinner in the evenings. He'd go out to eat instead with the cameraman, Otto Heller, a Czechoslovakian exile, who was likewise ostracised. 'You could tell there was a touch of Otto being a Jew boy,' believes Gerry. 'People didn't talk about it, but it was around in those days. Ealing's directors had tremendous talent but they were a bit stuffy. Charlie Crichton, who directed *The Divided Heart*, was a decent fella, but he was rather abrupt and he wasn't exactly a jolly chap, and I don't think he really had much time for Otto.'

Heller had been hired a few times by Ealing due to the fact that he was supremely fast. His skills would later grace several top-notch 1960s classics such as *Peeping Tom*, *The Ipcress File* and *Alfie*. During shooting, Gerry and Heller struck up a friendship, mainly due to the Czech's faltering grasp of the English language. 'He was a very nice fellow, Otto, but he didn't speak very good English. In fact his English was appalling. And he couldn't read for tuppence, so he used to ask me what the scene was we were doing. Every day I would have to tell him what was going on.'

One particular morning Heller caught Gerry's attention and asked, 'What's this Richard de Third?' Being an ex-elementary

school boy, leaving at the age of fourteen, Gerry wasn't exactly an expert on such matters.

'Well, it's Shakespeare, Otto.'

'I know, but vot is it?'

'Why do you ask?'

'Because I am going to see Sir Oliver tonight.' He meant Laurence Olivier, who was looking for a cameraman to shoot his film adaptation of the classic play.

Thinking fast, Gerry went over to Balcon's office to see Michael Birkett, who he knew to be an educated man. 'Michael,' he said. 'Can you give me a "once upon a time" version of Richard III and could I have it by the end of shooting today.' Birkett seemed delighted by the request and by late afternoon Gerry had a couple of pages of synopsis.

Usually, Gerry and Heller travelled home together, catching the Tube from Ealing and alighting at South Kensington, where Gerry lived, sharing a quick coffee before Heller caught the train to Baker Street. In the café Gerry gave Heller the low-down on *Richard III* for his interview with Olivier, which went so well Heller was given the job. Before leaving, he asked Olivier if he had an assistant director because there was this chap at Ealing who'd helped him out. 'Send him over tomorrow night,' said Olivier. Gerry duly turned up and was hired, trebling his wages into the bargain. It proved to be his movie breakthrough, leading to a career in international movies working on the likes of *Anastasia* (1956), *Our Man in Havana* (1959), *Exodus* (1960), *Cleopatra* (1963) and *Tom Jones* (1963), before becoming a director in his own right.

On his last week working on *The Divided Heart*, Gerry was sent to see Hal Mason in his office. 'Look, Gerry, we're very satisfied with your work and we're prepared to offer you a

permanent job here at Ealing. The only thing is, the studio is closing for a fortnight for its annual holiday, and as you haven't got any holiday credit we can't pay you.'

Not exactly impressed, Gerry took great pleasure in revealing that he'd already got a job. 'Hal Mason was very cross as I remember,' says Gerry. 'Really cross. "Well, we won't ask you again," he said.'

Although he didn't like the atmosphere much at Ealing, Gerry did appreciate the highly organised way in which the place was run.

> There was a very interesting routine there, from what I observed. I realised that the directors and producers saw the rushes of each film and acted like a committee. Once or twice, walking through the stages I was surprised to find a set standing that we'd finished working on weeks ago. Obviously it had been packed away and then the committee had said, you can do with another mid-shot or a couple of close-ups, so they quite calmly rebuilt the set and we'd have another go at it. It was a remarkably good opportunity to put things right and improve things. It was very efficient.

One of the most impressive aspects of *Out of the Clouds* (1955), a routine drama comprised of several small stories dealing with the passengers and crew on an average day at a busy airport, was the production design, especially the airport terminal set.

At the time, the first permanent passenger terminal was in the process of being built at London Airport (later Heathrow) and Ealing's art department secured a major coup. 'We managed to get the original plans from the architects,' says Norman

Dorme. 'And we built part of the concourse, with this big stairway that went up. I clearly remember the architects arriving at the studio one day to see the set which we'd built more or less according to their drawings and them later telling us that after seeing their plans in actuality it allowed them to make a few adjustments before the whole thing was built for real.'

The film featured an interesting cast, although the female lead, Margo Lorenz, made herself quite a pain according to Christopher Barry, 'due, I think, to her insecurity'. As for James Robertson Justice, Christopher found him to be, 'certainly a character to reckon with and not one to cross'.

The airport consisted of just the one major runway and the film required numerous shots of airplanes taking off and landing. David Peers was handed the job.

> Thanks to the marvellous PR chief at the airfield I was allowed to go anywhere, anytime in my little Ford Popular. The cameras were set up on the edges of the runway and we got some stupendous shots of tyre rubber scorching the Tarmac. Much later in my film life I had occasion to organise a shoot at Heathrow and, quite apart from the exorbitant cost, we were not allowed even on the aprons.

Again, David was working as production manager on the unit, his job revolving around organisation; it came with great responsibility and certainly kept him on his toes.

> Whilst one was concentrating on today's shots, one was always thinking about the following day, what time to call the artists for make-up, what changes to the sets

257

were needed, adding a couple of flats here, removing a door there, and so on. Maybe the electricians had to move the gantry and reposition the lights. Maybe Wardrobe had to alter a dress or buy another pair of boots. Maybe the rushes revealed a major or minor blip to one of yesterday's shots and that meant having to do it again or revamping it in some way. So the task of a production manager was to not just concentrate on today's work but tomorrow's as well, and quite often next week and next month!

The Ship That Died of Shame (1955), from a short story by Nicholas Monsarrat, was a film that tackled the subject of servicemen after the war trying to readjust to the difficulties of civilian life. The plot had the crew of a much-decorated motor gunboat, now all unemployed, who buy her back from a scrapyard and use her to smuggle black-market goods across the English Channel. This was a worthwhile topic to be sure, but one that might have worked better in the years directly following the cessation of hostilities, not ten years later. As it was, the film came across as dated to the cinema-going public and created the impression that Ealing was behind the times and adrift amidst the current trends in cinema.

For Christopher Barry, though, the film proved a significant one as it saw him promoted to first assistant. 'It was obviously exciting, as well as something of a learning curve. It was terrific working out of Portsmouth with the Royal Navy and their motor torpedo boats at up to fifty knots!' Having not forgotten his cock-up on *Lease of Life*, when half the cast ended up in the wrong town, Christopher chalked up another bad 'boob' one day when they were shooting on the gunboat. Lunchtime arrived

when he suddenly realised that everyone's lunchboxes were on the supply ship anchored some twenty miles away and valuable shooting time was lost as they sped back to retrieve them.

Back in the studio, Christopher received his comeuppance when one morning he was on the deck of the mock-up boat, checking that everyone was ready to go for a take. 'Unknown to me, Basil Dearden gave the cue for a tip-up tank to pour its load of water which showered down, soaking me, much to the delight of the crew! I rushed out to the wardrobe department for dry clothes, gaining a good pair of Richard Attenborough's grey flannels in which to return to the set. I kept them for many years.' Despite this prank, Christopher had a lot of time for Dearden, working with him three times in total at Ealing. 'He was always extremely friendly to me and a good man to work with and to observe at work.'

The Ship That Died of Shame was not a great success but it has its moments. In the scene where the gunboat is under attack from another gang of smugglers, there is a shot of Dickie Attenborough on the bridge, grabbing a German Schmeisser Maschinenpistole and returning fire. 'But back in those days they didn't have 9mm blanks, which the Schmeisser took, as they've got today,' remembers Tony Rimmington. 'They had crimp blanks, which only fired one round and then they jammed. The director was determined that Dickie fire the Schmeisser, so the decision was made to use live ammo. This particular gun wouldn't fire unless it had live ammo.' With not a Health and Safety inspector in sight, Tony was asked to build what amounted to a shooting range that Attenborough could fire into; otherwise the bullets would whizz through the studio walls. 'So I made this sort of ramp out of sandbags and Dickie must have emptied a couple of magazines into it, all live ammo.

I put wings on the ramp in case there were any ricochets left and right and everybody got out of the way. The only people who were anywhere near it was the camera crew. You'd never get away with that today.'

In the end it wasn't bullets that proved the most dangerous thing on the set for Attenborough, but the gigantic tanks of water that on a certain cue were tipped over onto the deck of the ship where the actor was standing. 'Unfortunately we had underestimated the force of the water,' recalls David Peers. 'And poor Dickie emerged coughing and spluttering and screaming for help. He'd broken his arm. Rapid rescheduling then took place and a new wardrobe was made for Attenborough to allow space for the plaster cast underneath his jacket.'

Chapter Nineteen

Sellers & Co

While there is an argument for *Kind Hearts and Coronets* being Ealing's most accomplished comedy, certainly their most famous is *The Ladykillers* (1955). Curiously it was a film that began life as a dream, and when screenwriter William Rose woke up he hurriedly wrote down as much of it as he could remember. The same day he met Alexander Mackendrick, for whom Rose had written *The Maggie*, for a lunchtime drink in The Red Lion and told him all about his idea of five criminals planning a robbery in the house of a sweet old lady. When she discovers what's going on, they decide to kill her before she goes to the police, but they haven't got the guts and end up killing each other. When the two men went to see Balcon to pitch the idea to him, Rose recalled that Balcon never took his eyes off him as he related the story, just occasionally glancing over in Mackendrick's direction. When Rose finished, Balcon looked at them both and said, 'As I understand it there are six principal people in this film and by the end of it five of them are dead and you call this a comedy?'

William Rose was an American born in Missouri who came to England after the war to get into films. After completing a screenwriters' course, he at first struggled to find work. It

was after writing *Genevieve* (1953) for Rank that he came to the attention of Balcon and arrived at Ealing. Following *The Ladykillers*, Rose wrote three further Ealing films, but none matched the bravura and originality of this dark comedy. In the 1960s he returned to America where he wrote two of his most successful films, the slapstick epic *It's a Mad, Mad, Mad, Mad World* and the satirical *Guess Who's Coming to Dinner*.

Mackendrick had hoped to cast Alistair Sim as Professor Marcus, the unorthodox leader of a gang of crooks who stake themselves out in an old lady's attic, pretending to be a string quintet. However, Balcon was against it. 'We're making money with the Guinness films, we're on a run of strength there. It's got to be Guinness.' When Alec was offered the role and first read the script, he called Mackendrick up. 'But, dear boy, it's Alistair Sim you want, isn't it?' It didn't matter. Professor Marcus became another brilliant Guinness Ealing character.

Guinness's first approach was to play him as a cripple, dragging his leg pathetically across the floor. 'In my office Alec gave an imitation of a cripple which was really gruesome,' Mackendrick recalled. 'Horrendously funny, but stomach-turning in its effect. So I had to say, no, sorry, Sir Michael Balcon will never, never stand for that.' Guinness was a bit put out by this and went over to the window as Mackendrick continued going through the script. As he talked, Guinness grabbed a pair of scissors and cut out some paper teeth, which he nonchalantly popped in his mouth, turned round and grinned at Mackendrick. The effect was startling.

The rest of the gang were filled out brilliantly. David Peers, who worked on the film as production manager, recalls them all.

There was Peter Sellers, who was just starting in the business. Cecil Parker, who I knew very well. He was a lovely man, a very good actor but almost too nice to be in the film game. Herbert Lom was possibly the most difficult one of the lot; he had his own ideas. As for Danny Green, who played One-Round, well, he was exactly as you would expect being an ex-boxer. He was very nice, but not endowed with the greatest of brains.

All they needed now was to find the perfect location for the house. Norman Dorme and a few others from the art department went to King's Cross to scout around. 'I found a street, with Victorian terraced houses on either side, and a brick wall across the bottom, then beyond that was all the railway lines going out of King's Cross station. I thought it was an ideal setting.' This was Frederica Street, long since demolished. Even better, it was a No Through Road so it was ideal for filming purposes. 'We built the house across that brick wall at the bottom, and that wall went straight through the house, although in the film it looks as if it just came in at the side.' The house was a composite set with a reinforced roof, as people needed to climb on top of it. It was also perfectly proportioned and sturdily constructed in order to withstand the elements. There was nothing inside except a mass of scaffolding.

With the unit due to film there for several weeks it was David Peers' job to go round to each house and tell the occupants what was going to happen. 'The local people were very cooperative and didn't complain at all. At this one house they were very charming people and used to allow us to go in and have a cup of tea. They also kindly offered their hospitality to the actors to go in and sit there and rest.'

Before starting work in the mornings, the crew would all meet up in a greasy spoon café near Frederica Street for fried egg and bacon sandwiches. Meanwhile the director and other senior types would breakfast across the road at the Great Northern Hotel. However, as the days went by, people gradually defected from the Great Northern, preferring the fry-up at the greasy spoon and the gossiping of the crew.

Dorme visited the location one day in order to measure up a few things that had to be reproduced in the studio. He climbed over the wall and walked down the embankment and across the bridge.

> And when I got home, when I took my shoes and socks off, my feet were black – not just dirty, black! It was the soot. Everything around that area was layered in soot. I noticed something else, too. This was in the middle of summer but all the windows of the houses down the bottom of the street were tightly shut. It was fairly obvious why, and they all had that sort of sheen on them that you get with petrol on water. God, to have had to live in a place like that!

After a few years working as Balcon's personal assistant, Michael Birkett had landed his first job on a film. 'I was the third assistant tea boy on *The Ladykillers*,' he jests.

> And I had a motor car in those days – not everybody did – so I used to put the cast into it, Alec Guinness, Peter Sellers, Herbert Lom and Cecil Parker. I used to drive them about and of course any insurance company would have had a heart attack if they found out, but in fact I

didn't crash into anything; I was quite a good driver. I used to drive them to and from location, we moved around quite a bit.

One of Michael's jobs on *The Ladykillers* was unorthodox to say the least.

Sandy was very keen that there should be big puffs of smoke covering this house. So I was sent up onto the roof to see when the trains were coming. I sat up there and as one began to approach would shout, 'Stand by', and then finally, 'Roll 'em, action', which was the cue for Alec to start off down the path. And it worked, very successful I was. I had to duck behind the chimney when I said action so the camera didn't spot me.

Michael remembers Katie Johnson, who played Mrs Wilberforce, the old lady the gang try to dupe, as enchanting and very sweet. The insurance company, however, were extremely worried due to her advanced years (she was in her mid seventies) and the possibility that if she died or fell ill the filming would have to begin again with another actress, and that would mean an increase in the budget. What they proposed was an enormous fee for her insurance. 'Katie got to hear about this,' recalls Michael. 'And she came up to me one day on location and said, "I hear they're having a little trouble with me on account of the insurance, so I'd like to help," and she reached inside her purse. The actual premium was £1,500, something colossal like that, so the idea of Katie reaching into her purse for a couple of shillings to help was so sweet. I said, "Katie you're not to do it, I won't have it. It's something the

studio pays for so don't worry yourself about it." She was a darling lady.'

The whole crew adored her. The studio had put Katie up in a boarding house on Ealing Common, which was about half a mile away from the studio, and organised a car to pick her up in the morning and bring her in. 'Oh I don't need a car,' she said. 'I can walk.' Another memory of Katie is that she had one of those old-fashioned sweet jars full of Fox's Glacier Mints that she would bring onto the set with her and insist on giving one to Michael Birkett every day. 'There you are, my dear, that'll keep you going.' The last thing Michael wanted at seven in the morning was to suck on a Fox's mint. 'So I used to put them back into a jar myself, and at the end of the picture I had a full jar of Fox's Glacier Mints and Katie had an empty jar.'

In real life Katie was not at all like her screen character, who is rather absent-minded and an innocent in a changing world. 'No, she was much brighter than that,' reveals Michael. 'She was entirely naive in the sense that she was a bit batty about things, but she wasn't as dim or gullible as Mrs Wilberforce.' In fact, David Peers remembers Katie as being quite cunning. 'Alec Guinness was the star but Katie very nearly stole the film from him and in the scenes played between them it was amusing to watch each striving to upstage the other.'

As for the rest of the cast, Michael found himself particularly drawn to the young Peter Sellers. 'We all thought he was a star in the making. No doubt about it.' Sellers himself didn't think so. Balcon revealed that during filming, Sellers 'was desperately anxious. He kept asking, "Is it alright? Am I any good?"'

Sellers was on the cusp of becoming quite famous. He'd done *The Goon Show* and was beginning to make films, although *The Ladykillers* was his first film of distinction.

According to Michael, he had just bought his first second-hand Rolls-Royce.

> But after a few days we noticed he was looking very carefully at the paintwork, and had decided that it wasn't up to scratch. He used to stick little bits of sticky tape anywhere on the paintwork where he thought it was imperfect. We all thought this was neurotic to a degree, and we said, 'Peter, you'll go bananas if you carry on like this.' But he told us that he was going to write to Rolls-Royce saying, now look here. We tried to persuade him to be more rational, but he wasn't.

David Peers can remember a very real sense of rivalry between the members of the cast, but Sellers had an ace up his sleeve; his gift of mimicry.

> One day whilst on the King's Cross location it was pouring with rain and we all sat around, glumly waiting for it to stop. Peter came in with a tape recorder and played a tape in which he had mimicked everybody on the set, especially Alec and Sandy. It was brilliant and from then on we all took much more care of what we said within Peter's hearing.

Michael has never forgotten the occasion when Mackendrick asked Sellers to improvise something in the scene where his character Harry, a retarded teddy boy, draws the short straw and has to bump off the old lady. 'OK, I'll see what I can do,' said the comic actor. Mackendrick had set the camera up at the far end of the set and Sellers had to walk towards it, turning

over in his mind how he was going to commit the murder. 'He went through a whole catalogue of how to assassinate people,' says Michael. 'He did strangling, shooting, drowning, knifing, everything, a whole array of assassination techniques, as he made his way down to where the camera was and then at the very end just gave a despairing look that meant, can't do it, don't know how. It was an absolutely brilliant shot, but for some reason it wasn't used in the final movie. It was all completely off the top of his head.'

Michael could tell that Sellers was very much influenced by Alec Guinness. On the set he'd watch him like a hawk, derive inspiration from him. According to Michael, 'Alec was without doubt the most inventive film star I ever met. You could rely on Alec to think of all sorts of clever ideas. Any shot you care to set up, Alec would improve it, he was marvellously inventive and clever about things.'

There was someone else, too, that Sellers had picked up on, not a fellow actor this time, according to Michael, but a member of the crew.

Ealing had a frightfully active union situation and Peter Sellers loved listening to them. I'm sure he got all sorts of ideas for when he played the ultimate union steward Fred Kite in *I'm All Right Jack* (1959). He borrowed all sorts of dialogue from them. I used to say, 'Listen out for the boom swinger, Peter, he's a union man and he makes marvellous union remarks.' One wonderful phrase of his whenever we did something he thought went against the work force, he'd say, 'It's barefaced provocation of the workers,' which went into *I'm All Right Jack*. Peter delighted in this boom swinger.

One of the highlights of the film was the robbery itself, again shot around the King's Cross area. On an early recce, Mackendrick had spotted one of those huge gasholders and thought it an ideal place for a high-angle shot. Grabbing David Peers, he wanted to go up and have a look. David followed rather gingerly behind.

I hadn't reckoned on the fact that you climb up a gasholder by a vertical ladder fixed to the side. Nor did I realise that the top is curved and there are no railings. So you stand at a hundred or so feet on this slippery curved roof and if you should slip you just go over the edge and that's it … curtains. I was absolutely terrified. And Sandy seemed to be totally ignorant about this and had no fear whatsoever, walking around, went to the edge, went back to the centre, talking all the time. I stood there numb with fear.

Eventually Mackendrick said, 'Yeah, I think this'll do very well.' All David wanted was to get back on terra firma.

Once down, David told Mackendrick that there was no way on earth he was going to risk sending a crew with a heavy Technicolor camera up that blasted thing. With some reluctance Mackendrick agreed and a cherry picker was used instead. 'Sandy was one of those men for whom anything was possible,' says David. 'If he wanted it, he would get it, even if it meant killing half the crew. But he came round eventually and saw sense.'

After the robbery, the gang stash the money in a cello case as they make their departure from Mrs Wilberforce's house, only for the case to get stuck in the door and for Danny Green's

One-Round to give it too much of a heave so it breaks open and pound notes flutter out onto the pavement. While planning the shot, Mackendrick and others debated just how much money could actually fit into a cello case. As it happened, Michael Birkett got in touch with his bank manager to see if he could solve this dilemma. The answer was something in the region of £60,000, which disappointed Mackendrick somewhat since he was hoping it might be nearer £200,000. Still, £60,000 was a hefty figure back in those days.

Mackendrick then faced another challenge. He wanted to use real notes. David Peers was dispatched to a bank to see what could be done.

> It was agreed that we could have just the top layer made up of real notes and all the rest would have to be fake. We must have had something like £1,000-worth of real notes lying on the top layer and the props department were told to look after them. I remember having fun with the property master saying, 'I think at the end of the day we ought to count the notes and make sure they're all there. I'll look after them overnight and bring them back in the morning.' There was always one or two missing but I wasn't too concerned about that, you know, that's life.

The Ladykillers is really Ealing's last hurrah; certainly it's the last film they made of any real distinction and art. The critics lapped it up. Alan Brien in the *London Evening Standard* thought it, 'undoubtedly the most stylish, inventive and funniest British comedy of the year'.

It also proved to be Mackendrick's Ealing swansong. Sensing that the studio was in decline, he left for Hollywood where he

made the classic *Sweet Smell of Success* (1957). But his career faltered after that and he only made a further three movies, none of which matched his undoubted creative talent. He ended up teaching Film at the California Institute for the Arts almost up until his death in 1993. It's Betty Collins who can probably best sum up what kind of man Mackendrick was.

I can remember once when Sandy was nominated for an Oscar for *Man in the White Suit* and I was more excited than he was. I pinned the notice that said he'd been nominated onto the wall of the office, and he came in and looked at it and he was so embarrassed. 'You can't put that up.' 'Why not?' I said. 'Because you can't.' He wouldn't have it and I had to take it down.

Chapter Twenty

"I'd Steer Clear Of The Film Business"

Armed with a special pass from his commanding officer, nineteen-year-old David Tringham was shown through the gates at Ealing Studios and directed to the offices of Hal Mason. David was unsure what lay in store for him but felt suitably confident, dressed as he was in a smart dark-blue double-breasted suit.

After a short wait he was ushered into an unimposing office and asked to sit down. To his left was Mason's assistant, Baynham Honri, a small academic-looking man with plain glasses who had been in vaudeville before entering films. In contrast Mason, who sat on the other side of a predictably large desk, was very dapper as David recalls, 'with clean features, hair sleeked back from a bullet-like forehead'. He was wearing a sympathetic, almost resigned, expression. There was hardly any small talk at all besides the obligatory good morning. Mason came straight out with it. 'If I were you, I'd steer clear of the film business. There's no future in it. Find something else to do.'

This wasn't exactly the advice David was hoping to hear. Almost at the end of his National Service, he was keen for a career in the film industry and his father, an advertising executive, had managed to wangle an interview for him at the

studio thanks to one of his secretaries having previously worked there for Balcon. Now here he was being told in no uncertain fashion not to come into the business at all.

'But I don't want to do anything else,' David heard himself say. 'I want to make films.'

'Make films?' said Mason. 'We all start off like that.' There was polite laughter. 'Which part of the industry are you interested in?'

'I don't know, really, I suppose I want to be the person who decides what happens, what's got to be done.'

'You want to be a director,' said Mason.

'Yes,' replied David. 'I suppose that's what it is.'

'The best way to be a director is through the cutting rooms,' said Mason. 'Be an editor. All our directors come from the cutting rooms, don't they, Bay?'

Honri nodded in agreement. 'Almost without exception,' he said.

'So that's what you should do,' said Mason. 'How does that sound?'

'Sounds marvellous,' said David, not believing his luck.

'By the way, what film directors do you admire?'

'Jean Cocteau, René Clair and John Ford.'

'Interesting,' noted Mason. 'What about our films? What do you think of them?'

'I liked *The Man in the White Suit*, and *Whisky Galore* was good.'

'Another of Sandy's fans. They all go for him,' said Honri.

'Anyway,' said Mason, ending the meeting. 'If you don't change your mind about coming into the business, and I suggest you do, give us a call when you come out of National Service and there'll be a job waiting for you.'

David said his thank-yous and was led out into the corridor by Honri, who asked if he fancied popping onto one of the stages before leaving to see how it was all done. 'They're shooting a picture called *The Ladykillers*. Being directed by Sandy Mackendrick. When you go on, keep to the back, don't make any noise and let yourself out when you've had enough.'

'Thanks, thank you very much. For everything.'

Honri pointed David in the right direction and, before turning to leave, said with a wry smile, 'The film business isn't so bad.'

The stage was a blur of activity and it took David several minutes to acclimatise himself. Much of the activity seemed directed towards a brightly lit area that contained the set of an attic room, where a bunch of oddball-looking actors, some dressed in flashy suits and holding musical instruments, were in discussion with an elderly lady. As David edged closer to hear what everyone was saying, there was a loud cry of, 'I think we're about ready.' The old lady exited the room and the other actors composed themselves. What David had been watching was a rehearsal. He was fascinated. As the camera pulled back, wardrobe and make-up people swarmed in for last-minute adjustments. A bell sounded and the red light went on. 'Turnover,' went a voice. Then, 'Action!'

It was at this point that David recognised a couple of the actors, Alec Guinness, despite the horrific set of dentures, and Peter Sellers. They were all pretending to play their instruments as the old lady knocked and walked into the room with a tray of tea. 'Cut.' The voice belonged to Mackendrick. 'Once more. I think we can do a better one.'

Everyone got on with their individual jobs as Mackendrick readied for another take. Just then David was approached by

one of the crew. 'This'll be a good one, this will,' the man said. 'Sandy's the best, knows what he's doing.'

'Does he?''

'You bet he does. Not like some of the others.'

Proudly David told the man that he fully intended to be working at the studio soon.

'Will you now,' said the man, not very impressed. 'Remember me, then. Name's Harry Phipps. Props. They always ask for me. I can get anything you want.'

David hung around for a while longer; nobody else bothered to come over and talk to him. 'But it was fascinating to watch the filming continue. So little seemed to get done, yet I could see progress being made from one shot to another. There was so much about which I knew so little, that I couldn't wait to get started and familiarise myself with it.'

As he'd been requested to do, David contacted Ealing after his demobilisation and was once again back in Mason's office, only to be told there was no job for him in the cutting rooms. No job at all, in fact, save for something in the upstairs office working with a gentleman by the name of Rudkin, who kept accounts of everything in the studio – charts, progress reports and the like. Mason asked for Rudkin to come down and in walked a rather gruff fellow who had the habit of barking in place of normal speech.

'OK young man, you'll do. Right. Start tomorrow.'

'Well, the thing is,' David said apologetically, 'I was going to go to Paris.'

'If you don't want the job …'

'I do. I do. It's just I've been two years in the army and I was hoping to have a short break before I started here.'

'If you don't start tomorrow, no job.'

David asked couldn't he at least start the day after tomorrow and it was agreed. He was paid £5 a week, the bare minimum, and his first duties were to deliver call sheets and other menial tasks. After just a few weeks his break arrived when he was asked to be third assistant for Basil Dearden on a comedy starring a very young Benny Hill called *Who Done It?* (1956). 'A piece of rubbish, really,' David admits. He also discovered rather quickly that third assistant did most of the jobs everyone else on the unit didn't want to do. In the film there was a chase around Notting Hill Gate, which required a bloodhound to stop at a road junction in order for Benny Hill to run past it. Animal training in British films was in its infancy, no one quite knew how to get this animal to do their bidding. Tom Pevsner, the assistant director, told David to run the dog round the block to get it out of breath. 'What a stupid thing to say,' argues David.

> It's a bloodhound, that's what they do, they run forever. I went chasing round with this thing and it didn't work. Nobody knew what they were doing. So one minute I was in charge of a barrack room of the most difficult soldiers in the army, the 39th Heavy Regiment, which was all the rejects and the troublemakers, and the next I was running this bloody dog around, trying to get it out of breath.

The hope with *Who Done It?* was that Ealing would create another comedy star in Benny Hill, a successor to the likes of Tommy Trinder, Will Hay and Stanley Holloway. His hit TV show had caught Balcon's eye, and Tibby Clarke had accompanied the comedian on a recent music hall tour of the country in a bid to capture his personality to fashion a script

that involved Hill donning numerous disguises as a private detective investigating a plot to assassinate British scientists. It was a tough schedule for the star as he was appearing at the time in a twice-nightly revue in London's West End. That meant waking up at six in the morning to get to the studio for make-up at seven-thirty, where he'd invariably slump down in the chair and fall asleep. After a busy day's filming, a car would race him to the theatre for the first of his evening performances. It was hectic, and often Dearden would turn round to direct Hill only to see him fast asleep right on the set.

During filming there was the inevitable fracas with the unions. Relations with union officials had the tendency to sometimes descend to the levels of total farce and such was the case here. One sequence in *Who Done It?* was to take place at Earls Court Exhibition Centre during one of their large-scale exhibitions, and the film-makers had made a deal with the venue's management to buy up a lot of old stands and ship them down to Ealing. 'The construction folk at the studio got very uppity about this,' recalls Rex Hipple. 'Because they wanted to make them, and the director said, "What for? They're already at Earls Court, all we have to do is bring them in."

Michael Balcon got wind of this, that there was trouble brewing, and so he said, "OK then, I'll shut Ealing for good." I remember at the end of that week all the secretaries were given their notice; he was going to close it up. And one couldn't blame him, the unions were just being bloody-minded.' What the unions probably didn't know was that the studios were already under the threat of closure, but Balcon's stance ended up working. 'I mean, Ealing was the goose that laid the golden egg for a lot of us,' says Rex. 'We were all on decent wages. But I was quite proud of Balcon. I thought he did the right thing,

he couldn't be held to ransom by the construction folk who just wanted to make all the sets that were virtually just sitting outside the gate waiting to be brought in from Earls Court.'

Another duty on the film for David was getting Basil Dearden his lunch. 'Go to the canteen, dear boy,' he'd say ('It was so patronising,' admits David), 'and get me a Wiltshire bacon sandwich with the rind cut off, best Wiltshire, and no crusts. And a coffee.' So off would go a mightily irritated David to fetch this, thinking – am I a waiter or something? And then he'd never eat the damn thing. 'So you were following him around like it was the bloody Dorchester or something. But that's the kind of thing you did; that was what the third assistant did. But there was a way of doing it, a thank-you, for instance.'

One night, going home, David met Dearden on the train. 'How are you getting on, dear boy?' he asked.

'OK,' said David. 'But I'm not mad about the coffee and sandwich service.'

'I would do it myself,' said Dearden. 'But I can't leave the camera.'

It made sense and did alleviate the resentment slightly. In fact, David got to quite like Dearden. When Ealing Studios closed down, just three months after David arrived, Dearden was the only one who helped him get another job. Out of work and desperate, David telephoned Dearden out of the blue. 'You probably don't remember me.'

'Of course I remember you, dear boy.' David asked if the director knew of any films starting up. Expecting to be told to bugger off, Dearden instead said there was one just about to get under way. 'Ring these people, it's called *The Green Man*. Just tell them I told you to ring.'

David arrived at the production office the very next day and was warmly received. 'You've been highly recommended by Basil,' said the producer. 'So we'd like you to do the film.' Just like that. It was a terrific break and David went on to become one of the top assistant directors in the business, working on numerous films including *Lawrence of Arabia* (1962), *Ryan's Daughter* (1970), *An American Werewolf in London* (1981) and *Highlander* (1986).

In style and execution, *The Green Man* was almost a typical Ealing-style film, and starred one of the studio's past collaborators, Alastair Sim. David caught a lift back into London once in Sim's private limo.

> I thought, this is my opportunity, I must ask him something serious about his craft. So I plucked up the courage and said, 'Mr Sim,' because it was always Mr in those days, no familiarity. I said, 'Do you mind if I ask you a question?' He said, 'What is it?' I said, 'What is your attitude to acting?' After the briefest of pauses he replied, 'I don't have one.' And that was that, end of conversation.

Dearden was one of the very few Ealing directors to carve out anything like a successful career after the demise of the studio, with *The League of Gentlemen* (1960), *Victim* (1961) and *Khartoum* (1966) among his most famous works. David recalls that on *Who Done It?* Dearden used to act out all the parts before a take and was sometimes much better than the actors.

'I used to laugh like mad at the back. He'd go, 'This is the way I'd like you to play it …' He had a slightly avuncular way of speaking. And he couldn't say his Rs properly.'

Tragically, in 1971, after directing the Roger Moore drama *The Man Who Haunted Himself,* Dearden was killed in a car accident. 'No one quite knew what happened,' David claims. Was it an accident, was it intentional, or had he been drinking? 'He crashed the car straight into the barrier between the slip road and the motorway.' He was decapitated at the wheel.

David left Ealing soon after *Who Done It?,* not having enjoyed the experience of working there at all.

> It wasn't fun, they weren't fun people, they were too pompous and insecure. They couldn't fool around and have a bit of fun because Michael Balcon might say you've got to take this seriously. Well, you take it seriously but there has to be a safety valve, and there wasn't at Ealing, they were just so uptight and not very nurturing. And it should be fun, making films is doing something creative, but they weren't into any of that, they played it safe.

Someone else who had grown disenchanted with Ealing and soon left was Christopher Barry. *The Feminine Touch* (1956), which followed a group of student nurses as they enter the National Health Service, was the last Ealing film he worked on. The reason he decided to go was simple: 'I was no longer being used as a first assistant and was being used mainly as a researcher for the upcoming film about Dunkirk over at the Imperial War Museum and newspaper archives, and saw my future as bleak.' Still, Christopher never regretted his time at Ealing; indeed saw his eight years working at the studio as a grand start to his career, first in the script unit and then in production. 'All this set me up well to get the job I eventually

got at the BBC. There was also the opportunities Ealing gave me to observe different directors at work and absorb much of the know-how needed anywhere in the film and TV industry.'

Once again it was Basil Dearden who helped out. Dearden must have recognised Christopher's plight at Ealing and told him about an ad he'd seen for production assistants in BBC TV Drama, and suggested it might be just the thing and that he should apply quickly. And so it proved. With his experience at Ealing, Christopher quickly climbed the ladder to become a fully fledged director on such series as *Z Cars*, *The Onedin Line*, *Poldark* and *All Creatures Great and Small*. But it was his sixteen-year association with *Dr Who* that is perhaps his greatest television legacy. It began in 1963 when Christopher was entrusted to direct the show's second-ever adventure, which introduced the now legendary Daleks. Christopher worked on a further three stories featuring the original doctor, William Hartnell, before returning in 1966 to handle the tricky job of introducing a new actor in the lead role, Patrick Troughton, thus cementing the long-term success of the series. With the third Doctor, Jon Pertwee, Christopher directed two episodes, 'The Mutants' and 'The Daemons', considered by many to be among the series' finest. In 1974, Christopher once more found himself introducing a new Doctor to the public when he was asked to helm Tom Baker's first adventure. As Christopher told me, 'If I didn't quite make my ambition to be a film director I achieved enough to assure me a happy and creative career.' Christopher passed away in February 2014, just a few short weeks after we had corresponded for this book.

Chapter Twenty-One

Ealing Shuts Down

At the time of its release, *The Long Arm* (1956) wasn't seen as anything significant, just a routinely efficient police drama about a team of British bobbies, led by Jack Hawkins, trying to solve a complex case involving a series of burglaries. It was, however, the very last picture made at Ealing Studios under Balcon's rule.

Michael Birkett was second assistant on the film and his lasting memory of it was working with Hawkins.

> Jack was everybody's favourite, a sweet man. I liked him very much. He once showed me a letter he'd been sent by a watch firm saying would he be kind enough the next time he was in a movie, instead of saying the time is such and such, would he say instead, the time by my Seiko watch or whatever is … And Jack gave me this letter and was totally outraged by it. Jack was very nice. We all loved Jack.

Appearing in a small role as a policeman was a young actor by the name of Nicholas Parsons, who would go on to have one of the longest careers in show business, still gainfully employed by

producers at the age of ninety as the perennial host of BBC Radio 4's *Just a Minute*. Nicholas found Ealing, 'A pleasant atmosphere to work in and very well run'. More importantly, he saw the studio's film output as a very real evocation of the characters and people who used to inhabit these islands.

The Ealing films certainly reflected Britain as it was in those days. They recreated an image. I was young during the war and things changed dramatically as the years progressed and we came into the 60s and all that breaking down of all kinds of old-fashioned attitudes and ideals and laws and the new freedom people found. But up till then I think those Ealing comedies were very faithful in reproducing the British way of life.

So all those chirpy Cockneys, working-class barmaids, scruffy urchins and dunderheaded public officials weren't a bunch of caricatures after all. 'I think they were very faithful reproductions of the terribly typical British characters that existed in our society before and during the war. And the public recognised those characters; they were themselves, their neighbours, their friends. That's why those Ealing films were so popular, especially the comedies.'

But things were already changing. The gentle traditions espoused in such films as *Passport to Pimlico* and *The Titfield Thunderbolt* were already becoming an anachronism. In an increasingly cynical world, Balcon's aim for every Ealing film to have some sense of national pride wasn't going to wash any more. Perhaps Balcon didn't have much desire to reflect the changes in British society. However, by the mid-1950s it wasn't only Ealing's outlook that was in jeopardy but its very existence.

With Balcon and Reginald Baker approaching their sixties, both men had begun to feel the strain of the huge loan they had taken out with the National Film Finance Corporation. And as the financial implications for Ealing continued to prey on Balcon's mind, rumours began to spread around the studio about its future. What's interesting is that some people were told what was happening, while others remained completely in the dark. Maureen Jympson was one of the first to leave early in 1955.

> It was beginning to wind down and a lot of us were beginning to think, maybe we should look for other jobs. And that's when my husband decided to go freelance, and he left and I followed suit. We were aware that it was going to be sold. It was a tragedy really. There were rumours that the council was trying to buy the studio to build houses on it or a developer was trying to get hold of it, but that never happened, thank God. I was very sad to leave, and I look back on my time at Ealing with great fondness. It was just a nice place to look forward to going to every day. But by then it was all coming to bits anyway; people were beginning to go their separate ways.

Over in the art department Tony Rimmington remembers them all being told the year before that it was closing down. 'We knew we were for the high jump. About six months before it closed, a load of strangers rolled in and started sticking green and red pieces of tape all over the furniture and fittings. It was going up for sale.'

Rex Hipple was one of those who recalls not hearing the rumours about Ealing closing, or maybe had just not given

them any credence. 'The only thing I remember happening, we were running the daily rushes for *The Long Arm* and suddenly these folk were all over the place like a swarm of bees and they were taking an inventory of the facilities. I never even thought about Ealing closing.'

In 1955 the BBC made an offer of £350,000 to buy the studio and Balcon accepted. With the money, he was able to pay back the NFFC loan. Ken Westbury can still recall the day the news broke.

> We were still shooting *The Long Arm* on 3A stage and there was a meeting called for one lunch hour and Hal Mason announced that it was closing down. It was quite a shock to a lot of people. The management said that people would be told whether or not they were being kept on. Cameraman Gordon Dines came over to us and said, 'Don't worry boys, you're all OK.'

It's strange to think that it was Hal Mason and not Balcon himself who announced the closure of the studio to its staff. It was a kind of moral cowardice on Balcon's part not to explain face to face to his workers, many of whom had been loyal to him and the studio for many years, what was happening and why. Instead he delegated the job to Hal Mason.

Interestingly, Norman Dorme has a completely different take on why Balcon had to sell up.

> It was all to do with his second-in-command, Major Reginald Baker. At Ealing he was known by everyone as Major Baker, he always kept his wartime bloody title. Major Baker had a son who was a Conservative MP, but

was also an embezzler and stole money from people like Sir Bernard Docker, the industrialist, and other well-known people. All this happened just before the studio closed. And Major Baker, who was half owner of the studio, took all his money out to pay back the huge sums that his son had stolen. And that's why the studio collapsed, on the stupidity of one person. Anyway, that was the rumour that was going round.

Whatever the truth, Ealing Studios didn't go out with a bang; instead it ended with a whimper. 'It just sort of faded away,' says Ken Westbury. Like the earlier closure of Denham in 1952, Ealing closed down bit by bit. 'If people weren't actually working on something, they were free to go before it closed,' recalls Betty Collins. 'If they'd got a job somewhere else, nobody was going to stop them from moving on.' The facilities simply ground to a halt. 'The construction shops and other departments suddenly went silent because there was nothing being produced,' says Rex Hipple.

Tony Rimmington remained until the very last day and remembers the impact it had on those left behind. 'Jack Shampan, the chief draughtsman, he was in tears. You would have thought that they had closed it purely to spite him because he devoted himself to that place. "I gave so much," he was saying. "I spent nights here working on those sets." Now it was closing.' Others, like Rex Hipple, believe that maybe it was time for things to come to an end. 'I think Balcon had done his time. I think he'd had enough. And he didn't want to compete with television. It broke our hearts when Ealing closed, but at the same time it was very understandable that he'd felt he'd done enough.'

Many of Ealing's staff went to work at other studios or turned freelance. Jack Shampan worked regularly in film and television, notably on the classic fantasy TV series *The Prisoner* where he was to create much of the distinctive 'look' of that show with his eye-catching set designs. Tony Rimmington got head-hunted by Rank and enjoyed a long and varied career as a draughtsman on such films as *Lawrence of Arabia, Superman, Aliens, The Battle of Britain, A Bridge Too Far* and *Doctor Zhivago*. Sadly Tony passed away just a few days after I visited him at his home where he was kind enough to share his memories of Ealing.

When David Peers was told that in a few weeks' time there wouldn't be a job for him at Ealing, he decided to switch his allegiance totally, and came out of the film world and made commercials for television before working for Lew Grade at Elstree. As for Joan Parcell, she got a job at Associated British Picture Corporation (ABPC) and later worked as a production secretary on the films *Lolita* (1962), *Billy Budd* (1962) and *Lord Jim* (1965), before emigrating to Australia.

For many of Ealing's former employees, their professional careers were never to be quite the same again. 'None of the other studios were like Ealing,' confirms Norman Dorme.

I later worked at Pinewood and Shepperton, nice places, but they didn't have that special quality that made Ealing special. When you were at these other studios you worked with a small team, maybe only two or three people. There were plenty of other people around, but they had nothing to do with you. At Ealing everybody was sort of connected, every department was connected. You knew everybody and everybody knew you. It was a family, a film-making community.

Rex Hipple stayed on at the studio and was taken on by the BBC. It was a strange experience working at Ealing without it being Ealing, as it were. 'It was different. It had lost its humanity in a sense, it became part of a massive organisation, the individuality had just disappeared.' Ken Westbury was also hired by the BBC as a camera assistant. 'I found out that all those little things I'd learnt at Ealing from people like Sandy Mackendrick and Dougie Slocombe I could put into operation. That was what Ealing represented to me, it was my university. That's where I did my studying and where I graduated from.'

Within a year the BBC had promoted Ken to a cameraman and there followed a highly successful career that saw him still employed at the network into the late 1990s, working on a myriad of productions, including *Play for Today*, *Pennies from Heaven*, *Bergerac*, *Silent Witness* and *The Singing Detective*.

Sometime in 1969 Ken was walking near the canteen when he saw Michael Balcon coming towards him, looking a bit lost. Ken went up to him. 'Sir Michael, nice to see you.' He was there to meet someone about doing a television interview. 'So I took him into the canteen. "Sir Michael, come in, sit down," I said. "I'll get someone to look after you." I don't think he'd ever been in the canteen before, apart from his own private dining room, which had a different entrance, I think.' One of the ladies working at the BBC used to be a waitress in the canteen and would take tea up to Balcon's office. Ken grabbed her and told her that Michael Balcon was here and could she get a tray of coffee and bring it to his table. 'He was quite pleased to see someone else he knew. And we sat there talking for quite a while. He was at a complete loss as to where he was, so I'm sure he'd never been in that canteen before.'

Just prior to Balcon leaving Ealing back in 1955, Sir George Barnes, controller of television and a personal friend, informed Balcon of his intention to put up a plaque honouring Ealing and asked what the wording on it should be. After much deliberation, Balcon decided that the right words should be: 'Here during a quarter of a century many films were made projecting Britain and the British character.'

Chapter Twenty-Two

Ealing Gets A New Home

Although the studio had been sold, Balcon intended to carry on producing films under the Ealing banner and so a new home would have to be found. During discussions Balcon had with John Davis, the managing director of Rank, prior to the sale of Ealing, one particular conversation stuck in his mind. It was a promise by Davis that two new stages would be built at Pinewood Studios for the exclusive use of Ealing. Whether Balcon misheard or misunderstood, Davis was later adamant that such a commitment was never made and that it would not be possible for Ealing to have sole use of these new facilities.

Nevertheless, Balcon felt betrayed and believed he could no longer move Ealing to Pinewood, where he feared it would lose its independence and become merely another subsidiary of the Rank Organisation. For one of the few times in their long association, Reginald Baker disagreed with Balcon and hoped that some compromise could be reached. Davis, too, implored Baker to make Balcon change his mind.

In the end, when it became obvious Balcon would not budge, Baker loyally stood by his friend's decision. After the final cut of *The Long Arm* was delivered to Rank, Balcon terminated the financial and distribution arrangement

deal Ealing had enjoyed with the organisation for the last ten years.

Having spurned the chance of a home at Pinewood, Balcon believed the reputation of Ealing was such that an alternative home would not be hard to find, and in the company of Baker flew out to New York looking for backers. News of their arrival travelled quickly through the industry grapevine and three major Hollywood movie companies set up meetings with them. In the end there was no need for any kind of negotiating or manoeuvring. An old friend of Balcon's happened to be in town, Arthur Loew, who had just taken over as the new head of MGM. Loew was keen for Ealing to become part of the company's British set-up over at Borehamwood in Hertfordshire. Contracts were signed and everything looked good, with Balcon happy for Ealing to be associated with such a world leader in cinema.

While most of Ealing's staff had already been displaced around the industry, key creative personnel and senior technicians remained and now transferred over to the MGM studios in Borehamwood, where a special block was allocated to them. But it just wasn't the same. 'I don't think any of us welcomed the change,' wrote Tibby Clarke later. 'There was little hope of the old team spirit being preserved now that we had ceased to be a self-contained unit, and the intimate atmosphere of our previous home was sadly missing from these new bleak acres of characterless buildings.' Clarke felt relieved that a new contract he had signed did not bind him exclusively to Ealing so he wouldn't have to work in the place all the time.

Even Balcon had to admit that the old magic was lacking. 'It would be no use pretending that we did not have heavy hearts over leaving Ealing. To comfort myself, I used to say it was

people that counted, not buildings. This was not strictly honest, as over the years there had developed at Ealing a spirit which had seeped into the very fabric of the place.' Norman Dorme sensed this when he visited his old friends now working at MGM. 'I was freelancing on a movie and I went down there and saw everybody. It was a very miserable little crew there, there weren't many left. It was very sad.'

Still, Balcon was determined to make the best of it. And to this end he made a radical decision and hired Kenneth Tynan as a script editor, perhaps in a bid to make more radical and challenging films. At the time Tynan was the country's leading theatre critic and one of the most audacious of literary journalists. His appointment came about after Tynan wrote an article in 1955 about Ealing Studios, calling it 'the most lively and exciting movie production outfit in England', and referring to their famous comedies, such as *The Man in the White Suit* and *The Lavender Hill Mob*, as 'patriotic neo-realism'.

Balcon read the piece and was impressed enough in the spring of 1956 to take Tynan on at £2,000 a year. The job of script editor involved vetting scripts, giving advice and coming up with subjects and stories for films. 'It seems nebulous enough to suit me splendidly', Tynan wrote in his diary. Actually, Tynan took the appointment seriously, hoping 'to act as a pipeline for the sort of blood transfusion I thought the British cinema needed'. Sadly it didn't end up working out quite like that.

For the time being Ealing continued to make pretty much the same kind of movies they'd always done and with the same kind of people. *The Man in the Sky* (1957) was a solidly made suspense drama starring Jack Hawkins as a test pilot who refuses to bail out when the engine of his company's latest prototype catches

fire. Much of the location shooting took place at an airfield in Wolverhampton, where one day the real pilot doing the stunt flying overdid it and ran the aircraft into a ditch.

The Man in the Sky was directed by Charles Crichton, the last film he would make for Ealing. Like many of Ealing's directors, Crichton found it difficult to maintain a successful career afterwards. He made a couple of films in the late 1950s, including the Peter Sellers comedy *The Battle of the Sexes*, but when he was invited to direct his first Hollywood picture, *Birdman of Alcatraz* (1962), he clashed with its star, Burt Lancaster, three weeks into shooting and was replaced by John Frankenheimer. By the mid-1960s Crichton had been swallowed up by television and in the 1980s was even directing corporate videos. When John Cleese approached Crichton to co-direct *A Fish Called Wanda* (1988), he hadn't made a feature film for twenty-three years. A massive international hit, Crichton was nominated for an Oscar and, while he never made another film, the profits from *Wanda* ensured he had a very comfortable retirement. He died in 1999.

Then there was *The Shiralee* (1957), another outdoor Australian picture. Les Norman had come across the proofs of the novel by Australian writer D'Arcy Niland, read it and thought it would make a wonderful film. Balcon, though, wasn't best pleased at the prospect. 'How dare you give me that filthy book with all that foul language.'

'Well,' said Les. 'The Aussies are sometimes inclined to call a spade a fucking shovel. But I'll write a script that will exclude all the expletives and you won't find offensive, but still retain the flavour of the book.'

Les Norman wanted Peter Finch to play the lead role of an itinerant bush labourer who returns home to find his wife is

shacked up with another man. In a burst of anger he drags off his young daughter only to later realise he is saddled with her and so must learn to face responsibility for the first time in his life. Since his first British film, *Train of Events* for Ealing, Finch had gone on to become an international film star, playing opposite Elizabeth Taylor in *Elephant Walk* (1954) and appearing in two respected war dramas, *A Town Like Alice* (1956) and *The Battle of the River Plate* (1956). He gladly accepted the role in *The Shiralee* and returned to Australia for filming, arriving in Sydney to a large crowd of reporters. Taking one of them aside, Finch asked, 'What do you do round here for a bit of crumpet?' The conversation was overheard by a young naive reporter and the next morning her headline ran: 'Mr. Finch expresses a fondness for crumpets'.

Made entirely on location around New South Wales, the crew returned to England afterwards full of stories. One that made Michael Birkett smile was of a local safari park. 'It was very famous and it had huge notices all over the park – Do Not Get Out Of Your Car and Do Not Leave The Windows Open. This was all because of the lions and tigers and everything. There were all these dire warnings. And underneath these warning notices somebody had scrawled – Pommies on bicycles go in free.'

And there were two disappointing comedies, made more disappointing by the fact that they were the last Ealing would ever make. *Barnacle Bill* (1957), despite the presence of Alec Guinness playing the last of a line of distinguished seafarers who, upon retiring from the Royal Navy, purchases a dilapidated amusement pier, was rather lacking in the charm of Ealing's past glories. *Davy* (1958) was a disappointing starring vehicle for Harry Secombe, as a young entertainer conflicted

over the chance of a big break and who must decide whether to remain with his family's music-hall act or go solo. Much better would have been a subject that Basil Dearden and Michael Relph were keen to do, a story about a young couple who inherit a debt-ridden old movie theatre. For some reason that Dearden and Relph could never understand, Balcon wasn't interested and the much-loved *The Smallest Show on Earth* (1957) was made eventually by Dearden at another studio.

Chapter Twenty-Three

The Dunkirk Spirit

Tom Priestley had always been interested in the movies: 'I think partly because my mother disapproved of them, she thought there was something slightly naughty about them. Although my father had a 16mm projector and we used to look at old Chaplin films when I was a child.' Tom's father was the celebrated writer and broadcaster J. B. Priestley, who over the years had many connections with Ealing. Under Basil Dean's regime he wrote the Gracie Fields' film *Sing As We Go* (1934), and his play *Laburnum Grove* was turned into a film in 1936.

Under Balcon, Priestley contributed the story for *The Foreman Went to France* and his play *They Came to a City* was adapted for the screen in 1944, in which he personally made an appearance. You might have thought that when Tom decided to go into films this would have helped him get a place at Ealing, but it wasn't quite as straightforward as that.

While studying at Cambridge, Tom found himself most days going to the cinema: 'That, if you like, was my training.' The art cinema in the city showed mostly French films and the film critic Leslie Halliwell ran a very good small independent cinema that put on three double bills through the week: 'So one got a good balance.' Leaving university, Tom took a

year out to teach English in Greece. Back in London he got a job with a touring theatre company and when the tour came to an end everyone got together to see if they could find him another job. His love for film was well known, so he was sent to meet the Welsh actor Kenneth Griffith, who had just finished filming the comedy *Lucky Jim* (1957). Griffith made an appointment for Tom to meet the film's editor, Max Benedict, who advised, 'If you want to work in pictures you should go into the editing department,' about which, quite frankly, Tom knew nothing. But Benedict was insistent: 'And the best company is Ealing.'

Tom wrote a letter to Balcon ('I have to admit, I name-dropped about my father when I wrote to Sir Michael, which can't have been a bad thing') and an interview was arranged with Hal Mason. 'It was like a lot of old cab horses, someone had left so they all moved up one and the bottom job was available, and the bottom job was assistant film librarian, which was so low that nobody of any ambition would think of taking it.' But he had to start somewhere, so Tom took the job.

He began his film life on about £5 a week. 'And I was paying half of that to my sister whose flat I was staying in, which didn't leave you with much money and by Wednesday I couldn't drink coffee because it was four old pence a cup and tea was tuppence ha'penny, so I could only afford tea. It was that tight.' Surprisingly, Tom doesn't think his university degree cut much mustard in those days; in fact, it was more of a hindrance with one's fellow workers, since it meant that you belonged to the other side. 'Because I had a degree and because I had a well-known father there was a certain resentment, as if I wasn't there for any other reason. So there was an undercurrent of, who do you think you are.'

Tom worked in the film library for about nine months and is a crucial witness to the way things were run over at Borehamwood and the morale of the Ealing staff there.

It was all rather sad because they didn't have their studio any more, and they were used to having a studio with heads of department. So all the heads of department came with them to Borehamwood, but often there was nothing for them to do. For instance, the dubbing mixer, unless there was an Ealing film in production, he just sat in an office staring out of the window. What could he do? It was all a bit like that.

Despite the fact there really wasn't a lot going on with Ealing it was still very exciting being at Borehamwood, which at 120 acres was one of the largest film-making facilities in Europe. Often Tom would wander around the huge backlot and see mock-ups of castles and other large sets. He was particularly impressed by the Chinese village that was built for the Ingrid Bergman film *The Inn of the Sixth Happiness* (1958). There was also the time he bumped into John Ford in the cutting rooms.

And he was kept pretty busy in the library, where producers and film and TV companies could hire bits of film. 'Say you had a sequence in Paris, you just buy a shot of the Eiffel Tower, put a bit of accordion music over it and there you are. But to actually send a camera unit to France with the equipment, it would take weeks of work and a lot of expense.' Another part of Tom's job was to go through old movies looking out for bits that didn't have any actors in that might be useful for other films. There was only one cast-iron rule in that place Tom discovered, and that was if anyone came from abroad they had

to pay in advance. This was because Orson Welles had used the library and never paid his bill.

During those months spent in the library, Tom kept applying to join the union without much success. 'Ealing were a bit sneaky because they said, oh, he's not actually working on film at all, which was not true because part of the function of being assistant librarian is you actually learnt how to handle film, which believe me has a life of its own; if you don't wind it properly it all flies on the floor or breaks. So it takes a while to get used to it.'

Tom admits that while the unions caused no end of troubles, they did provide a valuable service, especially when one thinks about how conditions were prior to their formation.

> One of the editors I ended up working with at Ealing told me what it was like when he started in the business and he could not go home until he was told to go home. And if it was late in the evening he couldn't afford a taxi, and there was no public transport, he would literally have to sleep on the floor. It may have gone too far the other way but there was a reason for the unions.

Eventually Tom got his break. 'Luckily one of the editing assistants, Mary Kessell, who was a good left-winger and knew the right people, said to me, "I'll have a word with them." So I finally got into the union.' It was good timing: Ealing were about to embark on an epic recreation of Dunkirk, and due to the mammoth scale of the production extra hands were required and Tom was made a second assistant sound editor. It was the first film he ever worked on.

Dunkirk (1958) was a huge undertaking, retelling one of the most significant episodes of the Second World War when

338,226 Allied soldiers were rescued from the beaches of northern France. It's really two stories, one of government bungling, especially in the slow gathering of rescue vessels in Britain, while the other follows John Mills' corporal as he leads his men through enemy territory to Dunkirk.

Michael Birkett found himself first assistant working under director Leslie Norman, of whom he was immensely fond. 'Leslie was very bright and very nice, but a rough diamond in a way, but actually very sympathetic. I got on frightfully well with him.' Certainly they needed to work as a team because *Dunkirk* was by far the biggest production Ealing had ever mounted, with a large cast that included John Mills, Richard Attenborough and Bernard Lee. In order to capture the scale of the event and maximise authenticity, Ealing was granted help from the War Office, resulting in the allocation of 300 members of the Yorkshire and Lancashire regiments for location shooting at Camber Sands, which stood in for the French coast. One of the things Michael had to instruct them to do was avoid the blue-coloured sand, which was where the pyrotechnics were buried for explosions. Because they were shooting in black and white, the cameraman had informed Michael that blue sand looked exactly the same as ordinary sand on the screen. 'So we put blue sand down for the stunt men and they were going to get blown up, not very seriously, but hoisted sort of three or four feet into the air. We said to everybody else, don't go near the blue sand because you'll get blown up.'

On one particular day the unit had access to some 4,000 troops. 'That was quite scary,' admits Michael, 'because I knew that Les would want to make the most of these 4,000 troops and get as many shots as he could.' It was a logistical nightmare, but a signals officer turned out to be Michael's saviour when he

turned up early that morning as the unit were preparing for the hard slog ahead. 'I know what you've got to do today,' he said. 'And I've done a little something which I think will help.' On his own initiative, this signals officer had placed concealed loudspeakers in the sand dunes; he then passed over a walkie-talkie to Michael and offered him the use of an amphibious truck. 'I've also split the 4,000 troops into 26 groups under different letters and I've given them all a bamboo stick with the number of their group on it. So when you say, put up your numbers, you'll see a forest of numbers from 1 to 26 and you can then tell them what to do.'

So all Michael had to do was shout into his walkie-talkie, 'Number 22 could you form a queue out to sea and make for the incoming flotilla. Number 11, would you please run up the beach." It turned out to be an absolute Godsend and the day's shoot went off without a hitch. 'This signals officer was absolutely marvellous. I owe it all to him getting through that day. Here was someone not familiar with film techniques, but he figured out what the problems would be and solved them.'

All the troops were under the command of Brigadier Bernard Fergusson, who served with great distinction with the Chindits in Burma. One lunch break, Michael and a couple of his assistants were having a quick bite to eat on the sand dunes when Fergusson's sergeant major appeared. Coming to attention he said, 'Brigadier Fergusson would like to see you in his caravan in ten minutes time if that's alright with you.'

'Oh, lovely, thank you very much,' Michael replied, looking at his assistants and wondering what it was all about.

Anyway, we went to his command vehicle, which had all sorts of radar and things whirring on top of the roof, all

the sorts of things you'd expect, so we thought, oh it's got to be something highly technical. We went into this command vehicle and discovered that it was entirely full of gin and vodka and wine, nothing else, absolutely solid with it, and he asked us, 'What will you have?' So we had these super drinks with the famous Brigadier Fergusson.

It was a tough shoot, not helped by some of the antics of the cast, especially Bernard Lee. 'You could never find Bernard, he was always in the pub,' reveals Michael. 'He was a terrible drinker really. But I had an assistant director of mine who knew about it and would always find out which pub he was going to.' By the end of the final week Michael found himself in hospital. 'I'd got glandular fever and jaundice all at the same moment, which I was told was not a clever thing to do.'

Dunkirk is far from a flag-waving war picture, dealing as it does with military incompetence and defeat, themes that were certainly in tune with the new cynicism in Britain following the recent Suez Crisis. It is an extremely well-made film, however. 'We all put a lot of effort into that film and we were all quite proud of it at the end,' says Michael.

Tom Priestley would occasionally leave the cutting room and take a wander onto the set of *Dunkirk*. 'They employed a lot of extras to play soldiers and I think some of the extras never actually bothered to do anything because there were so many. Let's say fifty would turn up at the studio and give their names, then they'd just stay in the dressing room playing cards.'

The person who ran the editing department Tom has never forgotten – this was the notorious Mrs Brown, 'who, bless her heart, didn't actually know anything about the creative side of

editing. But as head of the department she qualified to go to the screenings. We lesser mortals weren't even allowed to see the rushes. So dear old Mrs Brown would go and represent the editing department and would usually fall asleep and then they'd always ask, "What did you think, Mrs Brown?" "Oh yes, very nice."'

Mrs Brown's office was right next to the shooting stages, while the cutting rooms were way over the other side. 'So if you needed something, like some more pencils, you went over to Mrs Brown to get the docket. She had to sign the docket. Then you went to the store room, got a packet of pencils, but then you had to take them back to Mrs Brown who would just give you one or two, and then you went back to the cutting rooms.'

Something else Mrs Brown was notorious for was getting her female underlings to wear her new shoes for something like two or three weeks until they were worn in.

Despite the omnipresence of Mrs Brown, Tom was enjoying his time in the cutting rooms. 'You learnt on the job by doing it, by watching people, by learning how to manipulate the film.' Like many who worked at Ealing it was a great apprenticeship and Tom went on to become a renowned editor working on such films as *Morgan: A Suitable Case for Treatment* (1966), *Deliverance* (1972), *The Great Gatsby* (1974) and *Tess* (1979). His next Ealing film was *Nowhere to Go* (1958), a rare excursion for Ealing into film noir, depicting a criminal, played by George Nader, who escapes from jail in order to recover his stashed loot. When things go wrong a young socialite, Maggie Smith in her film debut, decides to protect him as he is shunned by the criminal community and hunted down by the police.

Having earned his stripes as an editor and then an associate producer, this was Seth Holt's first film as a director. 'Seth was

without doubt the most intellectual man ever at Ealing,' claims Michael Birkett. 'He was in a cultural league of his own. So when he made his first movie, he asked if I would be the assistant director and I said, of course, like a shot.'

Alas, Holt's promising career, like that of his brother-in-law Robert Hamer, was derailed by alcohol-related problems. After Ealing, Holt made two effective psychological thrillers for Hammer, *Taste of Fear* (1961) and *The Nanny* (1965), starring Bette Davis, who called him, 'The most ruthless director I've ever worked with outside of William Wyler.'

By the time he was slated to direct the pioneering youth-alienation fable *If...* (1968), a film he had helped develop alongside his friend Lindsay Anderson, illness and heavy drinking had weakened his morale and he handed it over to Anderson. Back at Hammer he directed *Blood from the Mummy's Tomb* (1971), but suffered a massive heart attack a week from the end of shooting and died. He was just forty-eight.

By the time *Nowhere to Go* was released, Kenneth Tynan, who had written the script with Seth Holt, had resigned his position at Ealing. During roughly two years working for the studio as script editor, only one of his proposals had made it to the screen – *Nowhere to Go*. The rest had either been ignored, died at birth or were dropped in an advanced state of production. These included an original screenplay by Lindsay Anderson about life in the casualty ward of a London hospital, Cecil Woodham-Smith's critique of the Crimean War, *The Reason Why*, which was later filmed by Tony Richardson as *The Charge of the Light Brigade* (1968) and Joyce Cary's novel *The Horse's Mouth*, a project that was later taken up by Alec Guinness.

Perhaps most interestingly of all was William Golding's novel *Lord of the Flies*, about a group of school boys castaway on a desert island who turn to savagery. Leslie Norman was slated to direct it with a script by Nigel Kneale of *Quatermass* fame. Peter Brook ended up filming it in 1963.

Tynan had laboured under the misapprehension that he'd been hired to shake things up at Ealing, to broach explosive, awkward and controversial subjects. And yet each time such a project was taken on board, usually at the third or fourth rewrite, Balcon would bottle it, unable personally, Tynan reasoned, to make something that might cause offence. It was a stance, Tynan felt, that Balcon firmly believed was shared by the cinema-going public. 'You may have been right,' Tynan wrote to Balcon not long after his resignation. 'On the other hand, at that stage in your career and at that nadir in the international repute of British films, it might have been worthwhile to gamble. More worthwhile, anyway, than making *Davey*.'

Tynan also refers in the same letter to Colin MacInnes' 1957 novel *City of Spades* about African immigrants in London. 'You bought that, but since it contained references to prostitution and drug-taking, not to mention a black man kissing a white girl, I never seriously expected to see it on the year's schedule.'

Tynan's departure seemed to sum up the prevailing mood at Ealing; there was a staleness hanging over the place and a sense of things winding down. 'It was running down,' says Tom Priestley.

And there were constant rumours that it was going to be closed, so staff were always frightened. If there was a longish gap between films people would get nervous and

say things like, if we're thrown out what do we do. I can remember one of our assistants, Robin Clarke, there was a gap between films so he actually left and took freelance work, came back and said, 'It's wonderful out there.' And it was, in those days there was a lot going on. But at Ealing there was always this fear factor generated of you can't leave us.

Tom's next film is a strange one, since it began life as an Ealing production but was never released as such (MGM took it over), though Balcon remained credited as producer. *The Scapegoat* (1959) was based on the novel by Daphne du Maurier and starred Alec Guinness and Bette Davis. The story concerns an Englishman on holiday in France who encounters his doppelgänger, a French count, Jacques De Gué. After a night of drinking with his double, the Englishman wakes up to discover that Jacques has disappeared, leaving him to play the role of the count and become his double's scapegoat in a complex web of family intrigue and deception.

Guinness had insisted that Robert Hamer direct the picture. It was an unselfish act of generosity but regrettably there were times when Guinness would have to take over the directing chores because Hamer was drunk. Tom Priestley was in the dubbing theatre once when Hamer was late and Guinness was growing ever more anxious and agitated. 'I do remember Hamer making Guinness do ten takes of the word, no, just to get it right: "Little bit lighter, Alec. A bit more emphasis."'

Just before *The Scapegoat* went on the floor Tom had asked for a raise. 'The management got very snooty about that, how dare you, we picked you up in the gutter kind of thing.' So he carried on as assistant sound editor on £7 a week, not much of

an improvement over his initial wages. The sound editor Tom was working with, a chap by the name of Alastair McIntyre, had been promised the next up-grade to film editor but had been passed over by somebody else, and so he'd left. 'One day he rang me up and said, "Tom, would you consider coming to work for me at £15 a week?" And I went straight round to the office and gave my notice in. Shock, horror, upset, how dare you, this is absolutely outrageous. And in the irony department, the editor of *The Scapegoat*, who was the famous Jack Harris (seen as the doyen of British film editors who worked on *Brief Encounter*, *Great Expectations* and many others), I remember him saying to me, "You'll never work in films again." And ten years later he came on as a second editor for something I was cutting.'

Chapter Twenty-Four

The End Of An Era

After three years at MGM Balcon had grown dissatisfied with the impersonal nature of the arrangement. Within a year of joining there had been a bitter stockholders' fight and Arthur Loew and other executives Balcon knew and had close friendships with left the company. After that, Balcon had little or no personal contact with the new management, who as it turned out had little interest in Ealing either, turning down ideas and projects that Balcon wanted to pursue.

The movie industry was changing, too, with a steep decline in cinema attendances, the growth of television and a rise in the cost of film production. So it was in this climate that Balcon and Reginald Baker were approached by Eric Fletcher, deputy chairman of Associated British Picture Corporation, with an offer to buy all the assets of Ealing. 'After much heart-searching,' Balcon admitted, 'we accepted this offer and our company came under new control.'

For many of those who had worked for years at Ealing and then made the move to MGM, there was a sense almost of betrayal. As Charles Crichton later disclosed,

Whenever we asked for more money Mickie Balcon

always said, 'What are you talking about? This is your studio. I'm getting old, I'm going to retire, and then the studio will be yours, so don't bloody well ask for any more money.' And then suddenly, I wasn't there, I'd left already, suddenly one day all those people who really thought that it was their studio were told, 'That's it, chums, fuck off.' And people like Charlie Frend were absolutely shattered.'

Sir Philip Warter, chairman of ABPC, appeared to give the impression to Balcon that Ealing would be able to continue production of films; in fact, the official press statement announcing the purchase expressly stated this to be the case. But *The Siege of Pinchgut* (1959), a crime thriller set in contemporary Sydney and directed by Harry Watt, which was shooting as the sale went ahead, turned out to be the end of the road for Balcon's Ealing. Michael Birkett was an assistant on the film. 'We were all aware that this was the death of the studio name, that this was to be the last film, absolutely. Everybody knew.'

On that very final day of shooting there was no great fanfare or huge sense of sadness at the end of an era; the equipment was collected up and everyone just drifted away. That's how Ealing Studios finished. 'It wasn't an emotional scene at all,' remembers Michael. 'I think mainly because the film wasn't shot at the old Ealing Studios, so there was no call to be emotional or sentimental about it.'

When it became clear that ABPC had no intention of giving Ealing a production slate of films, the staff were dispersed. For the majority of the Ealing directors, the future turned out to be a bleak one as they floundered outside of the closeted world

they'd enjoyed at Ealing. 'None of those people really did anything afterwards, except for Sandy,' says David Tringham. 'Within the closeted environment of Ealing they could prosper. They were protected.' Outside it was a very different story. After directing *The Siege of Pinchgut*, Harry Watt did not make another feature film and instead moved into television, as did Sidney Cole, who produced *The Adventures of Robin Hood*, *Danger Man* and *The Adventures of Black Beauty*. Charles Frend also worked heavily in television after directing only three post-Ealing pictures. By the end of his career he was shooting second unit on David Lean's *Ryan's Daughter*. Leslie Norman made four rather minor post-Ealing features before he also moved to television. Whilst today television is a respected medium, this was not the case in the 1960s; film directors only worked in television when they were out of work, meaning that it was something of a come down in their career.

It's not a great track record and begs the question, could these directors handle the cut and thrust of the movie business beyond the cosseted walls of Ealing. One of the reasons Michael Relph gave for why he and Basil Dearden succeeded better afterwards was because they kept more in contact with the rest of the industry. 'But most of the others from Ealing were fairly ignorant of all that was going on outside.' Thus Relph and Dearden were in a far better position than their fellow directors who had led 'an excessively sheltered existence'. They'd been together working under the same roof for just the one company for so long that surely it gave rise to complacency. By the end it had all just got a bit too incestuous and too much of a mutual admiration society, and that damaged creativity. 'The thing with the film business is, you don't need any qualifications,' says David Tringham.

But to be successful you have to have something you want to do, some film you want to make, some idea. And the thing with the Ealing lot is they didn't, they did what the boss wanted, they weren't independent, maybe only Sandy was. They were given jobs rather than chased an idea. I may be wrong but you never got the feeling they came to Michael Balcon with a subject they wanted to make.

This is a little unfair, since many of the directors from time to time did badger and hustle Balcon to green light a pet project of theirs. They weren't always successful, of course, and being under contract, as directors used to be back in the old Hollywood studio system, had to take what they were given, whether they liked it or not. 'They played it safe,' affirms David. 'They went by the book; this book that some useless person had concocted and these are the rules. And there was a definite class system, and it wasn't based on talent, it was establishment. The problem with Ealing was they made small-scale, parochial films and it bred these people to be part of one big family, all friends together. It was all very cliquey.'

Following the demise of Ealing, Balcon moved into independent film-making. In 1959 he formed Bryanston Films, a cooperative of independent producers, which included a coterie of old Ealing chums including Hal Mason and Monja Danischewsky. Another echo of Ealing was Robin Adair, who was commissionaire on the door of Bryanston's London office. Interestingly, given Balcon's timidity at Ealing to embrace challenging film subjects, Bryanston was at the forefront of the British New Wave movement when it teamed up in the early 1960s with Woodfall Films, a production company established

by the alumni of the Royal Court Theatre, namely playwright John Osborne and director Tony Richardson, to produce the kitchen-sink dramas *The Entertainer, Saturday Night and Sunday Morning, A Taste of Honey* and *The Loneliness of the Long Distance Runner.*

Balcon, however, was very much a peripheral figure in terms of the creative side of the films that were made at Bryanston. Certainly he did not wield anything like the power he administered as head of Ealing. There was one telling incident that occurred after the private screening of one of the Woodfall films. As had been the practice at Ealing, Balcon rose to his feet to give his opinion and was told in no uncertain fashion by one of the Woodfall executives that they were not interested in what he thought or what he had to say.

Balcon remained a committed chairman of the company until it expired as a film-making entity in 1965. Then, after spending a troubled two years as chairman of British Lion, Balcon essentially retired as an active force in the British film industry, although he remained as a long-serving member of the board of governors of the British Film Institute. He died at the age of eighty-one at his home in Sussex in 1977.

As for the studios themselves, these remained in the hands of the BBC until 1992 when they were bought by a group called BBRK which hoped to make films very much in the style of the classic Ealing comedies. Nothing came of this aspiration and by 1994 the venture had collapsed and the studios reverted back to the control of the BBC since the entire purchase price had not been fully paid. A year later the studio was sold once again to the National Film and Television School but they occupied the buildings for only a short time.

2001 saw the rebirth of the Ealing name when new owners, Fragile Films, took charge and turned the studio back into a film production facility. Their first release couldn't have been more apt, an adaptation of Oscar Wilde's *The Importance of Being Ernest,* a subject that surely would have found favour with Michael Balcon. Since then the studio has been a hive of activity; the now classic Simon Pegg comedy *Shaun of the Dead* was filmed there and in 2007 Ealing revived the *St. Trinians* franchise with two new installments based on Ronald Searle's infamous boarding school for girls. Ealing is also home to the Met Film School, London's leading provider of practical filmmaking courses. Independent television companies also make good use of the studio facilties; all the 'servant's quarters' scenes for *Downton Abbey* were shot on the old stages.

For many years after the break-up of Ealing Michael Birkett kept in touch with Balcon, often visiting him at his house in East Sussex. Never once, though, does Michael recall an occasion when the subject of the good old days at Ealing was brought up. 'We didn't talk about Ealing at all. No, not really. We never reminisced. We were a bit too sophisticated for that.'

Michael, however, does have his own views about what Ealing stands for, and on a more personal level what Balcon personally managed to accomplish with the studio was nothing less than a major cultural achviement. 'And it was entirely due to his own combination of naivety, innocence and acuteness. Also he must have had a good sense of what people wanted to see. Funnily enough we didn't purposely go out to make box office films. The Rank Organisation were notable for making films that they thought would do well, but we ourselves weren't

really aiming for the box office at all. We concentrated on good stories that hopefully people would want to see.'

The last word belongs, as it should, to Balcon himself. Once asked if he could categorize what it was that made an Ealing film or what was the philosophy behind it all he simply replied: 'By and large we were a group of liberal-minded, like-minded people. I don't know if anyone was terribly politically involved, we were film-makers: it was our life, it was our total life.'

FILMOGRAPHY

Note: This filmography lists only the pictures made during the Balcon era, 1938–1959.

THE GAUNT STRANGER (1938)
Director: Walter Forde
Cast: Sonnie Hale, Wilfrid Lawson, Louise Henry, Patrick
 Barr, Alexander Knox, Patricia Roc.

THE WARE CASE (1938)
Director: Robert Stevenson
Cast: Clive Brook, Jane Baxter, Barry K. Barnes, Peter Bull,
 John Laurie, Ernest Thesiger.

LET'S BE FAMOUS (1939)
Director: Walter Forde
Cast: Jimmy O'Dea, Betty Driver, Sonnie Hale, Patrick Barr,
 Basil Radford.

TROUBLE BREWING (1939)
Director: Anthony Kimmins
Cast: George Formby, Googie Withers, Gus McNaughton, Garry Marsh, Ronald Shiner, Martita Hunt.

THE FOUR JUST MEN (1939)
Director: Walter Forde
Cast: Hugh Sinclair, Griffith Jones, Francis L. Sullivan, Frank Lawton, Alan Napier.

THERE AIN'T NO JUSTICE (1939)
Director: Pen Tennyson
Cast: Jimmy Hanley, Edward Rigby, Mary Clare, Edward Chapman, Michael Wilding.

YOUNG MAN'S FANCY (1939)
Director: Robert Stevenson
Cast: Griffith Jones, Anna Lee, Seymour Hicks, Martita Hunt, Felix Aylmer.

CHEER BOYS CHEER (1939)
Director: Walter Forde
Cast: Nova Pilbeam, Edmund Gwenn, Peter Coke, Jimmy O'Dea, Moore Marriott, Graham Moffatt.

COME ON GEORGE! (1939)
Director: Anthony Kimmins
Cast: George Formby, Patricia Kirkwood, Joss Ambler, Meriel Forbes, Ronald Shiner.

RETURN TO YESTERDAY (1940)
Director: Robert Stevenson
Cast: Clive Brook, Anna Lee, Dame May Whitty, Hartley
Power, Milton Rosmer.

THE PROUD VALLEY (1940)
Director: Pen Tennyson
Cast: Paul Robeson, Edward Chapman, Edward Rigby,
Simon Lack, Janet Johnson, Clifford Evans.

LET GEORGE DO IT! (1940)
Director: Marcel Varnel
Cast: George Formby, Phyllis Calvert, Garry Marsh, Bernard
Lee, Coral Browne.

CONVOY (1940)
Director: Pen Tennyson
Cast: Clive Brook, John Clements, Edward Chapman, Judy
Campbell, Michael Wilding, John Laurie, Stewart
Granger.

SALOON BAR (1940)
Director: Walter Forde
Cast: Gordon Harker, Elizabeth Allan, Mervyn Johns, Joyce
Barbour.

SAILORS THREE (1940)
Director: Walter Forde
Cast: Tommy Trinder, Claude Hulbert, Michael Wilding,
Carla Lehmann, Alec Clunes, Danny Green.

SPARE A COPPER (1940)
Director: John Paddy Carstairs
Cast: George Formby, Dorothy Hyson, George Merritt,
 Bernard Lee.

THE GHOST OF ST. MICHAEL'S (1941)
Director: Marcel Varnel
Cast: Will Hay, Claude Hulbert, Charles Hawtrey, Raymond
 Huntley, Felix Aylmer, John Laurie.

TURNED OUT NICE AGAIN (1941)
Director: Marcel Varnel
Cast: George Formby, Peggy Bryan, Elliot Mason, Edward
 Chapman, Wilfrid Hyde-White, Michael Rennie.

SHIPS WITH WINGS (1941)
Director: Sergei Nolbandov
Cast: John Clements, Leslie Banks, Jane Baxter, Ann Todd,
 Basil Sydney, Michael Wilding, Michael Rennie, Cecil
 Parker.

THE BLACK SHEEP OF WHITEHALL (1942)
Director: Basil Dearden, Will Hay
Cast: Will Hay, John Mills, Basil Sydney, Henry Hewitt,
 Thora Hird.

THE BIG BLOCKADE (1942)
Director: Charles Frend
Cast: Leslie Banks, John Mills, Michael Redgrave, Michael
 Rennie, Will Hay, Bernard Miles, Robert Morley, Marius
 Goring, Michael Wilding.

THE FOREMAN WENT TO FRANCE (1942)
Director: Charles Frend
Cast: Tommy Trinder, Constance Cummings, Clifford
 Evans, Robert Morley, Gordon Jackson, Mervyn Johns.

THE NEXT OF KIN (1942)
Director: Thorold Dickinson
Cast: Mervyn Johns, John Chandos, Nova Pilbeam, Stephen
 Murray, Basil Sydney, Jack Hawkins.

THE GOOSE STEPS OUT (1942)
Director: Will Hay, Basil Dearden
Cast: Will Hay, Charles Hawtrey, Peter Croft, Barry Morse,
 Peter Ustinov, William Hartnell.

WENT THE DAY WELL? (1942)
Director: Alberto Cavalcanti
Cast: Leslie Banks, Elizabeth Allan, Frank Lawton, Basil
 Sydney, Valerie Taylor.

NINE MEN (1943)
Director: Harry Watt
Cast: Jack Lambert, Gordon Jackson, Frederick Piper, Grant
 Sutherland.

THE BELLS GO DOWN (1943)
Director: Basil Dearden
Cast: Tommy Trinder, James Mason, Mervyn Johns, Philippa
 Hiatt, Finlay Currie.

MY LEARNED FRIEND (1943)
Director: Basil Dearden, Will Hay
Cast: Will Hay, Claude Hulbert, Mervyn Johns, Laurence
 Hanray.

UNDERCOVER (1943)
Director: Sergei Nolbandov
Cast: John Clements, Godfrey Tearle, Mary Morris, Tom
 Walls, Michael Wilding, Stanley Baker.

SAN DEMETRIO LONDON (1943)
Director: Charles Frend
Cast: Ralph Michael, Walter Fitzgerald, Neville Mapp, Barry
 Letts, Gordon Jackson, Robert Beatty, James Donald.

THE HALFWAY HOUSE (1944)
Director: Basil Dearden
Cast: Mervyn Johns, Glynis Johns, Tom Walls, Françoise
 Rosay, Esmond Knight, Guy Middleton, Sally Ann
 Howes.

FOR THOSE IN PERIL (1944)
Director: Charles Crichton
Cast: David Farrar, Ralph Michael, John Slater, Robert
 Wyndham, James Robertson Justice.

THEY CAME TO A CITY (1944)
Director: Basil Dearden
Cast: John Clements, Googie Withers, Raymond Huntley,
 Renne Gadd, A. E. Matthews, J. B. Priestley.

CHAMPAGNE CHARLIE (1944)
Director: Alberto Cavalcanti
Cast: Tommy Trinder, Stanley Holloway, Betty Warren, Austin Trevor, Jean Kent, Harry Fowler.

FIDDLERS THREE (1944)
Director: Harry Watt
Cast: Tommy Trinder, Frances Day, Sonnie Hale, Francis L. Sullivan, Elisabeth Welch, James Robertson Justice, Kay Kendall.

JOHNNY FRENCHMAN (1945)
Director: Charles Frend
Cast: Tom Walls, Françoise Rosay, Patricia Roc, Ralph Michael, Paul Dupuis.

PAINTED BOATS (1945)
Director: Charles Crichton
Cast: Jenny Laird, Bill Blewitt, May Hallatt, Robert Griffith, Harry Fowler.

DEAD OF NIGHT (1945)
Director: Alberto Cavalcanti, Charles Crichton, Basil Dearden, Robert Hamer.
Cast: Michael Redgrave, Googie Withers, Mervyn Johns, Basil Radford, Naunton Wayne, Sally Ann Howes, Roland Culver, Frederick Valk.

PINK STRING AND SEALING WAX (1945)
Director: Robert Hamer
Cast: Mervyn Johns, Googie Withers, Gordon Jackson, Mary
Merrall, Sally Ann Howes.

THE CAPTIVE HEART (1946)
Director: Basil Dearden
Cast: Michael Redgrave, Mervyn Johns, Basil Radford, Jack
Warner, Jimmy Hanley, Gordon Jackson, Derek Bond,
Rachel Kempson.

THE OVERLANDERS (1946)
Director: Harry Watt
Cast: Chips Rafferty, John Nugent Hayward, Daphne
Campbell, John Fernside.

HUE AND CRY (1947)
Director: Charles Crichton
Cast: Alastair Sim, Jack Warner, Valerie White, Frederick
Piper, Harry Fowler.

THE LIFE AND ADVENTURES OF NICHOLAS NICKLEBY (1947)
Director: Alberto Cavalcanti
Cast: Derek Bond, Cedric Hardwicke, Mary Merrall, Sally
Ann Howes, Stanley Holloway, Sybil Thorndike, Bernard
Miles, Cathleen Nesbitt, Jill Balcon.

THE LOVES OF JOANNA GODDEN (1947)
Director: Charles Frend
Cast: Googie Withers, Jean Kent, John McCallum, Derek
 Bond, Chips Rafferty.

FRIEDA (1947)
Director: Basil Dearden
Cast: David Farrar, Mai Zetterling, Flora Robson, Glynis
 Johns.

IT ALWAYS RAINS ON SUNDAY (1947)
Director: Robert Hamer
Cast: Googie Withers, Jack Warner, John McCallum, Edward
 Chapman, Jimmy Hanley, Alfie Bass, Nigel Stock.

AGAINST THE WIND (1948)
Director: Charles Crichton
Cast: Robert Beatty, Simone Signoret, Jack Warner, Gordon
 Jackson, Paul Dupuis, James Robertson Justice.

SARABAND FOR DEAD LOVERS (1948)
Director: Basil Dearden
Cast: Stewart Granger, Joan Greenwood, Flora Robson,
 Françoise Rosay, Miles Malleson, Anthony Quayle,
 Michael Gough.

ANOTHER SHORE (1948)
Director: Charles Crichton
Cast: Robert Beatty, Moira Lister, Stanley Holloway, Michael
 Medwin, Wilfrid Brambell.

SCOTT OF THE ANTARCTIC (1948)
Director: Charles Frend
Cast: John Mills, Derek Bond, Harold Warrender, James
 Robertson Justice, Reginald Beckwith, Kenneth More,
 John Gregson, Christopher Lee.

EUREKA STOCKADE (1949)
Director: Harry Watt
Cast: Chips Rafferty, Jane Barrett, Jack Lambert, Gordon
 Jackson, Peter Finch.

PASSPORT TO PIMLICO (1949)
Director: Henry Cornelius
Cast: Stanley Holloway, Hermione Baddeley, Margaret
 Rutherford, Paul Dupuis, Basil Radford, Naunton
 Wayne, Charles Hawtrey.

WHISKY GALORE (1949)
Director: Alexander Mackendrick
Cast: Basil Radford, Joan Greenwood, James Robertson
 Justice, Gordon Jackson, Catherine Lacey, Bruce Seton,
 John Gregson.

KIND HEARTS AND CORONETS (1949)
Director: Robert Hamer
Cast: Dennis Price, Alec Guinness, Valerie Hobson, Joan
 Greenwood, John Penrose, Arthur Lowe.

TRAIN OF EVENTS (1949)
Director: Sidney Cole, Charles Crichton, Basil Dearden
Cast: Jack Warner, Gladys Henson, Susan Shaw, Patric
 Doonan, Leslie Phillips, Peter Finch, Valerie Hobson,
 John Clements, John Gregson, Michael Hordern.

A RUN FOR YOUR MONEY (1949)
Director: Charles Frend
Cast: Donald Houston, Meredith Edwards, Moira Lister, Alec
 Guinness, Hugh Griffith, Joyce Grenfell.

THE BLUE LAMP (1950)
Director: Basil Dearden
Cast: Jack Warner, Jimmy Hanley, Dirk Bogarde, Robert
 Flemyng, Bernard Lee, Peggy Evans, Bruce Seton.

DANCE HALL (1950)
Director: Charles Crichton
Cast: Donald Houston, Petula Clark, Natasha Parry, Jane
 Hylton, Diana Dors, Kay Kendall, Eunice Gayson.

BITTER SPRINGS (1950)
Director: Ralph Smart
Cast: Chips Rafferty, Tommy Trinder, Gordon Jackson, Jean
 Blue.

CAGE OF GOLD (1950)
Director: Basil Dearden
Cast: Jean Simmons, David Farrar, James Donald, Madeleine
 Lebeau, Herbert Lom, Bernard Lee.

THE MAGNET (1950)
Director: Charles Frend
Cast: Stephen Murray, Kay Walsh, James Fox, Meredith
 Edwards, Gladys Henson, Thora Hird.

POOL OF LONDON (1951)
Director: Basil Dearden
Cast: Bonar Colleano, Susan Shaw, Renée Asherson, Moira
 Lister, Earl Cameron, Max Adrian, James Robertson
 Justice, Alfie Bass, Leslie Phillips.

THE LAVANDER HILL MOB (1951)
Director: Charles Crichton
Cast: Alec Guinness, Stanley Holloway, Sidney James, Alfie
 Bass, Marjorie Fielding, John Gregson, Audrey Hepburn,
 Robert Shaw (uncredited).

THE MAN IN THE WHITE SUIT (1951)
Director: Alexander Mackendrick
Cast: Alec Guinness, Joan Greenwood, Cecil Parker, Michael
 Gough, Ernest Thesiger, Vida Hope, Howard
 Marion-Crawford.

WHERE NO VULTURES FLY (1951)
Director: Harry Watt
Cast: Anthony Steel, Dinah Sheridan, Harold Warrender,
 Meredith Edwards.

HIS EXCELLENCY (1952)
Director: Robert Hamer
Cast: Eric Portman, Cecil Parker, Helen Cherry, Susan
 Stephen, Clive Morton, Geoffrey Keen.

SECRET PEOPLE (1952)
Director: Thorold Dickinson
Cast: Valentina Cortese, Serge Reggiani, Charles Goldner,
 Audrey Hepburn, Megs Jenkins, Irene Worth.

I BELIEVE IN YOU (1952)
Director: Basil Dearden
Cast: Cecil Parker, Celia Johnson, Harry Fowler, Joan
 Collins, George Relph, Godfrey Tearle, Laurence Harvey,
 Ursula Howells, Sidney James, Katie Johnson, Brenda de
 Banzie.

MANDY (1952)
Director: Alexander Mackendrick
Cast: Phyllis Calvert, Jack Hawkins, Terence Morgan,
 Godfrey Tearle, Mandy Miller, Marjorie Fielding, Eleanor
 Summerfield, Jane Asher.

THE GENTLE GUNMAN (1952)
Director: Basil Dearden
Cast: John Mills, Dirk Bogarde, Robert Beatty, Elizabeth
 Sellars, Barbara Mullen.

THE TITFIELD THUNDERBOLT (1953)
Director: Charles Crichton
Cast: Stanley Holloway, George Relph, Naunton Wayne, John Gregson, Godfrey Tearle, Hugh Griffith, Sidney James.

THE CRUEL SEA (1953)
Director: Charles Frend
Cast: Jack Hawkins, Donald Sinden, Denholm Elliott, Stanley Baker, John Stratton, Liam Redmond, Meredith Edwards, Bruce Seton, Glyn Houston, Virginia McKenna, Moira Lister, Alec McCowen.

THE SQUARE RING (1953)
Director: Basil Dearden
Cast: Jack Warner, Robert Beatty, Maxwell Reed, Bill Owen, Joan Collins, Kay Kendall, Sidney James.

MEET MR. LUCIFER (1953)
Director: Anthony Pelissier
Cast: Stanley Holloway, Peggy Cummins, Jack Watling, Barbara Murray, Joseph Tomelty, Gordon Jackson, Joan Sims, Ian Carmichael.

THE LOVE LOTTERY (1954)
Director: Charles Crichton
Cast: David Niven, Peggy Cummins, Anne Vernon, Herbert Lom, Gordon Jackson, Felix Aylmer, Humphrey Bogart.

THE MAGGIE (1954)
Director: Alexander Mackendrick
Cast: Paul Douglas, Alex MacKenzie, James Copeland, Abe
 Barker, Tommy Kearins, Andrew Keir.

WEST OF ZANZIBAR (1954)
Director: Harry Watt
Cast: Anthony Steel, Sheila Sim, Edric Connor, Orlando
 Martins.

THE RAINBOW JACKET (1954)
Director: Basil Dearden
Cast: Robert Morley, Kay Walsh, Edward Underdown, Bill
 Owen, Honor Blackman, Wilfrid Hyde-White, Sidney
 James.

LEASE OF LIFE (1954)
Director: Charles Frend
Cast: Robert Donat, Kay Walsh, Adrienne Corri, Denholm
 Elliott.

THE DIVIDED HEART (1954)
Director: Charles Crichton
Cast: Cornell Borchers, Yvonne Mitchell, Armin Dahlen,
 Alexander Knox.

OUT OF THE CLOUDS (1955)
Director: Basil Dearden
Cast: Anthony Steel, Robert Beatty, Margo Lorenz, David
 Knight, James Robertson Justice, Eunice Gayson.

THE NIGHT MY NUMBER CAME UP (1955)
Director: Leslie Norman
Cast: Michael Redgrave, Sheila Sim, Alexander Knox, Denholm Elliott, Ursula Jeans, Michael Hordern, Nigel Stock.

THE SHIP THAT DIED OF SHAME (1955)
Director: Basil Dearden
Cast: Richard Attenborough, George Baker, Bill Owen, Virginia McKenna, Roland Culver, Bernard Lee.

TOUCH AND GO (1955)
Director: Michael Truman
Cast: Jack Hawkins, Margaret Johnston, June Thorburn, John Fraser.

THE LADYKILLERS (1955)
Director: Alexander Mackendrick
Cast: Alec Guinness, Cecil Parker, Herbert Lom, Peter Sellers, Danny Green, Jack Warner, Katie Johnson, Frankie Howerd.

THE FEMININE TOUCH (1956)
Director: Pat Jackson
Cast: George Baker, Belinda Lee, Delphi Lawrence, Adrienne Corri, Mandy Miller.

WHO DONE IT? (1956)
Director: Basil Dearden
Cast: Benny Hill, Belinda Lee, David Kossoff, Garry Marsh, Ernest Thesiger, Charles Hawtrey.

THE LONG ARM (1956)
Director: Charles Frend
Cast: Jack Hawkins, John Stratton, Dorothy Alison, Geoffrey
 Keen, Ursula Howells, Ian Bannen.

THE MAN IN THE SKY (1957)
Director: Charles Crichton
Cast: Jack Hawkins, Elizabeth Sellars, Walter Fitzgerald,
 Eddie Byrne, John Stratton, Lionel Jeffries, Donald
 Pleasence.

THE SHIRALEE (1957)
Director: Leslie Norman
Cast: Peter Finch, Dana Wilson, Elizabeth Sellars, George
 Rose, Sidney James.

BARNACLE BILL (1957)
Director: Charles Frend
Cast: Alec Guinness, Irene Browne, Maurice Denham, Percy
 Herbert, Victor Maddern, Richard Wattis, Lionel Jeffries.

DAVY (1958)
Director: Michael Relph
Cast: Harry Secombe, Ron Randell, George Relph, Susan
 Shaw, Bill Owen, Joan Sims, Kenneth Connor.

DUNKIRK (1958)
Director: Leslie Norman
Cast: John Mills, Richard Attenborough, Bernard Lee, Robert
 Urquhart, Ray Jackson, Ronald Hines, Michael Bates,
 Kenneth Cope.

NOWHERE TO GO (1958)
Director: Seth Holt
Cast: George Nader, Maggie Smith, Bernard Lee, Geoffrey
 Keen, Bessie Love.

THE SIEGE OF PINCHGUT (1959)
Director: Harry Watt
Cast: Aldo Ray, Heather Sears, Neil McCallum, Victor
 Maddern.

Sources and Acknowledgements

Balcon, Michael, *Michael Balcon Presents A Lifetime of Films*, Hutchinson & Co., 1969.

Barr, Charles, *Ealing Studios,* Cameron & Tayleur/David & Charles, 1977

Bond, Derek, *Steady, Old Man! Don't You Know There's a War on?* Pen & Sword Books Ltd, 1990.

Bright, Morris, *Our Thora: Celebrating the First Lady of Showbusiness*, Hodder & Stoughton Ltd, 2001

Burton, Alan and O'Sullivan, Tim, *The Cinema of Basil Dearden and Michael Relph*, Edinburgh University Press, 2009.

Clarke, T. E. B., *This is Where I Came in* by, Michael Joseph Ltd, 1974.

Duguid, Mark, Freeman, Lee, Johnston, Keith M. and Williams, Melanie (eds), *Ealing Revisited*, Palgrave Macmillan/British Film Institute, 2012.

Ellis, David A., *Conversations with Cinematographers*, Scarecrow Press, 2012.

Faulkner, Trader, *Peter Finch: A Biography*, Angus & Robertson, 1979.

Foner, Henry, Dorinson, Joseph and Pencak, William A., *Paul Robeson: Essays on His Life and Legacy*, McFarland & Co Inc., 2002.

Granger, Stewart, *Sparks Fly Upward*, Granada, 1981.

Guinness, Alec, *Blessings in Disguise*, Fontana Press, 1986.

Hawkins, Jack, *Anything for a Quiet Life*, Elm Tree Books, 1973.

Hill, Leonard, *Saucy Boy: The Revealing Life Story of Benny Hill*, Grafton, 1990.

Hogg, James, Sellers, Robert and Watson, Howard, *What's The Bleeding Time? James Robertson Justice: A Biography*, Tomahawk Press, 2008.

Holloway, Stanley, *Wiv a Little Bit o' luck: The Life Story of Stanley Holloway*, Leslie Frewin, 1967.

Kemp, Philip, *Lethal Innocence: The Cinema of Alexander Mackendrick*, Methuen Publishing Ltd, 1991.

McFarlane, Brian (ed), *Sixty Voices: Celebrities Recall The Golden Age Of British Cinema*, British Film Institute, 1992.

MacKenzie, S. P., *British War Films, 1939–1945*, Hambledon Continuum, 2001.

Mills, John, *Up in the Clouds, Gentlemen Please*, Weidenfeld & Nicolson, 1980.

Neame, Ronald, *Straight from the Horse's Mouth*, Scarecrow Press, 2003.

Perry, George, *Forever Ealing*, Pavilion Books, 1981.

Pertwee, Michael, *Name Dropping*, Leslie Frewin, 1974.

Read, Piers Paul, *Alec Guinness: The Authorised Biography*, Simon & Schuster Ltd, 2003.

Seaton, Ray and Martin, Roy, *Good Morning, Boys: Will Hay, Master of Comedy*, Barrie & Jenkins, 1978.

Tynan Kathleen (ed.), *Kenneth Tynan Letters*, Weidenfeld & Nicolson, 1994.

Warner, Jack, *Jack of All Trades*, W. H. Allen, 1975.

BECTU History Project

BFI library

BFI Screenonline

Westminster reference library

'Inside Ealing', unpublished essay by Michael Relph

'The Ealing Comedies' – BBC documentary, 1970

Index

Index

Index

Crichton, Charles 41, 58–9, 72, 73, 76, 91, 92,
 94, 106, 125, 128, 150, 160, 167, 172–3,
 174, 198, 226, 235, 254, 293, 308–9
Crown Film Unit 27, 46
Croydon, John 142
The Cruel Sea 130, 181, 226–31, 249, 251
Cummins, Peggy 234

Dalby, Stephen 115–16, 212, 213
Dale, Dick 236–7
Dance Hall 167–8
The Dancing Years 143
Danischewsky, Monja 3, 27, 60, 94, 120, 126,
 145–6, 147, 149, 151–2, 199–200, 311
Davey, Bert 69
Davis, Bette 304, 306
Davis, John 162, 290
Davy 294–5
Day, Frances 63
Dead of Night 70, 75–6, 77–8, 81, 138
Dean, Basil 10, 20, 21, 22, 169
Dearden, Basil 25, 26, 39, 56, 57–8, 60, 61, 68,
 76, 82, 84, 104, 108, 160, 163, 165,
 168–9, 219, 249, 251, 259, 276, 278,
 279–80, 281, 295, 310
Deliverance 303
Denham Studios 11, 75, 180, 230, 286
The Devils 218
Dickinson, Thorold 35, 217, 218
Dicks, Ray 150
Dighton, John 126, 153, 154, 183
Dines, Gordon 251, 285
dining rooms 204–5
The Divided Heart 253–4, 255
Docker, Sir Bernard 286
Doctor in the House 236
Doctor Who 48, 281
Donat, Robert 252
Dorme, Norman 5, 49–52, 60, 69, 84–5, 85–6,
 90, 91, 100, 106–7, 111, 112, 121–2,
 129–30, 137, 147, 148, 192–3, 199,
 204–5, 256–7, 263, 264, 285–6, 287,
 292
Dors, Diana 143, 167
Douet, Alex 105, 106, 110, 112, 113–14, 146,
 198
Douglas, Rowland 34
drinking culture 198–9, 213–14
du Maurier, Daphne 306
Dunkirk 299–302

Ealing Studios
 arrangement with Rank 75, 162–3
 assets sold to ABPC 308–9
 democratic spirit 64–5, 120, 177, 191, 206
 family atmosphere 3, 14, 191, 221, 234, 287,
 311
 filmography 315–32
 layout 2
 production pattern 84–5
 production transfer to Borehamwood 290,
 291–2, 298
 projection of traditional British values 33,
 74–5, 158, 283, 289
 rebirth of Ealing name 313
 self-sufficiency 69
 studio sold to BBC 284–9
 war years 11–74
 see also entries for individual departments
Eastmancolor 117
Edwards, Meredith 160
Elephant Walk 294
Elliott, Denholm 228
Elstree Studios 143
end-of-shoot parties 85
ENSA 22, 247
The Entertainer 312
Eureka Stockade 132–5
Evans, Clifford 32–3
Exodus 255

Farrar, David 29, 104
The Feminine Touch 280
Fergusson, Brigadier Bernard 301–2
Festival of Britain 69, 95
Feyder, Jacques 106
Fiddlers Three 63–4
Fields, Gracie 7, 20–1, 296
film extras 14, 84, 144–5, 148, 181–2, 302
film library 122–3, 298–9
film noir 303
Finch, Peter 87, 134, 135, 160–1, 293–4
fire safety 38–9, 56, 197
The First of the Few 126–7
A Fish Called Wanda 293
Flaherty, Robert J. 11
Fletcher, Eric 308
flying bombs 67–8
focus pullers 40
For Those in Peril 58–9, 61
Forbes, Bryan 175, 227

339

Index

Ford, John 273, 298
Forde, Walter 25, 27
The Foreman Went to France 32–3, 73, 296
Formby, Beryl 21, 23–4
Formby, George 20, 21, 23–4, 30
The Four Just Men 15
Fowler, Harry 29, 91, 92, 219
Fox, James 220
Fragile Films 313
Frankel, Cyril 215
Fraser, Bill 30
French, Harold 143
Frend, Charles 19, 33–4, 46, 65, 66, 108, 111, 112, 150, 198, 226–7, 228, 229–30, 231, 252, 253, 309, 310
Frieda 104–5

Gainsborough Pictures 10, 25, 127, 218
The Galloping Major 141
Galton, Ray 174
Gandhi 219
gantry system 128
Gaumont-British 10, 16, 77, 142, 161
Genevieve 141, 262
The Ghost of St Michael's 25
GoldenEye 213
Golding, William 304–5
The Goose Steps Out 25–6
Gordon, Richard 236
Grade, Lew 287
Granada television 142
Granger, Stewart 17, 107, 168, 202
Graves, Thelma 247
Great Expectations 94, 154
The Great Gatsby 303
Green, Danny 263
The Green Man 278–9
Greenham, Chris 118, 124
Greenwood, Joan 150, 157, 183
Grierson, John 125, 126
Griffith, Hugh 160, 226
Griffith, Kenneth 297
Guess Who's Coming to Dinner 262
Guinness, Alec 71, 154–6, 160, 172–3, 174, 175, 176, 183, 186–8, 201, 206, 220, 233, 262, 264, 266, 268, 274, 294, 306
Guy, Fred 69

Habberfield, Mary 8
Hale, Sonnie 63

The Halfway House 56, 57–8, 61
Halliwell, Leslie 296
Hamer, Robert 46, 76–7, 80, 81, 102–3, 118, 128, 150, 153, 154, 187–8, 209, 213–15, 306
Hammer 304
Hanley, Jimmy 17, 165
A Hard Day's Night 204
Hardwicke, Cedric 93
Harman, Jympson 151
Harper-Nelson, Margaret 218, 247, 248
Harris, Jack 307
Hartnell, William 281
Harvey, Laurence 219
Hawkesworth, General John 34
Hawkins, Jack 181, 222, 227, 228, 229, 231, 282, 292–3
Hawtrey, Charles 25, 26
Hay, Will 13, 25–6, 28, 38, 44, 179
health and safety, disregard for 26, 47–8, 112, 165, 173, 186–8, 208–9, 230–1, 260, 269
Heller, Otto 40, 254–5
Hepburn, Audrey 175, 201, 202, 217–18
Highlander 279
The Hill 213
Hill, Benny 276–7
Hillary, Richard 36, 58
Hipple, Rex 3, 179–81, 182, 185, 205, 209, 226–7, 236–7, 252, 277–8, 284–5, 286, 287–8
Hird, Thora 29–31
His Excellency 209–10, 211–13, 214
Hitchcock, Alfred 10, 16, 21, 76, 142
Hobson, Valerie 160
Holloway, Stanley 56–7, 62, 63, 93, 120–1, 137, 172, 173, 176, 226, 233–4
Holt, Seth 9, 118–19, 182, 191, 303–4
Honri, Baynham 272, 273, 274
Hopper, Victoria 22
The Horse's Mouth 304
Horsman, Jack 41–3
Houston, Donald 160, 168
Howard, Elizabeth Jane 63–4
Howard, Leslie 126
Hue and Cry 60, 91–3, 138, 219
Hulbert, Claude 25, 38
Hulbert, Jack 10

I Believe in You 219
If… 304

340

Index

Index

Index

Index